DE GRAZIA

T0163472

THE MAN AND THE MYTHS

JAMES W. JOHNSON
WITH MARILYN D. JOHNSON

THE UNIVERSITY OF
ARIZONA PRESS
TUCSON

The University of Arizona Press
www.uapress.arizona.edu

© 2014 The Arizona Board of Regents
All rights reserved. Published 2014
First paperback edition 2015

Printed in the United States of America

ISBN-13: 978-0-8165-3050-2 (cloth)
ISBN-13: 978-0-8165-3197-4 (paper)

Cover design by Leigh McDonald
Cover image courtesy of the DeGrazia Foundation

Unless otherwise noted, all photographs are courtesy of the DeGrazia Foundation.

Publication of this book is made possible in part by a subvention from the DeGrazia Foundation.

Library of Congress Cataloging-in-Publication Data
Johnson, James W., 1938–
 De Grazia : the man and the myths / James W. Johnson with Marilyn D. Johnson.
 pages cm
 Includes bibliographical references and index.
 ISBN 978-0-8165-3050-2 (cloth : alk. paper)
 1. De Grazia, 1909–1982. 2. Artists—United States—Biography. 3. Arizona—Biography. I. Title.
 N6537.D4J64 2014
 709.2—dc23
 [B]

 2013034401

To Kim, Thayer, and Kiley with our love

Writing about an artist is a thousand sidesteps with a miracle in between. No one knows the miracle, only the sidesteps. If you see a flash of light wait and watch for revelations.

—*Marion De Grazia*

Contents

DE GRAZIA

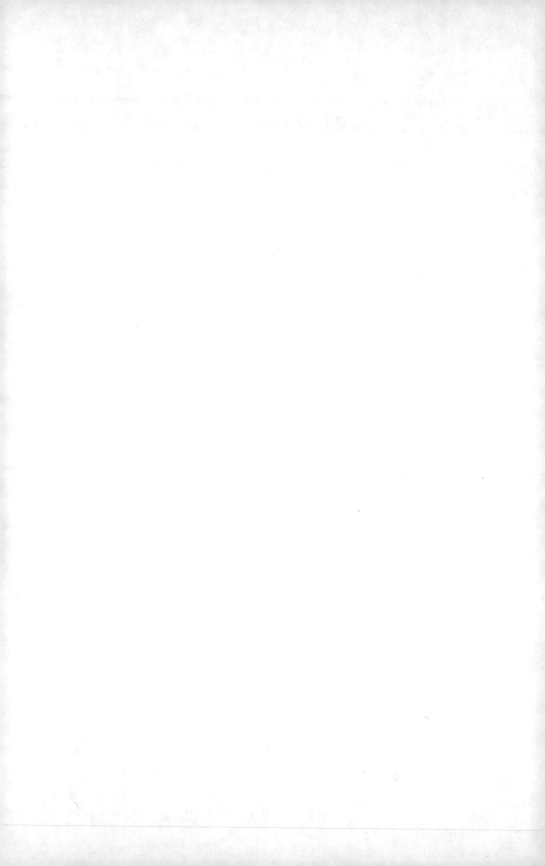

Introduction

People expect an artist to do wild things, crazy
things. I don't want to disappoint them.
—*De Grazia*[1]

TED DE GRAZIA ONCE described himself as "not saint nor devil, but both."[2] There's a lot of truth in that.

Coming up with the real Ted De Grazia is a biographer's nightmare. It's a nightmare of the artist's creation, since De Grazia protected his privacy as fiercely as he produced his paintings. His wife, Marion, may have helped him keep his life private, even after his death, by destroying material in the Gallery in the Sun's archives that had potential, no matter how remote, to compromise her husband's passion to remain inscrutable. Jennifer Potter, who was the Gallery in the Sun's executive director during the 1990s, said that Marion shredded newspaper articles and photographs after his death. "I did manage to save some photos," she said.[3]

De Grazia cooperated on two biographies, both coffee-table books that revealed little about his private life, thanks to his spoon-feeding the authors only what he wanted them to know. One of the authors, William Reed, called De Grazia an elusive character, both physically and spiritually—one who was hard to tie down for a major work on his life and thoughts. Reed titled his 1971 book *De Grazia: The Irreverent Angel* and described it as a literary portrait.[4] Harry Redl wrote the other biography, *The World of De Grazia*, published in 1981. In addition, De Grazia kept in his folders several partially written, never-finished biographies that included handwritten comments in the margins, suggesting that he controlled what the authors wrote about him.

Who better to know him than his two wives and his paramour of eleven years? His first wife, Alexandra, wrote a brief memoir of their ten-year marriage. His second wife revealed little about their thirty-five-year marriage, while his lover wrote a 238-page tell-all book about their relationship, but only after De Grazia's widow had died. In turn, De Grazia never said or wrote much about the three women closest to him.

De Grazia always talked openly about his early years in Morenci and his time at the University of Arizona. But he rarely shared anything about his Bisbee days, and following that period in his life he focused on communicating only what he wanted people to know.

This biography relies heavily on stories in newspapers, magazines, books, and relatively few personal papers, as well as a dozen interviews by the author and fifty oral histories. Most of those interviewed chose their words carefully, often declaring that they didn't want to talk about some incidents in De Grazia's life even as they hinted at womanizing, hard drinking, and carousing.

De Grazia often told outrageous lies to writers for newspapers, magazines, and books, making it a struggle to sift through them for truth. Court documents are limited to the probate of his estate and two filings for divorce, only one of which was finalized.

Yet it is possible to piece together a picture that sheds some light on De Grazia, whose art remains among the most often reproduced in the world. The purpose here is to get behind the myths to the real De Grazia. The author makes no pretense of judging his work. This is the story of an artist's life and not his art, although that subject surely lurks on the periphery. Nor does this author want to leave you with the impression that he breached the high adobe wall of secrecy that De Grazia erected around himself.

If one thing stands out, it's his individualism. No one was quite like him, and he liked it that way. In fact, he thought more individualism in the world would be a good thing. "The individual is gone," he said in 1967. "Individualism is being lost. I live on the fringe of society."[5]

While De Grazia could charm people—especially women, for whom he had a weakness—he could exasperate others. The macho image he carefully nurtured concealed a self-centered personality coupled with a huge ego. He admitted to being a lousy father, and only in the final years of his life did he seem to find real intimacy in

a relationship. He had four children, the last with his lover, Carol Locust, at the age of sixty-five.

On the other hand, De Grazia had a good sense of humor and showed occasional signs of sensitivity and generosity. Still, he did not suffer fools. "He was an egotistical bastard to some, an angel to others," said Locust. "His personal image did not fit with what some people thought an artist should look like. And De Grazia didn't give a damn."[6]

He probably drank too much, saying, "The only time I drink is when I'm alone or when I'm with somebody," but he didn't belt them back the way he led people to believe.[7]

He loved to lie, boasting, for example, that in his poor days he ate dogs and cats. Longtime drinking buddy Shorty Thorn would listen to De Grazia and then, with a wink, say, "That's not exactly the way it was."[8]

One friend suggested that De Grazia drank too much from the Hassayampa. The Hassayampa River flows in northern Arizona from Prescott to Wickenburg. It's a legend that if someone drinks from the Hassayampa with his head pointed downstream, he will never again tell the truth.[9]

De Grazia once told Locust that if you disguise yourself with "junk," nobody thinks to see through it to the real person. "Or if you disguise something that you don't want anybody to recognize, then you say things around it so they won't really know."[10] For example, he never dispelled capricious claims that he'd had seven or more wives. When he filled out a two-page biographical folder for the *Tucson Daily Citizen* in 1965, he wrote about his marriages, "Too many wives"; about his children, "Too many to numerate"; and about grandchildren, "Too many to numerate."[11]

He also never disclaimed rumors that he had an Apache or Tarahumara mother, despite knowing full well that both parents had emigrated from Italy. When he grew bored answering the same questions from reporters over and over again, he gave them ever-changing stories. He liked to embellish rumors "and just get the biggest kick when he'd see it printed in the newspaper," said his stepson, Hal Grieve, who added that, "yes, he loved to bait reporters, and he would give them the biggest line of bull you can imagine to see how much of it they would swallow."[12] He didn't mind negative publicity.

"Negative publicity was better than none," said Cassandra Prescott, a member of the De Grazia Guild.[13]

He told his stories with a shrewd mixture of humor, humility, and showmanship. This tactic served to keep people from prying into his personal life. "The most precious thing in life at my age is privacy," he said in his later years.[14]

Newsman and historian Abe Chanin once asked De Grazia why he once told a reporter that he had sired sixteen children in Mexico. "You know that's not true," Chanin said. De Grazia replied, "Well, if you want to sell paintings, you have to be considered eccentric, so I'm eccentric, and I sell paintings."[15] Said teacher and freelance photographer Dick Frontain, "He was better at that game than any artist I have known."[16]

A reporter once asked him the name of the greatest American artist. De Grazia replied, "I am the great American artist." Recalling the incident later, he said, "I only said that because that is what people want to hear from artists. They expect artists to be brash. So I said it, and it made people more interested in my paintings."[17]

There you have it: De Grazia's brilliance as a marketing strategist. He was a showman who knew how to attract attention. As part of his persona, for example, he usually dressed like a down-on-his-luck prospector in old cowboy hats, moccasins or boots, flannel shirts, and blue jeans with a red bandana sticking out of a rear pocket. He grew a graying beard. Somewhere along the way he picked up a tattoo that looked like the sun symbol on the New Mexico state flag, which comes from the Zia Pueblo symbol for the sun. When he lost a front tooth, he replaced it with a gold one.

His garb made him easily identifiable. He wore the same sort of clothes whether painting, going to the bank, buying a car, or attending weddings and funerals. He even claimed that he wore his long shirts to sleep in. Said fellow artist Hutton Webster Jr., "De Grazia is a man of deep personal sincerity hiding under a mask of studied buffoonery."[18]

Dick Frontain knew the De Grazia behind the public face. "Late at night, early in the mornings, and on trips he spoke like the very intelligent, educated man that he was," Frontain said. "For the public, for collectors, for autograph seekers, he spoke honestly but simply . . . like a short, chubby Lincoln of the Southwest."[19]

Calling De Grazia an enigma or a complicated man doesn't explain him. He often even contradicted himself, saying one thing and doing another. The lies—his "ho ho ho line of malarkey," as one writer put it—were deliberate, designed to make him appear more exciting.[20] "Ask me no questions, and I'll tell you no lies," he once said. "But some will not accept that. So I answer them any way I feel."[21]

Those who participated in the DeGrazia Foundation's oral history project didn't say much about him that could be considered unfavorable. It's possible they still wanted to respect his privacy, even after death, or perhaps he avoided talking much with them about his private life. Early home movies of De Grazia and his family are available at De Grazia's Gallery in the Sun archive, but virtually nothing since then can be found. His children might have family pictures, but one of them has died; a second declines to be interviewed about her father; and the third adores her father to the point of blindness about his shortcomings. His fourth, born to Carol Locust, was only eight years old when De Grazia died, and he remembers little.

"De Grazia ain't so hard to understand," he once said about himself. "You know, when somebody doesn't act and think like everyone else, people want to make him into some kind of a nut. I think that helps them sleep better."[22]

If you were to rate De Grazia's whoppers on a scale of one to ten, with ten being top, the list would look something like this:

Number of wives and children: grossly exaggerated. He had two wives and four children, one by his mistress.—9.

Womanizing: Hard to prove. No doubt he had several affairs. Friends hinted about them. Certainly he carried on one for eleven years, until his death.—7.

Drinking: He drank heavily at times, but De Grazia surely exaggerated his alcohol use. It's doubtful he could have achieved so much had he been the committed alcoholic he claimed to be.—7.

Professionals: He claimed to dislike bankers, lawyers, physicians, and politicians, but he used them all.—4.

Shortly after his death in 1982, De Grazia's second wife, Marion, wrote two literary accounts of his life. In them she never mentioned him by name, and they provide little new information about him.

Her writing, though, is captivating in places. Here is a sample that fits this introduction:

> *From time to time somebody with a notebook under his arm will come to him. "I would like to write the story of your life, the real story." Eventually they do not appear anymore. Many accounts have been written about creative persons. Surely they are only surface accounts. Creativity is not easy to explain or should be.*[23]

In his declining years, Ted De Grazia often sat in the late afternoon on the patio at his gallery and home in the Catalina Foothills of Tucson with his attorney, Tom McCarville. They would discuss De Grazia's insecurities as an artist and worry about the artist's legacy: How would he be remembered after he passed on? Would he be thought of as a great artist rather than just a well-known one? Would he become famous, like Van Gogh, only after his death? Or would he be just another commercial painter? Would he be compared to Norman Rockwell or Walt Disney, or would he be likened to Paul Gauguin? Why didn't critics care for his work? Would he always be thought of as the painter of little Indian kids carrying baskets of flowers, with dots for eyes and mouths?[24] If De Grazia and McCarville reached any consensus, it was that his work had a common denominator: it appealed across the board to some critics and to many people.

With McCarville's legal assistance, De Grazia set up a foundation to maintain his gallery and his thousands of paintings after his death. As many as 130,000 people visit the gallery in a good year, spending tens of thousands of dollars in the gift shop for prints, books, ceramics, and other works.[25] Internet sales are strong.

Even though De Grazia remains immensely popular long after his death, critical acclaim still eludes him. Just because he produced thousands of paintings doesn't mean he ranks among those considered the best. Critics called his paintings "kitsch," a German word made popular by Clement Greenberg in 1939 to describe art designed to pander to popular demand, a lowbrow form of art.[26] In return De Grazia called critics "miserable bastards, feeding off someone else's talents."[27]

De Grazia could have remained forever a starving artist desperately trying to win over critics. Or he could have attempted simply to

make a good living with his artwork. He chose to do both, one more successfully than the other. He died a multimillionaire, thanks to his genius at selling art the average person could afford. If nothing else, De Grazia was, indeed, an artist of the people.

Financial success released him from the pressure of not knowing where he would get his next dollar—a frequent difficulty for him early in his career—so that he could focus on his work. A master storyteller, he left as one of his many legacies works about the native peoples of the Southwest and Mexico. Even so, mention De Grazia to average people who know of him, and they will typically reply, "Oh, you mean that guy who drew the cute little kids with no faces?"

De Grazia must have bristled when academicians and critics said those paintings had little artistic merit. Nevertheless, those who judge the artist judge the audience as well. Granted, some of De Grazia's paintings probably do drop to the level of kitsch. But a great many capture a complex "stew" of Southwestern culture that has never been duplicated.

His early work, influenced by the renowned Mexican muralists Diego Rivera and José Clemente Orozco, showed great promise, his critics said, but De Grazia soon wandered from their influence to what became his more familiar and popular style. Paintings of Native American children became his "burdensome trademark," as one critic put it.[28] Interestingly, Rivera also painted pictures of young children holding baskets of flowers, but critics loved his work.

De Grazia ultimately became more popular with people outside Arizona than with those in his home state. This could be attributed to the influence of *Arizona Highways* magazine, which attracted thousands of tourists to the state, many of whom had seen De Grazia's works in the magazine and wanted to see more. His alma mater, the University of Arizona, however, had little use for his paintings, and even as late as 2005 a staff member at the Tucson Museum of Art said the museum would never exhibit De Grazia's work because they only accepted "real artists." The museum later relented and did hold a small exhibit on the hundredth anniversary of his birth at the request of the DeGrazia Foundation.[29]

If De Grazia's art is to be recognized over the years, decades, or even centuries ahead, it will be because of his blending of the cultures that uniquely defined the Southwest and Mexico. The stories

his paintings tell could well evolve into an important snapshot of a world that is fast vanishing, a situation that De Grazia looked upon with sadness and anger. Not to be overlooked is his contribution to Southwest history—his books on Father Kino, Father Serra, and the explorer Cabeza de Vaca—and his extraordinary architecture.

Author Jonathan Eig once said that he always tried to find one word to summarize the entirety of each of his books. For example, when writing a biography of baseball player Lou Gehrig, he came up with the word *courage*. What one word might describe De Grazia? When asked that question, Lance Laber, executive director of the DeGrazia Foundation, said without a moment's hesitation that the word should be *driven*.

In the fifty years from the time he set foot in Tucson until he died in 1982, De Grazia painted more than twenty thousand canvases; created countless ceramics, enamels, and sculptures; wrote twenty-two books; produced a dozen films, some of which he starred in; consulted for two ballets based on books he illustrated; traveled extensively throughout Mexico and the Southwest; and built the Gallery in the Sun, Mission in the Sun, and several other structures.

In the end, he did leave a legacy in his art and architecture. The question is: How long will it last?

(Author's note: The artist's last name has been spelled *De Grazia* and *DeGrazia*. Although the DeGrazia Foundation prefers the spelling without the space, I chose to use the spelling that is on his family documents and how he appeared to sign his paintings. In addition, in keeping with the time during which De Grazia lived, I refer to the tribe as *Papago* instead of *Tohono O'odham*, since the change occurred about the time of his death. Moreover, I use the term *Indian*, instead of the current, "politically correct" nomenclature of *Native American*.)

1

The Miner's Son

You cannot start out lower than [working in
the mines], in every sense of the word.
—*De Grazia*[1]

AFTER TED DE GRAZIA DIED in 1982, workers clearing out his
cluttered home, workshop, and gallery in the Catalina Foothills of
Tucson found thousands of dollars in cash secreted in Chivas Regal
boxes in a storage room and in envelope boxes tucked under his bed.
By some accounts, the amount ranged from $100,000 to $500,000.
According to records kept by Ira Feldman, De Grazia's accountant,
the cache totaled $198,000.[2] But DeGrazia Foundation Executive
Director Lance Laber remains convinced it added up to a half mil-
lion dollars. In addition to the cash, workers found seventy ounces
of gold, worth as much as $1,794 an ounce; forty pounds of silver
ingots, worth about $34.43 an ounce; and a cigar box full of gold
twenty-peso coins, each coin worth about $704, all in 2013 dollars.[3]
 De Grazia could have stored the gold and silver thinking he would
eventually make jewelry from them. He once told TV personality Rita
Davenport that he had shoe boxes full of gold under his bed. "He
pulled out a shoe box when I was in his office one time," Davenport
said, "and it looked like gold nuggets."[4]
 No one knows for sure why De Grazia hoarded cash and precious
metals, except that he didn't like banks. "I bury my money," he liked
to say, even though he regularly did business with banks.[5] Feldman

said De Grazia would cash paychecks of $2,000 a month from a special pension plan set up for him by the foundation, and then he would stash away any money he figured he didn't need.[6]

He might even have planned to bury it eventually in the Superstition Mountains to keep it out of the hands of the "revenuers," as he claimed he did with some of his paintings. Since the gallery had no cash register to record sales and didn't take credit cards, a substantial portion of the money could have come from gift shop sales. Gallery clerks just threw whatever they collected from sales into a drawer, keeping no records such as receipts. In fact, before Feldman, De Grazia used a Taiwanese immigrant known as Colonel Chuk to keep track of finances with an abacus.

"Money's no good for anybody. It makes bums out of them. I think everyone should start from scratch."[7] After all, that's what he did. The wealth De Grazia accumulated began with his dirt-poor upbringing in the troubled mining town of Morenci in what was then Arizona Territory. Morenci gave birth to his understanding of social and cultural differences, sparked his interest in music and art, and kindled his "innate creativity, his independent behavior, and his populist philosophy of life."[8]

Despite his "bad birth," meaning difficult, at home on June 14, 1909, De Grazia grew up a healthy, mischievous boy who looked much like his mother.[9] He took delight in having been born in Arizona before it became a state because "it makes me sound better, like old whiskey."[10] Formally named Ettore De Grazia, Ted was the third child of Domenico and Lucia De Grazia, immigrants from Italy. His oldest brother, Greg, was followed by sister Roseanna. After Ted came Alice, Giselda, Frenck, and Virginia.

De Grazia's baptismal and birth certificates name him Ettorino, which means "Little Ettore" in Italian. Most of his life he signed legal documents as Ettore, which when translated into English means "Hector of Grace." A Morenci teacher anglicized his name to Theodore because it was easier to spell, and eventually Theodore evolved into the nickname Ted.[11] In the 1940s he became Ettore once again because it sounded European. Then in his fifties he went back to calling himself Ted. In his later years he preferred to be called simply De Grazia.[12]

Both of De Grazia's maternal and paternal grandparents have the same first names: Gregorio and Roseanna Gagliardi and Gregorio and Roseanna De Grazia. Those given names have been passed down through generations.

De Grazia's paternal grandparents and, later, his parents came to Morenci from Italy before statehood to carve out a living in the copper mines. Why they chose Morenci is unclear, but in the late 1800s and early 1900s Morenci grew into a boomtown, with plentiful jobs and a population of just over five thousand by 1910.

According to a family history compiled by De Grazia's brother Frenck, their paternal grandparents, Gregorio and Roseanna De Grazia, arrived in New York on December 10, 1886. They then made the twenty-three-hundred-mile trip by train to Lordsburg, New Mexico. There they boarded a stagecoach to Morenci. Gregorio apparently interested neighbors back in Amantea, Italy, to come to Morenci as well, in some cases paying their way.[13]

A group of California volunteers pursuing Apache renegades first discovered ore and minerals in Morenci around 1856, but copper mining didn't begin until about twenty years later. The first ore contained as much as 80 percent copper. In the early 1900s three major companies operated mines in Morenci and the nearby towns of Metcalf and Clifton. By 1909, Morenci, named after a town in Michigan, was considered the home of a mother lode of copper, a bonanza that still produces 380,000 tons a year, making it the second largest copper producer in the world.[14]

The town of Morenci itself, at an altitude of 4,836 feet, sat on a steep mountainside called Longfellow Hill. In the early days, two major mining companies, Arizona Copper and Detroit Copper, also owned the hotel, hospital, store, and all of the homes. The companies' vertical alignment of structures on the hill made Morenci one of the most dangerous towns in the United States and its territories. Deliveries to homes had to be made by pack burro and a ladder. Those wealthy enough to afford a car had to park at the bottom of the hill and hike up on foot or follow burro trails to their homes. One account claims that small children had to be tethered in their yards while playing to keep from tumbling down the hill. Everyone breathed the thick, black soot belched by a nearby smelter.

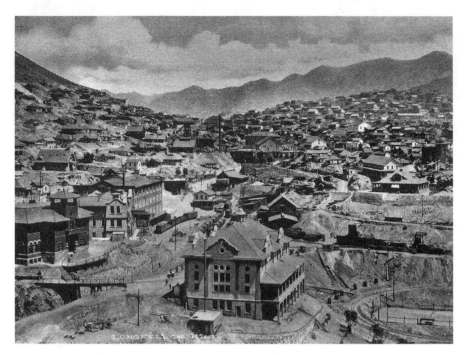

Figure 1. Morenci, Arizona Territory, Ted De Grazia's birthplace, in the early 1900s.

People stayed because of plentiful jobs in the mines, which produced 750,000 tons of copper over a fifty-year period ending in 1922. At twelve and a half cents a pound, that represented total revenue of $187.5 million.[15]

Italians flocked to Arizona in higher numbers than any other ethnic group. While the general population of Arizona Territory grew between 1900 and 1910 from 122,931 to 204,354, an increase of 66 percent, the number of Italians—most of them from the Calabria and Lombardia regions of Italy—increased from 699 to 1,531, a 119 percent rate of growth.[16]

Despite its large Italian population, Morenci came to be considered a "Mexican camp" because of the number of Mexicans recruited to work in the mines. These two predominant ethnic groups mixed freely, with relatively little ethnic strife.

De Grazia's parents were the product of a marriage arranged when they were children.[17] His father's home, Amantea, was a fishing village

surrounded by citrus groves on the western coast of Italy in the province of Cosenza, Calabria, where singer Tony Bennett and New York Yankees shortstop Phil Rizzuto had roots. His mother, Lucia Gagliardi, lived in nearby San Pietro. Lucia's manifest from the *Trojan Prince*, the ship on which she traveled to America, shows that she arrived on August 12, 1902.[18]

Domenico, Gregorio's son and Ted's father, was born May 27, 1881. No record could be found of Domenico De Grazia arriving through Ellis Island. Perhaps he came via Mexico. In 1902 Domenico instructed a friend in Italy to ask Lucia to join him in Morenci to be his wife. Domenico sent his friend the fare for Lucia's passage. Domenico and Lucia married in Morenci on November 12, 1903, with Justice of the Peace William H. Chapman presiding.[19] While records are incomplete, family recollections are that Domenico also became a U.S. citizen that year.

When the future grandparents Gregorio and Roseanna De Grazia arrived in Morenci, they no doubt quickly discovered they would be living in a town controlled by the mining companies. These companies determined where they would live, where their electricity would come from, and where they would buy their food and clothing.[20] The town itself was a hodgepodge of streets and homes built on the rugged hills surrounding the mines. The high school sat on an old slag dump. Players kicked field goals in football games at the north end of the playing field because balls kicked toward the south end would disappear down Morenci Canyon.[21]

Cold winters, hot summers, and work stoppages, strikes, and closings at the mines made life difficult in Morenci. As a mucker, Domenico De Grazia descended day after day into deep, dangerous tunnels to extract copper for meager wages. He brought home a paycheck of less than three dollars a shift, paid in cash. He once told Ted he feared he would be mugged as he walked home from work, so he would pull his jacket up over his ears and hold tight to his money.[22]

Despite the hardships, the De Grazias managed to eke out a living for themselves and their seven children. Later in his working life, Domenico became a mine foreman, which undoubtedly improved the family's standard of living.

By choice, mine workers lived in segregated sections of Morenci, which one resident compared to Rome because both had seven hills.

Dirt roads connected all of the hills. The only paved road was Burro Alley, the town's main thoroughfare and the only one with a name. It remains known as Burro Alley today.

The hills were known either by letters of the alphabet or by numbers. The De Grazia family lived on Number Six Hill, or Devil's Back Hill, set aside for Calabrese immigrants. In those days Italians weren't considered white by race. Census records show miners listing their ethnic group as white, Italian, or Mexican. The De Grazias identified with the Mexican culture even as they socialized with Italians.[23] They more than likely lived in a Mexican-style home—one with thick walls made of adobe brick and with a flat roof.

As poor as the De Grazias were, they still found time to celebrate life, particularly on Sundays, when they would attend church and then come home to huge family parties featuring plenty of music and "dago red" wine. A family picture shows five-year-old Ted with his father and seven other men, each with a bushy mustache and each drinking wine from a keg.[24]

Union members frequently went on strike for improved wages. Long-lasting strikes no doubt made it even more difficult for miners to get by. In 1915, for example, six thousand miners struck over low wages, the companies' high profits, the cost of company housing, and the prices of goods and services at company stores and hospitals, as well as recognition of their union.[25] The average miner in the Clifton-Morenci mines at that time earned $2.30 a shift. White miners on average earned more than Italians, and Italians, more than Mexicans.[26]

At one point during that strike, a brass band led two thousand strikers through the dusty streets of nearby Clifton.[27] The strike lasted five months, halting the potential production of ten million pounds of copper.[28] Miners who had been barely scraping by on their meager salaries with hardly any savings had a difficult time making ends meet.

That same year, 1915, De Grazia's grandparents returned to Italy, most likely because of the strike. Gregorio was fifty-nine years old, perhaps too old to work any longer in the mines. He also may have been afflicted with the lung disease that eventually claimed his life.

A second strike took place in 1917, when copper was desperately needed by the Allies fighting World War I. The strike ended only after a presidential commission came out from Washington, DC,

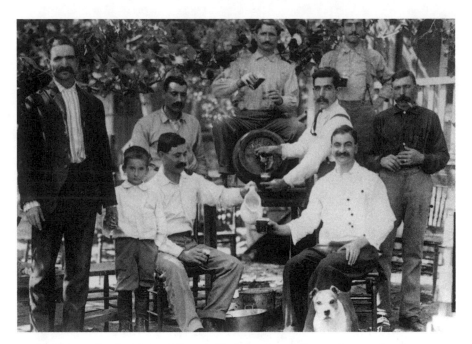

Figure 2. On Sundays, Morenci's miners got dressed up and cele-brated with a keg of wine. De Grazia holds the hand of his father, Domenico.

and negotiated a settlement.[29] Wages then rose to $4.12 a shift, even though production dropped.[30]

De Grazia grew up in a culture where Mexicans, Italians, Indians, and Chinese comingled. Because he spoke Spanish and because of the spelling of his name, people often mistook him for a Mexican. He didn't dispel that impression. Neither did he deny later in life that he was part Apache. After all, Morenci abutted an Apache reservation, which De Grazia often visited as a youngster. "I've lived with the Indians so long that people think I'm Indian," he said. "Let them think what they want. I'm an Italian, but sometimes I think Indian."[31]

He said he considered himself "just a part" of all that he'd been through and all that had been around him.[32] In other words, living in a small mining town with so many different cultures couldn't help but make him the kind of person he became known as for the rest of his life: independent and individualistic, with great sympathy for common folks.

All of it influenced De Grazia's art. His understanding of cultural variations especially helped him when he traveled through Mexico observing the Mexicans' as well as the Indians' ways of life.[33]

In the early 1900s Morenci's reputation had become that of one of the toughest towns in Arizona.[34] As a boy De Grazia would hang around an area populated by gamblers and prostitutes known as New Town. Cockfights were common. "It was a hard town where I grew up, hard liquor, hard living. Fights and killings? Well, nobody paid attention. I saw three guys who had their bellies ripped open in fights."[35]

De Grazia spent his childhood "doing just what kids do," including playing hooky from school, which had no truant officers to chase him. He daydreamed a lot. "Kids need to dream, people need to dream. . . . I think dreaming is important; the fantasy world is important—and I guess I've had more than my share of both."[36]

He often came home filthy after a day of playing on the desolate, mined earth, but he battled washing up. "I hate water. It was a fight to get me cleaned up, and I rebelled at the Sunday dress-up order," he said.[37]

His parents apparently put him to work as a little boy. He never identified that work or how it fit into his life otherwise, but in his later years he thanked his parents for doing so. De Grazia always had a strong work ethic, which he tried to instill in his own children. He believed nobody should be given something for nothing and that everything worthwhile came about through hard work. "There is nothing more healthy than to see a young kid with men at work and at play. It's a blend that is normal as breathing," he said in a 1971 phonograph recording of his thoughts and philosophy. "A child begins by observing, running errands, as a helper, and finally as a worker. . . . Hard work is good for the body and the soul. Work is the highest achievement a human can obtain. As you get older you will see that work is almost a privilege."[38]

Art as work seems to have become part of De Grazia's ethic early on. For example, he cut the small squares of colored tissue paper originally used to wrap fruit into shapes of flowers, animals, birds, and "everything I could think of." Then he stuck them to butcher paper with flour-and-water paste. To help his mother pay for food,

he tried to sell these little pieces of "art" along the road for a few pennies. His brother Frenck would hail passersby to encourage them to buy the trinkets.[39]

Color fascinated De Grazia from an early age. When he went on long hikes with his father, he would gather colorful rocks in the rugged Gila Mountains surrounding Morenci. He tried unsuccessfully to make paints from the vivid minerals in them. He also boiled flowers and even attempted to paint using the purple juice from cactus fruit.[40]

Pulverized rocks not used for paint were mixed with clay and molded into figures. Later in life De Grazia remarked that his interest in art "did not begin under the tutelage of an educated art instructor, but rather as a boy's fascination with mud."[41] He made sculptures out of it and put them in his mother's oven while she baked bread. One of the pieces, "Face of Christ," remains on permanent display today in De Grazia's Gallery in the Sun.[42]

Artwork in Holy Cross Catholic Church, where the De Grazia family worshipped,[43] clearly left a lasting impression on young Ted. Catholic churches in Southwestern mining towns tended to reflect Mexican culture more than anything European, although his mother had an elongated, medieval, El Greco–like Christ that she had brought with her from Italy and that affected him deeply. *Retablos*, devotional paintings of Catholic icons derived from folk art, and primitive carvings of saints adorned Holy Cross, like other Catholic churches in the region.[44] Though never a churchgoer as an adult, De Grazia eventually developed his own spirituality, which he expressed over and over again in his paintings and architecture.

Joe Pulice, one of young Ted's closest buddies growing up, lived next door. Like most boys, they loved mischief. A favorite prank was to gather up gunnysacks that the Phelps Dodge Mercantile Company used to sell coal in hundred-pound lots to town residents. The boys collected the empty sacks and then sold them back to the storekeeper, who counted them and told the boys to put them on a pile of sacks in the back of the store. One of the boys stayed with the storekeeper and collected their money—five cents per bag—while the other walked to the back and then slipped out a side door with the same sacks. The next day they returned and sold the sacks again. They mostly used the money to buy candy and ice cream, but sometimes they enjoyed the local theater's silent movies. They liked cowboy actor Hoot Gibson.

One time they were caught, and "we had to work that much harder hunting sacks," Pulice said.[45]

De Grazia learned to speak Spanish because so many of his young playmates were Mexican. He got his first exposure to bullfighting by watching mock bullfights in Morenci's dusty streets. The experience gave him a lifelong appreciation of the sport.[46] The boys probably played mumblety-peg and kick the can, popular games in Morenci in those days. They also rode burros that wandered loose, although "it was harder on us to keep them moving than the enjoyment of riding," Pulice said.[47]

Often they explored abandoned mine shafts and tunnels that prospectors had dug years before, using candles or lighted oil-soaked rags to find their way. The tunnels were no more than fifty yards down an arroyo below their homes. Sometimes they hid burros in the tunnels for a day or two so they could keep riding them. De Grazia became an accomplished rider during those years.

He skipped school regularly with another buddy, Isasis Moreno, an Apache, with whom he passed the time roaming nearby mountains. Sometimes De Grazia stayed several days with the Indians, causing his mother to search feverishly for him, worrying that he might have tumbled down a mine shaft or fallen and hurt himself.[48] Eventually, when he felt like it, De Grazia returned home to the demands of family and school. The wanderings with Moreno probably cultivated his lifelong pattern of escaping to a different world when life felt too demanding or unstable.[49]

De Grazia blamed his unruliness on the fact that he was the black sheep of the family. He recalled that all of his brothers and sisters seemed close to each other but not to him, so he "used to take off to the mountains, to the creek, and to the bad part of town."[50]

His wanderlust began as a toddler. His mother had to tie him to the leg of the kitchen table so she could keep track of him. "There were six other children in our family," De Grazia said. "My mother had to work hard and couldn't take time out to chase after me."[51]

Once when his mother asked him to go to the store to buy yeast to make bread, he ran off to play. "I was a terrible trial to her, but I couldn't help it. How could I stay inside four ugly walls when there was so much beauty to explore outside?"[52]

In 1920 a saddened Ted told Pulice that he and his family were moving to Italy because the mines had closed, thanks to demand for copper dropping dramatically after the war. Hundreds of miners had been laid off. Eleven-year-old De Grazia and Pulice cried when they realized they might never see each other again.

The morning of Ted's departure, he went to Joe's house dressed in nice new clothes and talked him into hiding out with him in one of the tunnels so De Grazia's parents couldn't find him and take him to Italy. De Grazia's family looked for Ted for several hours before Joe's mother discovered them in a cave. Joe got an immediate spanking, and the boys had to crawl up the hill, soiling their clothes. "Ted got home, and I heard some screams. I knew what was happening," Pulice said. Young Joe went outside and saw the De Grazia family walking away from the house toward an automobile waiting to take them to the train. As they drove off, Joe broke into tears again.[53]

2

To Italy and Back

The teachers must have liked me, because
they always kept me after school.
—*De Grazia*[1]

THE TRIP TO ITALY MADE a strong impression on young Ted. The De Grazias were crammed into the ship's hold for a week with dozens of other passengers. De Grazia never forgot the putrid smells of vomit and bodies that had gone too many days without baths. "Oh, it was like a nightmare," he told his daughter, Lucia, years later. "I never want to see a boat as long as I live."[2] He became a committed desert rat. "I don't like the ocean because I don't understand it," he said on a trip to the Gulf of California in 1978. "I'm afraid of it, too. I'm not fond of water."[3] Another time he wrote, "I love the desert, but I don't care for the sea. I don't fish. I don't even swim. I don't care too much for drinking water, either."[4]

Ted's family thought they would spend only six months in Italy, but when it came time to leave, De Grazia's maternal grandparents broke down in tears over the likelihood of not seeing their children and grandchildren again. Then-four-year-old Frenck recalled, years later, seeing "the emotional drama that was displayed." The grandmother became bedridden for a couple of years, which, Frenck said, "I reasoned was a put-on ploy." The family decided to stay.

While in Italy, young Ted staged shows for other children with his guitar and a trumpet that he had recently learned to play, covering a

storm culvert with a sheet to look like a stage. Frenck collected the two-cent fee.[5]

Also in Amantea, De Grazia became exposed to the art of the Catholic church once again. The church of Saint Bernardino of Siena, built in a Romanesque-Gothic style featuring "a lancet window surmounted by a cross with nine ceramic dishes," may have been one of them.[6] After watching the church decorators and artists, Ted again took up working with clay. He also began to paint religious themes.[7] "I still consider the church art of Italy to be some of the finest ever painted by man," he once said.[8]

De Grazia's mother wanted him to become a priest, but he balked at a religious life. He spent more time painting than he did studying church law.[9] Once, when it became his responsibility to pump the organ during High Mass, he quit pumping in the middle of a service, which of course stopped the music. Two monks picked him up by the ears, led him down some spiral stairs, "and out [he] went."[10] After that, De Grazia never formally participated in church life. His paintings, however, reflect a deep reverence for all things religious. As writer Elizabeth Shaw put it, "Mysticism was an element in the painter's nature, but as a non-conformist in religion, he maintained to the church the relationship of a loving but canny and critical son."[11]

In 1925 the De Grazia clan decided to return to Morenci, the family apparently afraid that Greg, Ted, and Frenck could be recruited into Benito Mussolini's fascist youth movement.[12]

Back home and now sixteen, De Grazia painted three works that were remarkable, if one considers his age and that he undoubtedly had had very little, if any, formal training as an artist. The paintings were favorites of his throughout his life. They survive today in the collection of the De Grazia Gallery in the Sun: the first in oil, twenty-four by sixteen inches, called *Indian Faces*, of two Indians holding a candle; the second an eighteen-by-eighteen-inch oil called *4 Horses*, depicting a black horse on either side of two white horses; and the third a twenty-three-by-fifteen-inch oil entitled *Three Sad Women*, of mourning women, the sadness based on his exposure to religious art and the culture of Mexican families living in Morenci.[13]

De Grazia and his siblings grew up in a home devoted to music. His father played guitar, and his mother played classical music on the piano. All seven children had instruments before shoes; this, during

the period when they were so poor Domenico had to put newspapers inside his jacket to keep warm in winter.[14]

Ted had lost his command of English in Italy while becoming fluent in Italian. To regain his native tongue, he tried to teach himself by reading the subtitles of silent films.[15] His parents insisted that he complete his schooling instead of going to work in the mines. "I . . . wasn't eligible to attend [school] in Italy," he recalled.[16] This put him so far behind that upon returning to Morenci he had to repeat the first grade. He quickly moved through the grades and graduated from Morenci High School with a full growth of beard at age twenty-three.[17]

Going back to first grade at age sixteen created social as well as academic difficulties for him. He had grown to five feet seven inches. Classmates' ridicule often led to fights. He broke his hand once in a fight with another student. Because the De Grazias didn't have money for a doctor, they allowed a Native American medicine man to apply pitch and tie a cloth around his hand to heal it. That same medicine man used lard to soothe his father's bones, which ached from working in the high humidity of the mines.[18]

De Grazia claimed that he daydreamed his way through school, quipping, "So I didn't turn out a good speller—so what?" He suspected that his teachers passed him "because I grew too big for the seats."[19]

He often commented that people needed no more than an eighth-grade education. "Educators have done a good job selling education," he said. "Too much school for everybody is no good. It makes people slaves to society. It produces more tax money, more money for politicians to throw away."[20]

Ted learned to excel on the trumpet during this time, when he and brothers Frenck and Greg formed a dance band called Greg's Blue Derbys, which played at gatherings throughout the area. "The Miner's Stomp" became one of the band's most popular songs. Ginger Renner remembered the band playing at a community center in Cliff, New Mexico, about sixty-five miles from Morenci. Renner, along with a high-school group from Silver City, New Mexico, drove thirty miles to Cliff to dance "because the music was so good."[21]

De Grazia began selling his art at the band's gigs—pieces of silk that he cut handkerchief size and painted with colorful flowers, available during intermissions for fifty cents each.[22]

Figure 3. Music was an important part of De Grazia's early life. Here he is at age sixteen (far left) with friend Joe Risso and his brothers Frenck, nine, and Greg, twenty.

He also wrote and copyrighted his own music. In 2010, twenty-eight years after De Grazia's death, the Tucson Jazz Institute recorded six of those songs for the first time: "Please Remember Me," "Te Quiere Mucho," "Perlita," "Bonita," "Hello, Stranger," and "I'm So Lonely and So Blue."

In 1928 Phelps Dodge, the third largest copper company in the United States, decided to halt underground mining in Morenci because the price of copper had fallen once again, this time to less than six cents a pound, which made extracting it an economically unfeasible venture. An excess supply of copper and the Great Depression brought about the price drop. In fifty-six years of operation, the mines had produced almost two billion pounds of copper. Huge tonnages of the ore, however, remained below the surface. In 1937, Phelps Dodge determined to get at it using an open-pit operation and, accordingly, reopened Morenci.[23]

Because of the open pit, all of the company homes had to be relocated or razed. By 1983, the original town no longer existed. De Grazia remembered seeing miners and their families, dogs, and belongings piled onto benches on the flatbeds of trains, shipped out of town by the company to avoid trouble and told they could go anyplace they wanted, at company expense.[24]

De Grazia knew he didn't want to spend his life deep beneath the earth, living in poverty while pulling copper out of stone for wealthy corporations. He had worked in the mines briefly after finishing high school, so he understood firsthand that if he didn't succeed at something else, he would likely spend the rest of his life underground. "A miner is at the bottom of the barrel next to begging," he said. "They had nothing. They had little to eat. And then—even when they got through working—they were still broke."[25]

De Grazia never forgot the dangers and the tragedies that came hand-in-hand with work in the mines. "There was always the dark shadow of the diaster [sic] whistle—a heart-rendering [sic] sound, which brought out the women and children waiting in terrified agony, waiting the fateful news, waiting for thier [sic] men to appear—stark faces and suspense while the men emerged from under the ground dripping in red mud," he wrote.[26] He especially remembered the Indian women who gathered at the mine after an accident. "All of them were covered with shawls. Their faces kept looking out from below the tops of the shawls, with only a small space left for their eyes, peering out to look at the cages coming up from the mine. People could feel their tension but not see it in their faces."[27]

Faced with the economic uncertainty created by the mines' closing, De Grazia and his father agreed that he needed more schooling. "So what does any red-blooded American boy do when he can't find a job? He goes to college. Hell, I had to get out of the mines. They were like tombs; I had to get away."[28] The night before he left home, the De Grazias had a big dinner, "a real feast," he said, "for my mother killed a chicken."[29]

The next day he helped a friend load his pickup truck in exchange for a ride in the back to Tucson. With his prized trumpet, fifteen dollars, an extra pair of jeans, and a shirt, he started off for his new life as a student at the University of Arizona.

3

Getting an Education

School is like medicine. You take it as needed, a little at a time.
—*De Grazia*[1]

AT SOME POINT DURING the truck ride to Tucson, the driver asked De Grazia what he was going to study. "Anything," he replied. "Maybe music, maybe art. Doesn't make much difference. There are only two things I don't like, swimming and physical education." He had gotten out of swimming in high school by diving into the school pool as far out as he could and coasting to the other side, thereby "proving" that he could swim.[2]

Tucson in 1932 couldn't have been more different from hardscrabble Morenci. With a population of about thirty-two thousand, the city attracted health seekers and tourists in droves. Of the 45 percent of the permanent population that was of Mexican extraction, most lived in a barrio west of downtown. They usually worked on the railroad or as clerks, domestics, and agricultural and day laborers. Since De Grazia was accustomed to living among a variety of cultures in Morenci, he likely became well known in the barrio. They were his people; he spoke their language.

Tucson had twenty-five hotels, forty-five tourist courts (rates higher in winter), five movie theaters, two newspapers, and two radio stations. For the ill, there were more than thirty hospitals and sanatoriums. The burgeoning University of Arizona stood out as the town's centerpiece. Tucson also had two golf courses, with green

fees of fifty cents, or seventy-five cents on holidays. La Fiesta de los Vaqueros, the Tucson rodeo, was a popular event.

Motorists drove down wide, paved streets lined on both sides with pepper and orange trees, Italian cypress, and tamarisk. The Works Progress Administration's *Guide to 1930s Arizona* pointed out that the center of Tucson was the intersection of Broadway and Stone Avenues downtown, where one- or two-story buildings sat below "two box-like skyscrapers." Dozens of cars with out-of-state license plates as well as limousines with guest-ranch names printed on their sides cruised downtown near hotels. "Occasionally, there is a spluttering Model T Ford driven by an old sourdough, his long mustache whipping in the breeze," the WPA guide noted.[3]

The city was mostly residential, with few industries to offer employment. Many of the wealthiest Tucsonans lived in the foothills of the Catalina Mountains on the north side, a place that beckoned to De Grazia over the next three decades. The foothills appealed to him, not as a place where he could afford to live, but instead as one where he could escape Tucson's fast-growing population.

De Grazia enrolled at the university and its relatively new music department almost immediately after arriving in Tucson. There, he fell under the influence of Professor Joseph De Luca, known as "the world's greatest euphonium soloist," and a one-time member of the John Philip Sousa band. De Luca composed the "University of Arizona March."[4] Music of the great masters enchanted De Grazia, and he found music professors who encouraged him, which he called "a boon to [my] spirit." He also studied art, working toward bachelor's degrees in both subjects.

He must have wondered how he would fit in with clean-cut college men in corduroys and comely women in knee-length skirts after Morenci's grime and poverty. He also must have been awed by the seventy-five-acre campus scattered with forty building that housed three thousand students and three hundred faculty members and staff. The fifteen dollars in his pocket when he left Morenci disappeared quickly as he paid for tuition, food, and shelter. He borrowed textbooks or used ones in the library.

As an art major, De Grazia often painted in the home studio of Katherine Kitt, a pioneer developer of Tucson's art community as

well as head of the art department. Kitt had a "definite influence" on his career, De Grazia said. "We fought over what she considered my shiftlessness, and she never complimented me verbally, but she confirmed her trust in me by buying many of my first postcard reproductions."[5]

Kitt's home, on South Fourth Avenue in Tucson's Armory Park, served as a gathering place for artists. Cele Peterson, known as Tucson's "First Lady of Fashion" for her longtime ownership of high-end women's clothing stores, saw many of De Grazia's early works in Kitt's studio. "He was really a shining example of what the University of Arizona was producing in art," she said. Peterson added that while De Grazia's paintings brought him fame in later years, Kitt disliked his work.[6]After De Grazia had achieved some acclaim, Kitt told Peterson that she "would give anything to just shake the daylights out of [him]." Peterson asked why. "This is a young man that has a talent that is so God-given, it's a pity to see it wasted on commercialism." Peterson replied that De Grazia was painting exciting things. "Oh, Cele," Kitt retorted, "that boy, that man, could be as great as any artist that has ever, ever put a brush and paint on canvas." Peterson said she mentally added to Kitt's assessment, "And maybe he would have died a poor man had he continued on that score."[7]

When De Grazia started school, he took "bonehead English," a remedial course for students whose English fell below university standards. He still couldn't spell, and "I never could get straight what modified what, whom, and why."[8]

He moved into Cochise Hall, a campus dormitory, where he roomed with a saxophone player named Ambrose Baca. In an adjoining room, John Pintek, later to become an attorney, roomed with James Kingsbury of Bisbee. Pintek and De Grazia got to know each other by virtue of getting drunk together on bootleg whiskey—Prohibition had banned production, transportation and sale of liquor since 1920. A woman named Louise, who lived by the railroad tracks a short walk from campus, provided it. "The whiskey was so bad you had to hold your nose sometimes to drink it," Pintek said.[9]

After a month in the dorm, De Grazia realized he couldn't afford to continue living there. He and Pintek rented an apartment for which each paid seven dollars a month. Sustenance for De Grazia

often consisted of bread so stale he had to dunk it in coffee to eat it. "But there was one thing that kept you going: You don't want to go back into that mine."[10] He and Pintek decided to take turns cooking, but De Grazia proved to be lacking in culinary skills. "To put it politely," Pintek said, "let's just say that he was very indifferent about cooking."[11]

For money, De Grazia picked up odd jobs and joined a band that played at bars, for local dances, and in houses of ill repute. With Pintek as manager, the band also picked up gigs playing for fraternity, sorority, and dormitory dances on campus. De Grazia described his playing as "loud and lousy," but he made a dollar a night for his efforts.[12] Soon, though, he formed his own band, one that included brother Frenck, by then attending high school in Tucson. Ted posted signs around campus that said, "UofA Cafeteria, Ted De Grazia and his orchestra, starring Edith Leverton, Sunday dinner 12:15 to 1:30 Nov. 4"; "Campus Grill Presents Ted De Grazia and his ten-piece orchestra with Charlie Farrell, Sunday May 10th, 7–8"; "Los Asper-antes, Spanish Club featuring Ted De Grazia with William Novick, Hispanic Songs and Dance, Thursday, Nov. 8, 11:40 a.m." In addition to his dance band, De Grazia joined the UA concert band in 1934.

Sometimes his father sent him money, but De Grazia always sent it back, insisting that he could take care of himself without any help.[13] He found work digging ditches and planting trees around the sprawl-ing campus for thirty-five cents an hour. "My trumpet, and a pick and shovel, put me through college," he said.[14] Years later, while showing friends around the campus, he would point to the then full-grown trees he had planted.[15] He even helped build a dam and a road into scenic Sabino Canyon for the Works Progress Administration. Once he landed a job washing dishes at the Pepper Tree Inn, where the woman in charge fired him after his first day on the job. But, she said, he could come to breakfast the next morning. Shamed by the firing, he didn't take her up on the offer.[16]

"It wasn't all bad. At the time it was rough," he reminisced, "but I was young and I was with other people who were poor so I didn't feel the whole class thing."[17] Fellow students spotted him barefoot on campus more than once because he couldn't afford shoes.[18] Certainly, his Morenci upbringing conditioned him to such poverty. Years later, Pintek visited De Grazia at his gallery after he had become famous

Figure 4. De Grazia led a band to help pay for his education at the University of Arizona.

and told him, "Well, Ted, you can put on shoes now, you know. You don't need to [continue] this Indian act."[19]

Somehow De Grazia managed to scrape up a few dollars for a bicycle that he rode to jobs playing trumpet at the Club La Jolla in South Tucson or the Beehive in the barrio, where the Tucson Convention Center stands today. Prostitution blossomed in Tucson during the Great Depression, especially at the Beehive in Sabino Alley. "It was a rough place, but I hung around there. I guess I was just killing time."[20]

De Grazia didn't enjoy college academics. He usually took the last seat in classrooms because it gave him an easy way to leave any-time he wanted.[21] "I was not interested in copying plaster casts or artificial class setups. I knew that my style was already asserted. So no amount of discipline for doing class work would change me—or even interest me."

He acknowledged that he frustrated his professors because he wanted to paint what he knew, not what they urged him to paint. "I had come to school because I was a painter, not to become one. . . . I could not paint to please the public with pretty pictures in ice

cream colors. It would not be me. So in spite of criticism I stuck to my own style. . . . For a while I quit because there was so much opposition. Because there was so much fight. For a while I thought no more about painting."[22]

"No professor, no school, nobody can make you what you're going to be. . . . I never liked the attitude of the professors. To me it was that they were way up there, and their attitude was that you were way down there, dumber than hell." So he would take off to Mexico or Indian country, "anywhere I didn't feel too dumb anymore."[23]

All of this soon changed. In the fall of 1934 a comely sophomore sat on the Commons (now the Mall) on a hot Sunday with three classmates. The young women were "very *alegre* and blithe and deb- onair . . . and two of us were also buxom," Alexandra Maria Diamos recalled. They were listening to De Grazia's band playing on the Commons. When he blew his trumpet, Diamos said, his playing was "sweet as honey with long sweeps of pain and longing." She remem- bered thunderous applause following De Grazia's solo.[24]

The next week, Diamos and the suave trumpet player ran across each other in the university library. Smitten by the handsome young man with slicked-back black hair and a trim mustache under a prom- inent Italian nose, she invited him to dinner at her parents' house, at 330 South Stone Avenue, where the headquarters of the Tucson Police Department are located now.

Alexandra's wealthy father, Nicholas, owned movie theaters throughout Arizona, including the stately Fox Theater on Congress in downtown Tucson, which cost $350,000 to build and housed an $18,000 Wurlitzer organ at a time when a two-bedroom house cost $9,000.[25] Among his other theaters, situated in Douglas, Bisbee, Nogales, and Phoenix, as well as in Cananea, Mexico, the Grand The- ater in Douglas was considered to be one of the finest west of Chicago.

Diamos, a Greek immigrant, had come to Tucson in 1912. "It was like I was back home in my village in Greece," he said.[26] Soon he met and married his wife, Ana, half Yaqui, a quarter Mexican, and a quarter Irish. Two years later Ana gave birth to Alexandra, who grew up in comfort and wealth. And now Alexandra had a beau for dinner at her house. Naturally, they ate a Greek dinner of lamb, rice pilaf, goat cheese, and wine. "Real olive oil in the salad, and anchovies and

[capers]," De Grazia exclaimed. "Am I ever sick of mayonnaise." For dessert they ate Greek honey cakes. At one point, De Grazia ate so many meals prepared by Ana Diamos that his brother Frenck began calling him Panzuto Bruto, or "Ugly Potbelly" in Italian.[27]

The romance thus began. At the end of the school year, De Grazia's parents, brother Greg, and sister Virginia drove to Tucson from Morenci to meet the Diamoses. By then, Nicholas Diamos had given De Grazia a job as assistant manager of a five-hundred-seat movie theater, the Plaza, at the intersection of Congress and Plaza (later Court Street), not far from the more opulent, twelve-hundred-seat Fox. The job allowed De Grazia to attend classes during the day and work at the movie house until 11 p.m. or midnight.[28]

The love-smitten young man now could afford a car and a "small but quite flawless" diamond for Alexandra. Nick Diamos consented to the marriage only when Ted promised he would finish his bachelor's degree by 1938, a promise he failed to keep.

The newly engaged couple and their parents celebrated with a buffet supper where "intimate friends" joined them in the garden of the Diamoses' new home at 1401 East Mabel Street, a luxurious five-year-old house at the intersection with North Highland Avenue, just north of the university. Alexandra wore a silk gown woven by monks of the monastery of Athos on a mountainside near Athens. It had been brought from Greece by her father.[29]

On June 19, 1936, almost two years after they met and five days after his twenty-seventh birthday, Ted and Alexandra married at Saint Augustine Cathedral, 192 South Stone Avenue, at 6 a.m., in a ceremony scheduled early in order to avoid the blistering summer heat. The *Tucson Daily Citizen* called it "one of the most beautiful wedding ceremonies to be performed this summer." Despite the hardships of the Great Depression, the wedding had to have been among the most elaborate of the season. Alexandra, twenty-one, wore a high-waisted, white satin gown designed on princess lines and carried a crystal rosary belonging to her grandmother. A soloist sang "Ave Maria," arranged by De Grazia's brother Frenck. After the wedding Nicholas and Ana Diamos played host to a breakfast for 180 people at the ritzy Pioneer Hotel. Later that night, out-of-town guests attended a garden party at the Diamoses' home that lasted

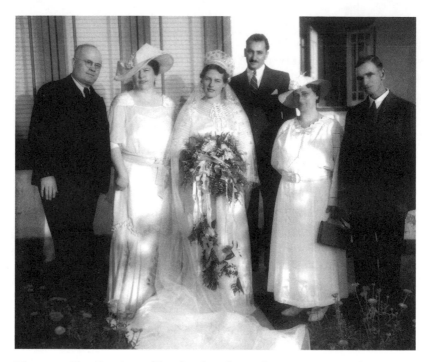

Figure 5. De Grazia and his bride, Alexandra, were married on June 19, 1936. From left are her father, Nicholas Diamos; her mother, Ana; his mother, Lucia; and his father, Domenico.

until midnight. The next morning the newlyweds headed to the Grand Canyon for a two-week honeymoon.[30]

Before De Grazia's marriage, another milestone in his development as an artist had taken place. In January 1935 the University of Arizona had played host to an exhibition of Mexican modern art that featured the works of Diego Rivera and José Clemente Orozco. Rivera was considered by many to be Mexico's greatest painter. Orozco, a social-realist painter, helped establish the 1920s Mexican mural movement. Their exhibit proved to be a great inspiration to De Grazia. This might have been De Grazia's first exposure to the Mexican masters, but it wouldn't be his last.

4

The Bisbee Years

I'm not a joiner. I belong to no group.
—*De Grazia*[1]

SOON AFTER THE WEDDING the newlyweds moved to Bisbee, a booming mining town of twenty thousand people about ten miles from the border with Mexico, where Nick Diamos had made Ted manager of the Lyric Theater at 10 Naco Road, at the very bottom of the notorious Brewery Gulch.

In Bisbee's heyday, Brewery Gulch had as many as forty-seven saloons and countless houses of ill repute. The southernmost mile-high city in the United States, it was widely considered one of the liveliest spots between El Paso and San Francisco.[2] Bisbee in the 1930s produced half of Arizona's gold, silver, and copper. Phelps Dodge mined the Copper Queen at the edge of town. The mine had an average annual payroll of $5 million. As was true in many mining towns, Bisbee residents called Phelps Dodge "The Company," primarily because it also owned the largest hotel, the hospital, the only department store, the library, and more. The town, three times larger than it is today, had 218 businesses.[3]

Bisbee sits at the confluence of Brewery Gulch and Tombstone Canyon, where houses cling to the sides of steep hills. The topography provoked an old saying that "most any fellow with a chaw in his jaw can sit on his front porch and spit down the chimney of his neighbor's house."[4]

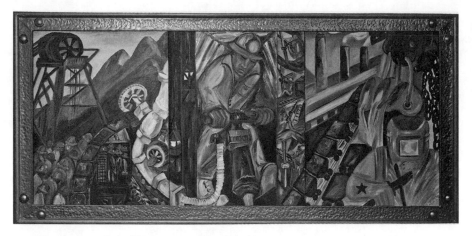

Figure 6. While living in Bisbee, De Grazia painted this mural depicting life in the mines.

When the De Grazias moved into a rented one-bedroom apartment, Alexandra took an almost immediate dislike to the town. "Bisbee made me feel like I was in some foreign country," she wrote in her memoir, "and I told Ted I'd never venture forth after dark," apparently referring to the menace of miners who frequented saloons and houses of ill repute.[5] Most of the miners—immigrants from Mexico, Italy, England, and middle European countries—spoke English poorly, if at all.

De Grazia became a businessman. He dressed in a suit and tie, joined the civic clubs, and even played a round of golf or two— although not very well—at the Bisbee Country Club, eight miles south of town on the road to Naco.[6] John Alexander, a professional magician who performed in Brewery Gulch saloons, described De Grazia as "a big shot in town."[7] He oversaw two showings at the theater every evening and matinees on Wednesdays, Saturdays, and Sundays, with new movies twice a week. He kept to a schedule, rising at 6:30 a.m., eating breakfast, and heading out the door by 8:00.

De Grazia's inexhaustible energy and drive went into high gear. It didn't take him long to find a place to paint, a space in the theater between his office and the movie projector booth where boxes of film were stored. He would paint two or three hours at the theater, usually in the early morning, and then do his banking and run errands. The

family would eat dinner at 5 p.m., and then he would go back to the theater until 11 or midnight.[8]

De Grazia seemed at this time to be seeking a way to use art as a social statement about class struggle. *Mining*, one of his first paintings after moving to Bisbee, is a three-panel, black-and-white triptych that clearly depicts the companies' indifference toward workers. The first panel depicts huge mining equipment in the foreground with a line of small, anonymous workers entering a mine shaft in the background. The second panel presents a close-up look at a miner operating a hydraulic hammer. The third panel illustrates a modern industrial site with a smokestack fouling the air above while a worker toils below. The three panels together also was De Grazia's attempt to demonstrate to mining companies the indispensable role of the workers who operated the machinery. The painting had similar qualities to a 1930 painting, *Steel*, by Thomas Hart Benton, who became De Grazia's friend later in their careers.[9]

As well known as they were in town, Ted and Alexandra shied away from social gatherings. Even after De Grazia became more famous, he felt uncomfortable socializing. "He never was really very much for that kind of life," one-time Bisbee resident Eleanor Rice Feeney recalled.[10] He did, however, carve out time to indulge in a musical sideline, playing trumpet at the Blue Moon saloon just outside Bisbee.

De Grazia made several improvements in the operation of the theater. When he learned, for example, that one of the town's leading physicians, Hal Rice, and his wife were extremely hard of hearing, he arranged to have earphones put into the theater to help them. Their daughter recalled that movies were pretty much the only entertainment at the time in Bisbee, so making it possible for her parents to hear "was a very great boon for all of us, 'cause we got to see all the movies, and they could hear them."[11]

One day De Grazia dropped by the local studio of artist and sign painter George Sellers. Sellers had helped De Grazia set up the studio at the Lyric,[12] and they had become drinking buddies. Sellers' work included a relief map he made of Cochise County using forty-four pounds of screws, nails, and tacks and more than two thousand cups of plaster, all paid for by President Roosevelt's New Deal program. It remains today on the second floor of the Cochise County Courthouse.[13]

Sellers painted pictures that looked almost like photographs. De Grazia looked at the paintings, uttered some salty words, slapped his knee, and said, "I can paint those so-and-so pictures."

De Grazia's former college roommate, John Pintek, who returned to Bisbee to practice law, thought Sellers painted better than De Grazia. Sellers' paintings "were common things that you'd see, and know and be familiar with, whereas Ted was painting, oh, far out," Pintek said.[14]

De Grazia was spending so much time on his paintings that "I was forgetting everything else. Finally I found myself completely involved . . . in painting."[15] Bisbee's people and landscape were his favorite subjects. Magician John Alexander recalled that people in Bisbee didn't care much for De Grazia's primitive style. They "wondered what in the world he painted," Alexander said. "Everybody laughed at it. It looked like a little five-year-old kid had painted it."[16]

De Grazia reflected years later that his colors "weren't nice, not brilliant, they were somber." The same could be said of his subject matter—"beggars, people sleeping on the ground, *borrachos* [drunks], and cathouses." One Tucson critic called it "De Grazia's God-awful period."[17]

While at the university De Grazia had experimented with mixing music and art, his two great interests. He likely picked up his appreciation of classical music from his mother and often painted while reading sheets of it. He would read the rise and fall of the notes on the sheets and then use his brush to depict the music in paint. He also listened to music, seeking to explore the psychological relationship between feelings and moods evoked by classical music and abstract painting.[18] These explorations became the theme of his master's thesis, which he completed several years later.

In the spring of 1937, Nicholas Diamos put up a down payment of $3,000 toward the purchase price of $9,000 for a five-room, 960-square-foot frame house for Ted and Alexandra at 404 Roberts Avenue in Bisbee. The home, built in 1915, sits a little over a mile up Tombstone Canyon from the theater. The house still stands today. Ted adopted a German shepherd and bought several chickens, as well as "one mean rooster." Alexandra felt threatened by the rooster, calling out to her husband one day, "He's got me on the run, so you'll have to bring in the eggs."[19]

Not long after they moved to their new home, Alexandra became pregnant. She gave birth to their first child, Lucia Anita, named after De Grazia's mother, on May 15, 1938, in a Tucson hospital. Alexandra had wanted to be in Tucson, near her mother, for Lucia's birth, so Ted attended the birth and then returned to Bisbee. He seemed disappointed that Alexandra didn't give birth to a boy, but seventeen months later, on October 30, 1939, he got his wish with the birth of Nicholas Dominic, named after her father and Ted's. Kathleen followed three years later, on June 4, 1942.[20]

After a second trip to visit Alexandra and baby Lucia, Ted became so deathly ill with uremia—kidney failure—that he couldn't leave his bed. Dr. Rice heard that Ted had not reported for work at the theater and dropped by his house. He found Ted almost in a coma.[21]

Coincidentally, Rice had been chief surgeon at the Phelps Dodge hospital in Morenci when De Grazia's family had lived there. When the mines shut down, Rice had moved to Bisbee to practice. De Grazia served as a pallbearer at funerals for Rice and his wife when they died years later in Tucson, despite his hesitation at first to do it because he didn't have any dress clothes. The Rices' children told De Grazia that he could give their parents no better honor than to wear clothing familiar to people—Levis, a blue work shirt, and a cowboy hat.[22]

Ted was taken to the Bisbee hospital. A doctor called the Diamoses' home in Tucson to tell the recuperating Alexandra that his illness had reached the crisis stage. He asked if she and her family were coming to Bisbee and inquired whether Ted's parents had been called. Alexandra, who had been unaware that Ted was ill, collapsed into a chair. Leaving the baby with her grandmother, she and her parents hastened to Bisbee, arriving about 11 p.m.

Ted had gone into convulsions and bitten his tongue to the point that it "protruded from his open mouth as if it were a big purple balloon," Alexandra remembered. "His eyes were big and staring, and with his mutilated tongue of course he could not speak." Ted's parents arrived at 3 a.m. By 7 a.m. it looked like he would pull through. He remained hospitalized for two weeks before returning home.

Once during his convalescence he overdid it by returning to the theater to paint. He exhausted himself, and Dr. Rice ordered three days of bed rest. On the second day, Ted said he planned to go to the theater. An angry Alexandra told him, "Well, you go to the theater,

and I'll tell you what I am going to do. I'm phoning my sister Dina to come and get us, me and the baby, and take us to Tucson to my Mom's. Then I'm phoning your mother in Morenci for her to come to look after you, because you haven't got the sense to look after yourself, you get so engrossed in being Mr. Charming.

"If your Mom can't come she can send Greg or Virginia or who-ever, because I'm going to rest. The baby was ten days old when I had to travel here to Bisbee because you were dying, but I'm the one that will go into the grave, not you. . . . I don't give one half of one damn to stay here looking after an idiot like you." She reached over to slap him, but he grabbed her arm. Then she began to cry. Ted relented and stayed in bed. By fall he had fully recovered.[23] It had taken almost two months.[24]

The following January, Ted was searching for a way to perk up the theater box office after the holiday slump. "I know," Ted said, "a local newsreel, Bisbee coming to the show to see itself." He asked Alexandra, "What do you think?" She replied, "Why, it's a great idea." Ted bought a movie camera and began taking hundreds of feet of film of Bisbee people from all walks of life. He even made a

Figure 7. De Grazia's mother, Lucia, and father, Domenico, holding De Grazia's daughter, Lucia, in 1940.

promotional movie of a beauty contest featuring women from the area, with the winner attending the 1939 San Francisco World's Fair.

Soon, though, Ted became bored. "I can't go on filming forever," he said. "It's been fun, I've learned a lot, but I've got to get back to my painting." He didn't forsake movie producing, however. Over the years he made numerous films, particularly of adventures in the Superstition Mountains outside Phoenix.[25]

On February 26, 1940, De Grazia's father died at the age of fifty-six of pneumonia brought on by years of working in the Morenci mines. It had started with a cold. "He didn't have any lungs left to fight it, and he died," De Grazia said. "The mines killed my father. His lungs turned to rock because of the dust from the open pit. A lot of miners died that way."[26] His family buried Domenico De Grazia two days later at Evergreen Cemetery in Tucson.

De Grazia never talked much about his early days in Bisbee except for his professional life there. The most he would say about that time was that "for a time, I thought no more about painting. I was happy and accepted in society—wore a tie—shaved daily—and belonged to social clubs. I was a good guy. . . . I was putting on weight. Everything was just right."[27] But he also needed to get away from the rigors of being a businessman, an artist, and a father and husband. He had begun traveling across the border into Naco, Sonora, where he talked with Mexicans in Spanish like a "pure paisano" and caught the flavor of the border villages. That he could knock back mescal "without too many grimaces" helped him become more than a *turista*.[28]

The lure of painting soon returned, however, and he saw a way to market his artwork. He began putting posters up around Bisbee of himself standing in front of a painting with a sign that said, "De Grazia, Modern Mexican Artist. Own one of De Grazia's paintings. Buy an original at your terms. Write artist in Bisbee, Arizona, for a private exhibit in your house."

What with his painting, working at the theater, and traveling, De Grazia had little time for family life. Choosing whether to continue as a stable provider for his family or to follow the instincts of his creativity tormented him. "Not even I or those closest to me suspected that while I had excellent opportunities in business that I was gradually—slowly but surely—drifting away. Painting was beginning

Figure 8. Ted De Grazia in his Bisbee years.

to bother me. . . . It tempted me. I began to dabble with it. More and more. I had more canvases around me. Soon I was forgetting everything else. Finally I found myself completely involved awake and asleep in painting. I had to choose. Either paint or stay in society. The price was awfully high. I chose to pay the price."[29] Painting had become his mistress.

The summer after his father died, the De Grazias rented their Bisbee house to a young army officer and his wife who were stationed at nearby Fort Huachuca. They went to live with Alexandra's parents in Tucson for three months while Ted returned to summer sessions at the university.[30] That same summer, *Arizona Highways* discovered De Grazia.

5

Learning from the Masters

Primarily Diego Rivera gave me confidence.
He talked to me as he would another painter.
—*De Grazia*[1]

WHILE SPENDING THE SUMMER of 1940 in Tucson, De Grazia lined up an exhibit of his work called *Dust of Mexico* at the Arizona Inn, owned by former Congresswoman Isabella Greenway, in Tucson. One buyer turned out to be Raymond Carlson, editor of the fast-growing *Arizona Highways* magazine, who purchased several of his paintings for five to ten dollars apiece.

Carlson liked De Grazia's work so much that he decided to publish photos of six paintings, which the magazine called "Mexico and the Simple People," in the February 1941 issue of *Arizona Highways*. This proved to be De Grazia's first big break.[2]

Carlson had transformed the state-funded *Arizona Highways*, founded in 1925, into a popular monthly publication that at its peak reached 350,000 readers, three-quarters of whom lived outside Arizona. Carlson wrote that the *Dust of Mexico* exhibit, particularly the painting *Defeat*, pleased him because "we, too, feel very deeply about Mexico and the simple people there, and the painting makes one feel good inside."

A picture of De Grazia resplendent in a suit and tie, his hair slicked back and his mustache neatly trimmed, accompanied the article. Without the mustache his appearance resembled that of silent movie star Rudolph Valentino, also an Italian. De Grazia held a pipe in his

right hand with his index finger curled around the stem, much like the way Valentino held a cigarette.[3] De Grazia's friend, magician John Alexander, said he once kidded De Grazia about being "a little gigolo" because of the way he dressed in those days.[4]

At this time De Grazia began using a theme that flowed through his paintings the rest of his life. "I like to portray people as they really are," he said, "not merely to present a tragic view of life, but to enrich the experience of those who have not really seen the common Mexican people."[5]

Carlson, who wrote articles accompanying the paintings, quoted Charles Tracy, an author, dramatist, and artist, as saying that De Grazia had approached him with several paintings. "I knew at once that regular art instruction was not for him," Tracy said, "so I encouraged him. Today he surprises me by exhibiting at least a score of masterful paintings. . . . In these days we tag such painters as 'primitives.'"

Tracy also said he wouldn't have been surprised to find many of De Grazia's paintings hanging in art museums within five years. "He understands and sympathizes with the underprivileged Mexicans, and with bold direct brush strokes he paints as his heart directs. He could never use color science or any other science with his kind of graphics—to him the sky is blue, clouds are white, old shacks are brown, the faces of his subjects are simple and sad—so he paints them that way—it is his kind of art, and it is wonderful."[6]

While the reviews pleased De Grazia, sales disappointed him. "One would expect that after a plug like that [the *Arizona Highways* article] you might hope to sell a few paintings," he said. "Actually, I did sell a few, but damned few. Those were pretty dark days, and more than once I considered throwing in the towel and going back into business. It was a constant struggle between the call of the artist and the demands of economics." It didn't help that World War II was imminent, and people were either financially strapped or disinclined to buy the paintings of a virtually unknown artist.[7]

About the same time that the first *Arizona Highways* article appeared, a De Grazia painting, *Matador in Grey*, was exhibited at the Academy of Allied Arts in New York City, one of thirty-one paintings submitted by some of the nation's leading artists. De Grazia's was the only painting submitted from west of the Mississippi. *Matador in Grey* depicted the frenzy, action, and drama of the bullfight.[8]

And it seems the Mexican people appreciated De Grazia's art. In a ceremony usually reserved for a president or governor, a matador—a woman named María Cruz—opened the bullfighting season in Naco, Sonora, Mexico, on May 11, 1941, by killing the first bull in De Grazia's honor because of the way he had portrayed Mexican life.[9] Two weeks later, De Grazia entered the bullfighting ring with Cruz, dressed in full matador regalia of gold and red, to do battle with a bull. Film of the event shows only two or three passes by the bull as De Grazia wielded the red cape. He didn't spend long in the ring, often running to safety. He escaped unscathed, and Cruz wound up killing the bull.[10]

After the *Arizona Highways* exposure, De Grazia escalated the pace of his painting and the variety of his subjects. He focused a lot on subjects with motion inherent in them—bullfights, cockfights, Indian wagon races, galloping horses. He had learned to reduce his stories-in-paint to their simplest level, with color and movement essential to his style. "The bullfight is as beautiful as a ballet, a riot of color, a tragic drama," he said. "The bullfight has color, line, and power. Lines are beautiful. As an artist, I notice these things."[11]

Sometime in late 1941, De Grazia apparently carried on an affair—or, as Alexandra put it, "danced attendance on a woman" in Bisbee.[12] She told her husband to feel free "to take up a new life with another woman but not to think it would be a threesome, that I would bow out."[13]

In September, his father-in-law grew angry with De Grazia for giving out free movie tickets to poor children while he denied them to police officers and firefighters who had formerly gotten in free.[14] Longtime Bisbee resident Al Hirale remembers being one of the children who caught tickets De Grazia dropped from a second-floor window.[15] Diamos decided to transfer De Grazia from the Lyric in Bisbee to the Arizona Theater in Phoenix—a "promotion" the *Bisbee Shopping News* reported[16]—perhaps at Alexandra's request to get her husband away from the other woman. Soon after, Alexandra discovered she was pregnant, so her father delayed their move until June, after the birth of Kathleen Louise on June 4, 1942. They bought a house in Phoenix and moved in late July.[17]

Within days of moving in, De Grazia decided he wanted to travel to Mexico City for two weeks. Alexandra agreed to go with him.

They arranged to leave the children with her parents, but their departure had to be delayed because De Grazia lacked a birth certificate, required in order to travel deep into Mexico. Since he had been born at home, his parents had neglected to register his birth. De Grazia contacted his former roommate, attorney John Pintek, to help him secure what he needed.

On April 14, 1942, the Arizona Department of Health issued a Delayed Certificate of Birth after De Grazia sent in supporting evidence of his birth in Morenci: a baptism certificate from Holy Cross Church dated July 4, 1910, and records certified by the Morenci superintendent of schools. Both documents listed his first name as Ettorino.[18]

In mid-August 1942, the De Grazias drove their 1940 Ford coupe to Laredo, Texas, crossed the border, and then drove the Pan-American Highway for three and a half days until they arrived in Mexico City. They carried several of Ted's paintings from the *Dust of Mexico* exhibit in the back seat, including *Defeat, Viva, Felicidad,* and *Un Domingo*—all paintings that reflected a political consciousness. De Grazia wanted to show his paintings to the acclaimed revolutionary artists Diego Rivera and José Clemente Orozco, hoping they would give him encouragement to keep at his work.[19]

Bone tired from the eighteen-hundred-mile trip to the Mexican capital, Ted and Alexandra took a nap and slept so soundly they almost missed going to the Palacio de Bellas Artes at 10 p.m. to see a classical ballet. During intermission, Ted surprised Alexandra by asking, "What do you say we get out of here, okay?" De Grazia wanted to go to the Palacio Municipal, hoping that Rivera would be working late painting murals. De Grazia had sketches he wanted to show the painter. An unhappy Alexandra relented and agreed to leave with him. They drove around Mexico City, with Ted poring over maps, until they found the palace. There, they slipped five dollars to a security officer, who told them they could find Rivera working on the second floor.[20]

They did, indeed, find the muralist—on a scaffold with an assistant—and waited forty-five minutes without being acknowledged. Alexandra wanted to call up to Rivera, but Ted said no. At about 1 a.m. she spotted a ladder. Climbing to the top of the scaffold, she said in Spanish, "Master, we are Americans from Arizona. We arrived here

in the capital today. May my husband show you some of his sketches when you come down?" Rivera replied, "Yes, when I'm done."[21]

Alexandra worried that Ted would be angry about her intrusion on Rivera, but her fears were unfounded. They sat on the floor and waited some more. Shortly, they heard a noise from a corridor to the left of the room, and a man and Rivera's wife, Frida Kahlo, also an acclaimed artist, came in carrying baskets of food.[22]

After some chitchat, Kahlo asked De Grazia, "Why are you here?" Ted explained that he wanted to show Rivera his sketches. About that time Rivera came down off the scaffold, had a bite to eat, and then turned to the brash, thirty-three-year-old De Grazia and said, "Young man, let's see what you've got." De Grazia held up five sketches about six feet away from Rivera. The Mexican artist replied, "Good, good," nodding his huge head. "Come and see me about ten in the morning, and bring your sketches."[23]

The next day De Grazia met with Rivera while Alexandra slept. Rivera said he especially liked De Grazia's use of color. His black-and-white work also impressed Rivera, who noted the difficulty of painting in two colors. But Rivera disliked De Grazia's frames and offered to lend him a carpenter to work on them.

An ecstatic De Grazia returned to the hotel to tell Alexandra that Rivera had offered to take him on as a student assistant for two months, between mid-October and mid-December.

While they agreed that this was a good opportunity, they also realized that they would have to save up money in order to get by. "Two months with [Rivera] will be more profitable than two semesters in college art courses, especially for you who assimilates fast," Alexandra said. De Grazia said he would have to appeal to the draft board for an exemption from military service for those two months during World War II in order to work with Rivera.[24]

Selective Service had declared De Grazia 4-A on February 11, 1941, which meant he received a deferment because of his age, thirty-one. Records from the war years show that while the draft board reconsidered De Grazia's status several times, it never changed, probably because he had three children and was the sole support of his family.[25]

Rivera tried to help De Grazia's cause by writing a letter to the draft board himself. It is unlikely, though, that the letter had much bearing on De Grazia's classification. In Rivera's letter of September 2, 1942,

he wrote that De Grazia had a "promising future, [and] wishes to come to Mexico to study the techniques of fresco. Because of his work interests I am willing to take him to work under me."[26]

Six weeks later, De Grazia returned to Mexico City for his apprenticeship. He took artist George Sellers with him. They slept on the ground alongside the car when they stopped at night. In Mexico City, De Grazia lived virtually on the streets. "I didn't have any money . . . and I used to live with the Indians, sleep beside them on the sidewalks. And I got along on five cents a day. Got an ear of corn, about twelve to fourteen inches long, roast and eat all of it, the shuck, the whole damn thing. And you could buy a little pulque [mescal] to drink."[27] Sellers spent his time sitting in Mexico City parks, painting.[28]

Rivera told De Grazia to paint twenty oils, and he would put them on exhibit, urging him to "go to the Market of Thieves and paint." Stolen goods were sold to poor people at the market at very low prices. As one writer put it, De Grazia met people at the market "of human anxieties. . . . He painted their human miseries, their humble but anguished response to fate." Exposure to the poverty-stricken Mexicans stuck with De Grazia for the rest of his painting career.[29]

Rivera also suggested that De Grazia study under José Clemente Orozco to learn more about frescos. Orozco invited De Grazia to join his mural-project team at the Hospital de Jesús. He gave De Grazia a paintbrush and had him start on a small corner.[30] "The greater of the two [meaning Rivera and Orozco] was Orozco," De Grazia said. "He had more feeling and guts."[31]

De Grazia felt overjoyed to study under the famous artists. "If you want to learn to paint, you better spend some time with great painters," he remarked years later. "Since El Greco and Gauguin were dead, I had to go to Mexico City to see Diego Rivera and José Orozco."[32] Later he told historian Abe Chanin, "They were great human beings. . . . I remember one time Orozco saying to me, 'You know, whatever you want to do, you can do. Whatever you want to learn, you can learn. But you have to learn it; nobody can do it for you. And if you want it bad enough, you can do it.' I have never forgotten those words."[33]

His education in Mexico went beyond painting. After going to a bullfight with Orozco one day, De Grazia said, "From that afternoon on I understood the bullfight in a new way. I had seen a matador

Figure 9. A debonair De Grazia poses with acclaimed artist Diego Rivera in 1942.

who was a consummate artist and the *banderillos* and *picadors* in their exciting supporting role." The team of mules that came to drag away the dead bull "with drama and color I had never seen before" impressed De Grazia. "The sense of what takes place cannot nor should it be described verbally. Bullfights are to be seen."[34]

De Grazia found this an exhilarating time. He soaked up knowledge while also doing menial chores for the two renowned artists: sweeping floors, cleaning brushes, moving scaffolding, and mixing paint. "They were not the easiest people in the world to work for," De Grazia said, "but they knew their art, and I learned quickly."[35]

They treated him well, unlike the University of Arizona professors, who, he said, usually "looked down upon you as a dumb bastard."

Rivera and Orozco made him feel "for the first time in my life that maybe I was someone after all." He called the time he spent with them "good days" because they didn't preach theories, like teachers did at the university; instead, they showed him what to do.[36] Alexandra remarked later that the two-month separation "proved to be most successful and worth every sacrifice."

An impressed Rivera extolled "the flight of his executions, the keenness, the romantic and exalted observation, and the feeling of proportion" in De Grazia's paintings.[37] Both Mexican painters encouraged De Grazia to exhibit at the Palacio de Bellas Artes in Mexico City. In a letter to Alexandra on November 13, 1942, De Grazia wrote, "The show is on. Have had good and bad comments, mostly good. Three magazines want to do write-ups. Rivera was here yesterday and stormed around. Had all the paintings—eighteen—hung differently because of the light. He is a grand fellow."[38] A reporter from one of Mexico City's most prestigious magazines, *Hoy*, wrote about De Grazia's work in glowing terms.

De Grazia posed for a picture with the 300-pound Rivera, who towered over the five-foot-seven, 175-pound De Grazia. In it, Rivera is holding a palette and a paintbrush in front of an unfinished mural of two nudes romping in a field of sunflowers. De Grazia nonchalantly stands to one side, dressed in black pants and jacket, his right hand hitched on his belt and his dangling left hand holding his ever-present cigarette. He radiates confidence.[39]

De Grazia left Mexico City carrying two prized possessions—letters of praise from Rivera and Orozco. Rivera said the paintings that De Grazia brought with him to Mexico City and the ones he painted there "greatly interested me because of his brilliant artistic gift and his personal sentiment, so original that it prevails through some strange influences, perhaps unconscious." He said De Grazia would become a "prominent personality in American art." Orozco said De Grazia's painting "has all the freshness, simplicity and power of youth. . . . He will be one of the best American painters someday."[40]

The influence Rivera had on De Grazia's painting, both in style and in subject matter, cannot be overstated. Rivera used historical, social, and political themes; so did De Grazia. Rivera depicted the poor, the oppressed, and the downtrodden; so did De Grazia. Rivera painted murals; so did De Grazia. For the next decade and a half, De Grazia's

paintings incorporated the expressionistic flair that he had learned from Rivera and Orozco and "their poignant way of conveying the toil and poverty of Mexico's traditional underdogs."[41] Later, when De Grazia began creating art that appealed more to the mainstream, once again Rivera's influence became evident, for the Mexican artist believed that art was excluded from the masses.[42]

The one striking difference is that no one called Rivera's art kitsch, even when he painted *Muchacho Mexicano*, depicting a barefoot boy wearing a wide-brim hat and holding a piece of fruit, but De Grazia's was when he painted an Indian girl holding a basket of flowers. Both were painted in similar styles. In fact, many of De Grazia's paintings were patterned after Rivera's.

After his apprenticeship De Grazia raced home to Arizona, ecstatic, on the winding, sinuous mountains bisected by the Pan-American Highway. Lost in thought as he drove, dodging Indians walking from village to village along the shoulder of the road, he brimmed with confidence that he would soon cross the threshold of success as a painter. Between his exposure in *Arizona Highways* and now his glowing letters from two Mexican masters, fame at last looked within reach.

The euphoria did not last.

De Grazia returned home to Phoenix on schedule, and Alexandra reported that they had a "very happy Christmas." Soon afterward, though, Ted began getting restless. He resented the time the theater took from his painting and talked about going to New York City. In her memoir, Alexandra did not say why he wanted to go to the big city that he came to despise years later, but it is a fair assumption that he wanted to go where his artwork would have more exposure.

"Look," Alexandra said, "you go anywhere you want, but I'm not leaving home nor sending you money to get by in New York. We can sell this house and buy one in Tucson if you want to quit the theaters." She also suggested that he could work in a defense plant and go back to the university to finish his degree. "But I'm not going to keep the home fires burning while you roam around the country thinking you have a home to come back to."[43]

De Grazia had experienced a huge letdown when he returned from Mexico and approached University of Arizona officials about displaying the paintings that had proven to be so popular in Mexico

City. The school's officials were not impressed, deeply hurting De Grazia, who wondered if the school rejected him because Rivera passionately embraced the Communist revolution. If so, that never came to light. Despite the university's rebuff, De Grazia decided to return to school. But he never forgot the slight. After he became famous, his alma mater approached him in 1973 to display one hundred pieces of his artwork. Only after some reluctance did De Grazia swallow his pride and relent.[44]

Years later he erupted in a rare burst of anger at the University of Arizona after officials asked him if he would be willing to donate his studio complex on North Campbell Avenue to the school. De Grazia asked Abe Chanin to read a letter he had drafted in which he refused to donate the property. Chanin said De Grazia wrote "a terrible letter, I mean just as mean as could be, the meanest I'd seen in Ted."

Chanin asked him, "Ted, c'mon now, you're not going to send this letter, are you?" De Grazia replied, "Yes, I am." Chanin urged him to take out two particularly irate paragraphs "because these will be known for all time." He took them out.[45] "They'll never get it [the property] from me," De Grazia said, "after the way they treated me."[46]

Coincidentally, the curator of the University of Arizona art museum, William E. Steadman, knew De Grazia from their undergraduate days in 1943. Steadman recalled that De Grazia painted murals—in exchange for free, filling eats—on the wall of a cheap restaurant across the street from the university's Main Gate at North Park Boulevard and East University Avenue, on the west side of the campus. Steadman remembered the "clarity of his draughtsmanship, the extraordinary sense of coloration, the dramatic power of his subject matter."[47] Steadman finally brought a retrospective exhibit of De Grazia's work to the university in 1973.

6

Back to Tucson

I remember when I painted murals. I'd paint the whole wall—
all the walls of a room. I'd paint all day for twenty-five dollars.
—*De Grazia*[1]

THE NEXT YEAR, 1943, De Grazia gave up thoughts of wandering
and moved back to Tucson. He and Alexandra bought an older home
on North Stone Avenue that had a small cellar with a furnace and
two windows. Ted wanted to return to school, so his father-in-law
gave him a second chance to manage the Plaza Theater downtown.
De Grazia returned from work about 1 a.m.; painted in the cellar
until 3 or 4 a.m.; went to bed; then got up at 6 or 6:30 to attend
early classes at the university. In all, he got by on two and a half to
four and a half hours of sleep a night, catching up with ten to eleven
hours on Sundays.[2]

The university's rejection of his work made him even more driven
to succeed.[3] "At the university they called me the most likely artist
not to make a living painting," he said years later.[4]

For undetermined reasons, De Grazia soon left the employ of his
father-in-law and began working as a mechanic with Consolidated
Vultee Aircraft Corporation, the country's largest builder of military
planes by the end of World War II. He continued to attend his college
classes and also picked up a student pilot's license, issued on May
14, 1944. There's no indication he ever took flying lessons, and the
Federal Aviation Administration has no record of issuing him a full

pilot's license. Apparently he didn't care for flying, anyway. He said he went up in an airplane with a pilot who put the plane into a nosedive, and that ended his desire to fly a plane.[5]

De Grazia continued to paint smaller canvases, but success still eluded him. He sent paintings to the Palette and Brush Club at the Temple of Music and Art in Tucson, hoping to win a prize. All he received in response to his entry was a terse letter from the club that said, "Please come and pick up your paintings."[6]

During lunch breaks at Consolidated Vultee, De Grazia lay underneath either his assigned plane or other planes and sketched, probably to keep out of the blistering summer heat. He even drew a huge mural depicting one of the Convair military airplanes at the airport. One day at work he met William Graham "Bumpy" Bell, a shirttail relative of Alexander Graham Bell, the inventor of the telephone. Bell, a test pilot, flew B-24s at Consolidated Vultee. "I just love this

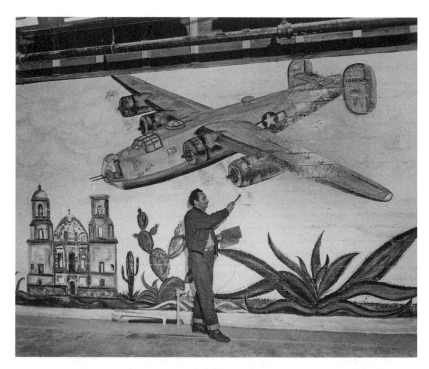

Figure 10. De Grazia painted a mural of a plane flying over San Xavier Mission while working as an airplane mechanic at Consolidated Vultee.

man's Mexican pictures," Bell told his wife. "I think he is a genius." The Bells decided to hire De Grazia to paint a mural for their bar.[7]

Once again, De Grazia's supercharged energy became evident. He would go to the Bells' house at 4 or 4:30 a.m. to work on the murals and then put in long hours at Consolidated Vultee. He painted a Mexican bar scene on one side of the bar itself and the story of the making of tequila on the other. On the walls, he painted a beggars' scene and one of a cockfight. Working at an exhausting pace, De Grazia finished the murals in about three weeks. To the Bells' regret, he didn't sign the murals. They paid him $250.[8]

De Grazia painted murals up and down the state, sometimes for money, sometimes for whiskey, and sometimes just for a friend. He sold his paintings the same way—"the price of a shot of whiskey for a Navajo print, and the price of a good cigar for a Mariachi."[9] In 1989 workers discovered two murals inside a vacant building in Phoenix that had housed a drag bar and, later, a political reelection campaign. One mural depicts how Indians made grain alcohol. The second shows a ballerina dancing in a martini glass. De Grazia drew the murals for free drinks when the building housed the 307 Lounge sometime between 1950 and 1956. "I always assess the value of my work in shots of whiskey," he said.[10] Today, the murals have been preserved on the brick walls of Greenhaus, an art gallery and interior décor shop, in the historic building at 222 Roosevelt Street.[11]

De Grazia's most unusual mural may have been *Power of the Press*, painted in 1944 on a wall in the offices of the university newspaper, the *Arizona Wildcat*, situated at the time in the boiler room of the engineering building. The mural reflected De Grazia's disenchantment with the university and with higher education. Hurt and angry over the university's refusal to stage an art show for him, he also questioned the value of a college education. "We hear the only way to fit into society is to get educated so that you understand the problems we have," he said, adding, "Get educated so you can make more money."[12]

The *Wildcat*'s editor, Lou Witzeman, commissioned De Grazia to paint *Power of the Press* on the south wall of the *Wildcat*'s newsroom. De Grazia would work on the fourteen-by-thirty-five-foot mural after classes, following a full day at Consolidated Vultee. Witzeman would check on De Grazia late at night and find him on a scaffold, busily

painting, with a tequila bottle nearby. It took him about two weeks to complete.[13]

The complicated and mysterious mural depicted a half skeleton, half machine riding the four horses of the Apocalypse as it trampled over the mask of happiness while skirting the mask of tragedy. In his right hand, the figure held planet Earth with a long sheet labeled "news" hanging from it. Several skulls topped with mortarboards looked at a hand holding the flame of knowledge reaching out of a pile of books. The skulls were meant to represent the search for knowledge.

The mural definitely evinced the influence of José Clemente Orozco, who had painted a mural at Dartmouth College called *Gods of the Modern World*, depicting outside influences on education. Painted in the mid-1930s, Orozco's mural portrayed skeletons dressed in academic garb presiding over the birth of useless knowledge, embodied by a skeletal fetus.[14]

University officials reprimanded Witzeman because he failed to get permission for De Grazia's mural. They sent a worker down to the newsroom with a five-gallon bucket of whitewash and orders to cover it up. "I was the one that caught the main hell," Witzeman said, noting that he and De Grazia were rebellious students. "It wasn't really *Power of the Press*. It was a personal statement of what he thought of education. . . . He was very pessimistic. It was a very dismal picture."[15]

De Grazia dropped out of school numerous times over the course of the thirteen years it took him to earn his bachelor's degree. Family obligations, jobs, and painting distracted him from higher education, but sometimes he would just get restless and travel throughout Mexico and Southern Arizona—even though he had promised Alexandra he would stay home. Restiveness became De Grazia's lifelong plague; it had goaded him in Morenci and Bisbee, too.

In 1966 De Grazia's then-wife Marion tried to explain Ted's restlessness in a book, *De Grazia: A Biographical Sketch*. "There was the going in and out" of the school, she wrote. "Always when life became too stable, there he was to upset the balance. This was hard for the people close to him. There was cause for worry. They did not understand him. But for him it was the search for beauty that

was most important. Because searching is motion. There was always motion in his turbulent life. It was no use trying to change him. The family gave up, the teachers gave up, society gave up. There he was alone in his searching."[16]

In 1944, De Grazia decided to build his own studio. He bought a scrubby piece of land on the outskirts of Tucson at 3568 North Campbell Avenue, on the southeast corner of the intersection with East Prince Road. "Why the hell not?" he asked. "I've certainly got something to put in it—I've got the world's largest collection of original De Grazias."[17]

A farmer wanted $500 for the land. De Grazia offered him $25 down and payments of $25 a month. The farmer said, "Hell, you guys never make any money," but then he said, "I'll take a chance."[18] De Grazia's older brother, Greg, who may have had the strongest influence of any of the siblings on Ted's life, loaned him the down payment. Greg had helped Ted earn money as a trumpet player in Morenci, then had encouraged him to attend the university. Eventually Greg helped him design the future Gallery in the Sun. While the two strong-willed men often disagreed, Ted took few actions without Greg's advice or criticism.[19]

De Grazia decided to open his own studio because he couldn't find anyone in Tucson willing to exhibit his paintings, despite the rave reviews from Orozco and Rivera. "I had well over a hundred paintings," he said, "and no place to show them."[20]

He built the studio with help from Mexican and Indian workers. "It took years to complete," De Grazia recalled. "Sometimes I would just say, 'the hell with it' and go off prospecting for gold in the Superstition Mountains," with his constant companion, Shorty Thorn.[21] He liked nothing better than to ride horses into the Superstitions with his friends, accompanied by several Yaquis, an ample supply of whiskey, and his gold-prospecting pan. "It was a game, an escape into the past," he said, "and I loved it and painted it."[22]

De Grazia and his workers collected materials from the desert around them as they toiled on the structure. Slowly, they built a small studio with window and door frames made of saguaro cactus ribs. This kind of creativity when it came to building supplies could be attributed more to lack of money than to environmental consciousness,[23] but it did jibe with De Grazia's love of the earth.

Figure 11. De Grazia decked out in Mexican garb to paint.

Over time the studio complex became a "kaleidoscopic ramble" of low adobe rooms with walls painted different colors, many of them covered with murals of flowers and Mexican peasants. A rustic fence of mesquite branches surrounded the lot.[24] In what today might be considered a feat of solar innovation, he eventually installed on the roof of one house a tank that he painted black to let the sun heat water for his showers.

One would think that De Grazia would have taken care of his hands, those precious tools with which he painted. But he'd work with shovels, saws, wrenches, and hammers to cut beams, lay adobe brick, tack down tar paper, and connect water pipes. He never had a serious accident, but he certainly received his share of bruises and cuts.[25]

"When I say I am intimately acquainted with every adobe in my studio, I mean it. I put them up. And as I felt the need for more room, I added another studio—one for display, one for painting, one for ceramics, one for living quarters," he said. "It's not a tourist, hotdog type of thing."[26]

De Grazia's daughter, Kathy Bushroe, reminisced in 1987 that she and her brother, Nick, had watched as their father made adobe bricks for the buildings. "I remember he had big piles of sand and a big hole filled with water that he used in making the adobes, and we would jump off the roofs of the completed rooms—which were very low—into the water hole or into the sand."[27]

The floors were rough cement, finished exactly the way De Grazia wanted. Help pouring them came from a civil engineer, the brother of De Grazia's college roommate, John Pintek.[28] Doorways were five feet ten inches high, providing the three inches of clearance De Grazia needed to get in. Over the years many customers had to duck to get through them. He formally called the complex De Grazia's Fine Art Studios and Gallery.

In addition to the rambling collection of spaces built for De Grazia's purposes,[29] he added small rooms that he rented out to other shops, including a jeweler and a Mexican restaurant called Rosita's, where he spent considerable time. He brought Rosita, an unmarried mother with a small son, to the complex and set her up in business. She managed to earn a good living from the restaurant.[30]

De Grazia's favorite meals at Rosita's were posole, a pork-and-hominy stew, and enchiladas with a fried egg. He would tell her, "Nothing fancy for me, Rosita. Plain, like poor people."[31] Once, when the restaurant needed some plumbing work, De Grazia and Rosita got into a heated argument, all in good fun, over who should pay for the repairs. They "cussed and discussed" who would pay, with De Grazia pounding the table and saying, "Sumbitch, sumbitch." In the end, he happily paid. De Grazia also would kid Rosita about

the *cucarachas* (cockroaches) in the building. "Keep 'em out of the meals," he would tell her.[32]

Phyllis Pichetto lived next door to De Grazia's Campbell Avenue studio. Years earlier, when Pichetto had operated a liquor store on her property, De Grazia had been one of her best customers, buying Chivas Regal by the box load.[33] She would watch him paint outside, about four feet from her kitchen door. He would throw away paintings he didn't like. One day Pichetto asked if she could have his scraps. "Sure, I don't care." Pichetto called them some "scribbly type paintings." In the mid-1990s she sold one of the scraps for $2,500.

Virginia Horky remembered meeting De Grazia at his studio for the first time. Driving by, she thought the studio looked interesting and popped in for a look. While there, she had to use the restroom. De Grazia took her to the back of the studio. She said she almost didn't use the facility "because when the door was opened I was startled, because, here, as you opened the door, were the very vivid—I called it 'De Grazia pink,' all the time, that real vivid pink—footprints that went from the door, across [the floor] down into the tub, and the footprints went up the side of the wall and up onto the ceiling. . . . I was agape with it, and all, and I commented when I came back out, and he said, 'Oh, just a little whimsical idea of mine.'"[34] Horky became De Grazia's longtime friend.

A visitor from Ireland once remarked about the studio complex, "My, what attractive ruins." To which De Grazia replied, "Yes, all in a lifetime." Another time, a tourist asked De Grazia, dressed shabbily in his work clothes, if he "speeka English?" De Grazia replied, "A leetle beet."[35]

De Grazia, a proud man, didn't take well to condescending behavior, even from someone who might spend money on a painting. He didn't care for arrogance, either. When customers came into his studio and said something like, "Oh, I can pay for this," or "I could buy all of this, but I don't like the art," De Grazia would tell them, "Nobody says you have to buy it." He then would turn his back and walk away, grumbling that "they aren't worthy of my time."[36]

De Grazia struggled in those days. Once he received a telephone call from a patron who said he wanted to buy several of his paintings. "Turned out he was a grocer, and I wound up trading a four-by-eight-foot canvas for eighteen dollars worth of groceries."[37]

De Grazia had to work at paying jobs while he built the studio because he couldn't earn enough from sales of his paintings to cover his bills. But just when things were getting really bad, an interior decorator asked him to do a mural in a new nightclub. The decorator's offer of one hundred dollars a day tickled him. He would have been happy to work for ten. He put in eight days, painting the jungles of Mexico, monkeys and all.[38]

He had already begun thinking about his legacy and wrote that he was glad he stayed with his convictions in art. "And I will continue to stick in spite of hell. I hope to break the legendary irony of my kind of painters. My work too will be accepted. I want to be around."[39]

Arizona Highways editor Raymond Carlson recognized that De Grazia had a lust for lasting fame, "wondering if the people . . . will ever accept him."[40]

De Grazia told Carlson, fast becoming one of his biggest boosters, that he had no answer for people who asked him to explain his painting. "The paintings," he said, "are my life. They are my experience. They are what I have felt and what I have known. How can I explain this in a few words? The onlooker must explain for himself. If he cannot, the painting is not for him."

Even as De Grazia's popularity picked up, he never changed his ways. In 1954 he and Carlson were wandering through the mining towns of Globe and Miami when they stopped at the Copper Hills, one of the most popular bars and restaurants in the state, to knock back a few. The establishment's owner, Danko Gurovich, talked De Grazia into painting a mural behind the bar in exchange for a case of tequila. Reportedly so drunk he forgot to sign the mural, De Grazia finally went back and did it in 1979. Gurovich, who had the mural appraised in 1985 at $95,000, wanted to give over its ownership to the DeGrazia Foundation but to keep it physically in the bar and maintain it there. Foundation officials turned down the offer. A fire destroyed the Copper Hills in 2001 and the mural along with it.[41]

One time Carlson and De Grazia spent a night on the town and then went missing. They turned up again after a weeklong drinking binge. They had left in De Grazia's dilapidated pickup truck and returned in a brand new Mercedes, which the artist had paid cash to buy.[42]

Another time he painted a mural in a bar at 4844 East Twenty-Second Street in Tucson owned by *Arizona Daily Star* photographer Jack Sheaffer. De Grazia had wanted to paint the four seasons on the west wall, but he ran out of room after he finished the third season.[43] He also painted a mural for the Barcelo family on the patio of their Mexican restaurant, Cosme's, on South Stone Avenue across from the then-home of the *Arizona Daily Star*. The mural has long been whitewashed over.[44]

De Grazia seemed to be everywhere at once, going to school, working, painting murals, and trying to be a husband and a father. Inevitably, something had to suffer, and it did: the home front.

7

A Marriage Ends

An artist must sacrifice too many
things—family, security, privacy.
—*De Grazia*[1]

AT THE UNIVERSITY, De Grazia pursued his fascination with the
relationship between art and music. He had thought the idea origi-
nal, but he soon discovered that the same concept had been proposed
by Aristotle more than 2,300 years before.[2] It is also likely that he
knew about Synchromism, an art movement stressing the musical
qualities of color founded in the early 1900s by two American paint-
ers in Paris.[3]

While in Bisbee he had constructed an intricate fourteen-foot
panel into which he had installed seven miles of wire, which con-
nected to a special keyboard that controlled more than three hundred
light bulbs. As music played, De Grazia manipulated the keyboard,
causing the panel to light up. The lights "translated" into various
colors, specific abstractions that De Grazia devised for all musical
notes, phrases, and movements. The same abstractions were used in
his paintings of music.[4]

De Grazia earned his bachelor's degrees in music and art and then
entered a master's program. For his thesis, he planned to continue
exploring the relationship between art and music. "Basically, music
and painting are the same, the common root being emotion," he
said. And he couldn't help but take a swipe at the art establishment.
"Too many painters today have forgotten the important lesson, that

true art is life interpretation, not merely an exercise in technique."[5] De Grazia contended that since music moved from left to right, he painted left to right, meaning that his paintings began on the left side of the canvas and ended on the right. "High notes rise, legato is female, staccato is male."[6]

He painted eight classical works from sheet music to support his thesis. Using brushstrokes that rose and fell with the notes on the sheet music, De Grazia's oil painting of Stravinsky's "Nightingale" seems to show a rain forest and a waterfall. His rendition of Tchaikovsky's Concerto no. 1 in B-flat Minor has a look of modern art with lines, circles, squares, and triangles and "gives the feeling of man caught in the whirlpool of life," while his painting of Rachmaninoff's Prelude, op. 23, no. 5 is black at the bottom of the canvas with brilliant colors shooting upward. In his thesis he wrote, "There is no doubt in this writer's mind that pure colors and music will in the future be inseparable and that one will not be thought of without the other. It will appeal to man's intellects, emotions, and imaginations."[7]

Under the direction of Professor Katherine Kitt, De Grazia conducted two tests to establish the relationship between music and art. He gave one test to 358 music, drama, and education students, who listened to Brahms's Hungarian Dance no. 5. The test's results surprised even him. "The principal inference to be drawn was that fundamentally people will feel in music what they experience in painting, which was an encouraging conclusion."[8]

The second test was a color-and-music pattern experiment given to 370 of the same types of students. He had them listen to Sibelius's Finlandia, op. 26. The test result, De Grazia said, "proved that the feeling roused by music can be translated into painting so that what the ear hears the eye can see."[9]

De Grazia suggested to the students that when making their choices they should listen, not to their brains, but to their emotions. Freshman Roberta Sinnock recalled that De Grazia used to sit on the wide steps of the library (now the Arizona State Museum) and hold court during class breaks. "We'd all sit around, and he was sort of the master, you know, because he was so far advanced in his work compared to us. And he was very kind to us."

The students looked up to De Grazia, then thirty-five, although Sinnock, who later became an illustrator for children's books, said

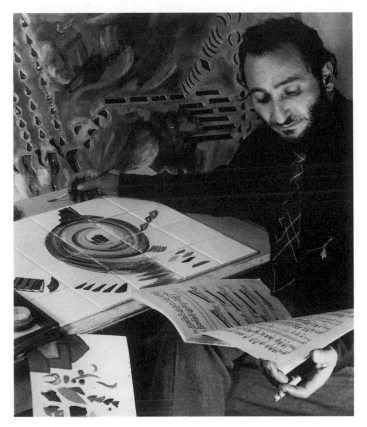

Figure 12. De Grazia painted to sheet music as part of his master's thesis.

he looked younger than his age and "he was very nice looking." To conduct the test, De Grazia set up easels with his paintings on them and then played music. He walked around the room pointing to the paintings as the music rose and fell. This, he felt, prepared the students to understand the questions on the test.

De Grazia then gave each student a piece of paper with directions on it. "There were little squares . . . and they had little squiggles in them," Sinnock said. "He would play a phrase and then he would ask, 'Now on your [test] mark for me which one of the squares with the drawing inside that seemed to you to fit that piece of music,' and so we got into it, we were really having fun with it, because it did seem to work."[10]

In his master's thesis, "Art and Its Relation to Music in Music Education," De Grazia wrote that "as we look at a painting that is a masterpiece of art which has survived through the ages, we find that what makes it great is not whether it is realistic or not, or because of its subject matter . . . its merit depends upon the play of light and color and the relationship of one form to another making a composition expressive and alive."[11]

Years after De Grazia died, Ginger Renner, who had known him since the late 1920s, looked up De Grazia's master's thesis in the University of Arizona library. "It's really a profound thesis, for a master's thesis," she told an oral history interviewer in 1996. "If you knew Ted just casually, in just the art area, you would never have assigned that kind of a scholarly mind to him . . . but he had it."[12]

On May 16, 1945, De Grazia received his master's degree during the university's fiftieth commencement. Few people in those days graduated from college, let alone earned two bachelor's degrees as well as a master's. In the 1940s, only 4.6 percent of the population aged twenty-five and older earned college degrees, while today it is almost one in four.[13]

The accomplishment of earning a master's degree demonstrated De Grazia's intellect as well as his drive. The number of hours spent putting together the tests, overseeing the students taking the tests, and compiling the results had to have been enormous. De Grazia would follow this characteristic pattern, working hard to earn big dividends, the rest of his life. Painting to music—mostly to Mexican songs—became a technique he used often. In a way, the music set the pace for the prodigious number of works he painted.

During the mid- to late 1940s, De Grazia's style began to change. Moving away from somber colors, his palette began to lighten with quiet charm and beauty. "Hell, it was the same style of painting, but I was lightening the colors instead of making everything so damned drab. I used to do a lot of studying of kids and kids are joyful, so my colors became joyful."[14] He figured out that he had to get away from the dark, serious paintings if he was to make a living; he had to appeal to the masses rather than the serious art collector.[15] It is, after all, not uncommon for American artists to have two sides to them, one that paints for art's sake and one that paints to earn a buck.[16]

Figure 13. De Grazia decked out in his cap and gown when he graduated from the University of Arizona in 1945.

The change in his style gives rise to speculation that he may have read *The Art of Experience,* first published in 1934 by John Dewey, who wrote that art grows out of human beings, is intended for human beings, and is not an isolated activity.[17] It suggests that De Grazia may have stopped painting for himself and instead began painting for others.

About this time De Grazia's marriage went on the rocks. John Alexander ran into Alexandra De Grazia near the university one day and asked about her husband's painting. "He's going nuts over this art," she said. "All he wants to do is paint these pictures and swing

the brush around. He won't come in the house, do anything with the kids, for two or three days at a time, because he's lost in his artwork."[18]

Alexandra feared that Ted was carrying on another affair. She noted that a "wall" had come up between them. "And soon enough I had a report from an acquaintance who had seen him a few times in the company of another woman."[19]

On top of that, Alexandra had just learned she was pregnant again. She decided not to tell Ted. "I was very, very hurt, not just angry, and I did a most wicked thing." She had an abortion, against her mother's advice. She told her father she wanted a divorce, but he opposed it.

Alexandra noticed that Ted had become "moody and distracted, and his mind and heart were elsewhere." He became angry when she told him she knew about his affair. "Even if some day you make a pile of money, and you will, being the work machine that you are," she said, "I still don't care to spend my life in an undeviating pursuit of just your goals. I want a life adapted to me also, to us both, not just to you alone." He ran out of the house, slamming the door as he left.

In a move that seemed like a demonstration of "I'll show you," Alexandra went out on a date with a friend of her sister's. Then she told Ted about the date. He appeared to be deeply wounded, "as I thought he would be. He slapped me and cried silently." Ted packed up his belongings and left to stay with his mother in Tucson. That summer, while her father traveled to Greece, she filed for a divorce, which Ted did not contest. [20]

Almost thirty years later De Grazia told his lover, Carol Locust, that Alexandra chose her family over him and that he "tried hard to stop it but I couldn't."[21]

At 10:53 a.m., July 31, 1946, Bisbee lawyer John Pintek, Ted's old college roommate, filed the divorce complaint in Pima County Superior Court on Alexandra's behalf. It took one hour and seventeen minutes between the time the suit was filed and the time Judge Evo De Concini granted the divorce. In the complaint, Alexandra accused Ted of a "series of excesses and cruelties," such as berating her in front of her friends. She also stated that he no long cared for her or intended to live with her.[22]

Theodore, as he was called in the divorce suit, agreed to pay $100 a month in support of the couple's three children: Lucia, eight;

Nicholas, six; and Kathleen, four.[23] De Concini gave De Grazia visitation rights with the children. Although not mentioned in the lawsuit, Ted kept their 1940 Ford coupe and the property at Prince and Campbell "for consideration of Ten & no/oo Dollars, and other valuable considerations."[24] She kept the house.

The children often visited their father at his studio. The two girls enjoyed their visits with him, but rebellious Nick proved to be a handful. Sister Lucia said that if Nick were diagnosed today he might be considered bipolar. Early home movies show an unsmiling, almost morose Nick at his third birthday party. Lucia said he grew up disliking his parents, constantly talking back to them. When Alexandra remarried, that marriage failed as well, probably because her husband couldn't deal with Nick's antics. Nick also had run-ins with Marion, De Grazia's second wife, who didn't care for boys. Ted cried over "Nicki's" behavior over the years.[25]

Despite his financial struggles, De Grazia managed to make the $100-a-month payments regularly. The money "must have been scraped together, because these were very lean years" for him, Lucia said.[26]

In later years, when he was wealthy, De Grazia remarked, "Being poor is not a bad thing. When a man is poor, he can appreciate a good meal. Even a cold glass of water tastes good. What rich man can understand that?"[27]

The Diamos family had never cared much for De Grazia, and although they didn't want to see Alexandra divorced, they didn't mind having De Grazia out of the picture. For his part, De Grazia once said that the Diamoses were all caught up in who they were and that they didn't accept him for who he was. They wanted to shape him into what they wanted him to be.[28]

Alexandra had to live thereafter with her family's "I told you so's."[29] For several years she operated a Mexican food restaurant in her home at 2239 East Fort Lowell Road so she could care for the children. Later she returned to college, earning her teaching degree and teaching junior high school Spanish and English in Tucson for many years.

Not long after the divorce, De Grazia took a job as an art teacher at the Fenster Ranch School, then on the outskirts of Tucson at North Country Club Road and East Glenn Street. He only lasted a

year, as he discovered that he disliked teaching. "It took too much out of me, and my own painting suffered," he said.[30] In truth, he disliked working for someone else. After that De Grazia devoted the rest of his life to his own art.

In his year at the Fenster school he painted a mural in the art classroom, which also served as the boarding school's dining room. The mural showed Indians planting corn. The school moved in 1974 near more remote Sabino Canyon because Tucson's growing population had begun to surround it. The original school buildings sat abandoned until 1984, when a developer discovered the mural during demolition. The developer, Paul Hazen, liked De Grazia's work and decided not to tear the dining-room building down, incorporating it instead as a recreation room for the Rancho Tranquillo townhouse development.[31] It still exists today.

8

Life after Divorce

I paint because there is a drive and
because it's the will of God.
—*De Grazia*[1]

DE GRAZIA STRUGGLED TO make ends meet after the 1946 divorce. He would leave paintings outside his small, rustic Tucson studio overnight with "For Sale" signs, but nobody would even steal them.[2] When his children came to visit him at the studio, they ate salad for dinner and sugarcane for dessert, all he could afford. The children complained they were tired of being given the same meager dinner repeatedly, but he told them, "I'm sorry, that's all I have." He might take them out for Chinese food if he sold a painting. Sometimes he bought them coats after making a sale. When he picked his children up after school for visitation and they stayed overnight at his Campbell studio, the only heat in wintertime came from a fireplace that would burn out, and they would wake up to bitter cold in the morning.[3]

No matter the hardship, De Grazia paid attention to his kids. He wanted to see report cards, and each "A" would earn a dollar.[4] At times he took them along when he went to Indian country to look for painting ideas. They slept in his car and ate peanut-butter-and-jelly sandwiches, and if he managed to sell a painting, "we would eat in a real drugstore," said his daughter Kathy Bushroe.[5]

Nick told a reporter in 1980 that his father sat him at a table at age six or seven with a paintbrush and had him fill in colors on Indian items he had made, which Ted then sold. Neither of his two daughters

Figure 14. During the mid-1940s De Grazia built a studio at North Campbell Avenue and East Prince Road in Tucson.

showed an interest in painting, while Nick dabbled in artwork over the years.[6] Ted begged the children to go to college, but none did.

Not all of the neighbors were happy with De Grazia's studio and the other storefronts he built. The Prince Road Improvement Society passed around a petition in the late 1940s to get him out of the neighborhood, but nothing came of it.

Toward the end of the 1940s, a developer decided to put a drive-in theater across the street from De Grazia's studio. Enraged, he formed a neighborhood group to oppose the plan. They lost. Afterward, De Grazia began thinking about moving to the Catalina Foothills to once again escape encroaching civilization.[7] He didn't hold grudges, though. Instead, he became a longtime friend of the drive-in's manager, Dick Frontain, whom he met for drinks every night about 5 p.m. when Frontain arrived to open the drive-in.[8]

On Thanksgiving in 1940 in New York City, a ten-year-old boy named Hal Grieve turned to his mother and said, "Let's get out of this dirty city." His mother, Marion Sheret, said, "Hey, all right. Where shall we go?" Young Grieve looked at a jigsaw puzzle map of the United States and pointed at Tucson. Not long thereafter, they arrived. Or so the story goes.[9] Fifty-seven years later, Grieve said he had no recollection of that event and that it might be legend. "That's

just a story I've heard often," he said.[10] He said he believes someone suggested Tucson because it had a growing art community.[11]

Grieve's mother, one of nine children of a stonecutter and a house-wife, was born May 8, 1905, in New Albion, New York, about fifty miles south of Buffalo. "I was," she said, "what they call an apple knocker from upper New York."[12] She graduated in 1927 from Buffalo State University and then married a sales engineer. They divorced soon after Hal's birth. She and Hal moved to New York City so she could study at Columbia University to become a sculptor. "They were nice teachers," she said, "but I learned nothing."[13] They lived mostly on alimony and child support in a loft on Fifth Avenue across from the main New York library. She worked for Macy's, where she sold office equipment, and attended school at night.[14]

In February 1941, they hopped a train headed for Tucson, arriving around Valentine's Day. "I loved [Tucson] the minute I came," Marion said. She bought a car, and she and Hal explored the city. They moved into a house on North Highland Avenue near Mansfeld School, across from the University of Arizona. Later they rented a cottage at East Fort Lowell Road and North San Francisco Street. That's where Hal met his lifetime friend Tony von Isser, who lived next door. After a couple of years, Sheret moved to Santa Fe, New Mexico, and then toward the end of World War II they moved to Alamogordo, New Mexico, where Sheret got a job cleaning spark plugs. But Tucson tugged at her again, and they moved back in 1946.[15]

One day De Grazia's studio caught her eye as she drove past on Campbell Avenue. She thought, "Oh, is that pretty . . . I wonder who lives there?"[16] Upon discovering that a neighbor knew De Grazia, she asked to be introduced. Sheret and the neighbor arrived at the studio to find De Grazia surrounded by a group of women, "and they're all laughing, and the more gullible they are, the more he puts it on thicker and thicker," Marion said. De Grazia looked over at her and said, "Where have you been?" in a tone that sounded like she had shown up late for work. Maybe De Grazia really meant, "Where have you been *all my life*?"[17]

That meeting started a romance with Miss Mary, as he called her. She called him De Gratz. "I refuse to call him Ted. It's such a common name."[18] Her son, Hal, said it was an "immediate and intense"

attraction.[19] The next time Marion visited the studio, he gave her a portrait of her that he had painted. "It's not a sweet sugar-and-spice painting," she said in 1996. "He must have seen something inside me that I didn't know about."[20] Writer Dorcas Rosenfeld described Marion in those days as having "a mysterious and gypsy-like aura about her. . . . She was charming, witty, and strangely beautiful."[21]

Fifty years later, in an oral history interview, Marion said the romance "just . . . happened" and offered scant details. Years later she composed a number of free-verse musings about Ted and their life together. The following verse recalled those early days.

> *I didn't know you,*
> *you didn't know me.*
> *And yet*
> *a spark*
> *was ignited,*
> *fluttered,*
> *and became*
> *a flame.*[22]

Grieve recalled that De Grazia frequently visited Marion at her home, much to his displeasure. "I was a little put out about it because, you know, I was used to living with my mother without the inconvenience of somebody coming around." Grieve said De Grazia dressed like a hippy, "but I got to know him fairly quickly and I found him to be a very, very decent guy. I got to like him very much."[23] A while later De Grazia offered Marion a job. "I figure somehow or other I was destined to come here and help him," she said. "I really think I was destined."[24]

After a two-month courtship, they decided to get married. "I was very impulsive in those days," De Grazia said. "She was real pretty, so I asked her to marry me right there."[25] De Grazia took his bride-to-be to Tehuantepec, on the west coast of Mexico in the state of Oaxaca, because, he told her, it had the most beautiful women in the country. They drove his Ford on the Pan-American Highway, and at night they slept beside the road, just as he always had. In five weeks, they drove 6,000 miles round trip on rudimentary roads, overcoming tire blowouts and a serious shortage of gas stations. There were, for

example, no gas stations along the 125-mile stretch between Oaxaca and Tehuantepec. De Grazia had to finagle gas from people in their homes.[26]

From Tehuantepec they boarded a very slow train for a twelve-hour trip through thick, rain-soaked jungle on the isthmus to the small village of Otiapa. As the train lumbered along, Marion grew increasingly amazed at De Grazia's ability to charm the Indians along the way. "De Grazia had a way with people—they all loved him, . . . and he spoke their language fluently."[27]

While the Indians went about their lives in Otiapa, De Grazia painted pictures of them, thirty-six in all.[28] He said he made friends easily with the Indians because, "although they have no idea what an artist is, [they] took particular interest in my work."

On June 14, 1946, Ted's thirty-seventh birthday, he and Marion, forty-one, were married in an Indian ceremony among the exotic plants, monkeys, bananas, and scantily dressed women of queenly bearing in the village. They drank a toast with coconut milk instead of champagne. Marion recalled the girls' laughter. "You could hear their laughs as they climbed the hills," Marion said. "Their laughs were so musical that they sounded like a tune."[29]

"When [Marion] married me, I thought I was a pretty hot artist," De Grazia said. "My paintings sold for $3 to $5, and I wasn't making over $50 a year. But we lived and breathed art." He made money, of course, in other endeavors, including ceramics, murals, and jewelry.[30]

De Grazia's paintings from that time exhibit clear influences from post-Impressionist artists such as Paul Gauguin and Vincent Van Gogh. Imitating painters he admired—Gauguin, Rivera, and Orozco, in particular—played an important role in De Grazia's development. Gauguin, for example, had traveled to Tahiti to live among and paint the Tahitians. De Grazia did likewise with the people of Tehuantepec. His painting *Isthmus Tehuantepec* is similar in many ways to Gauguin's *Beneath the Pandanus Tree*, painted in 1891.[31]

Once back in Tucson, Marion realized that the marriage in Otiapa had not been legal, so she and De Grazia went to Nogales, Arizona, to be married by a justice of the peace.[32] As a wedding present, De Grazia gave Miss Mary an "emerald" and silver pendant. Since he couldn't afford a real emerald, Marion's birthstone, he melted a 7-Up bottle and formed it into a cut-emerald shape, which he mounted

in the pendant. When she showed the necklace to friends, Marion would exclaim, "Isn't it beautiful?"[33]

Soon after the newlyweds returned home, they decided that Hal, then sixteen, didn't fit into their plans. Marion didn't care much for boys; when she became pregnant with Hal, she had hoped for a girl. Hal moved out and went to live in an old, abandoned trailer on the von Isser property. After a while, Tony's mother began to worry about Hal's health and called De Grazia. He talked it over with Marion, and they shipped Hal off to a boarding school in California.[34]

De Grazia continued to see his own kids, just not as often. He and Marion were focused on his succeeding in the art world, and they lacked resources to provide for the children beyond Ted's $100 support payments. Marion found it difficult when Nick joined them, not only because he was a boy but he was an unruly one at that. When Ted traveled to California with Marion to see his sisters, they would take the two girls, Lucia and Kathy, and leave Nick at home, at Marion's request.[35] Lucia said that when she visited her father he would be busy painting in the gallery. He would tell her to sit down and talk to him while he was painting. "Dad, I'm hurt," she said on one occasion. "I came to visit with you. You don't have to take time, but you don't have to be that businesslike." De Grazia replied, "I know, but I'm busy."[36]

The marriage did not progress smoothly. De Grazia grew moody, moping through periods of brooding, claiming that Marion didn't understand him. He disappeared into the desert for weeks at a time. "I am afraid that I was not always a good husband," he said later. "But how could it be otherwise? . . . An artist should never be married. You must work alone too much of the time. You can never create anything in a crowd. Your wife will say, 'Don't you love me?' What's that got to do with it? How can you talk in terms of conventional expressions and demands of love when your guts are on fire, and your mind is churning with a thousand things that are trying to get out and be? An artist must sacrifice too many things; family, security, privacy."[37]

In his later years, De Grazia regretted that his family suffered from his total devotion to art. "He was somewhat disappointed that he didn't have a little better family relationship with his daughters and his sons than he did," recalled Rick Brown.[38] De Grazia cautioned Brown, a businessman and admitted workaholic, not to make the same mistake.

9

Appreciating the Indians

He walked in beauty, his Indian friends said of him
This grizzled son of Arizona
Whose spirit soared on the cloudtips
And whose heart knew the earthbound creatures
—*Arizona Highways*[1]

DE GRAZIA LOVED TO TRAVEL over Indian land, whether Navajo, Apache, Taos Pueblo, Hopi, Yaqui, Cocopah, or Papago (now Tohono O'odham). He took off on his first drive around the Navajo Reservation in the late 1930s. The trip exposed him to a new world, one "remote . . . from mine."

Bumping along roads that were no more than wagon tracks in the sand in his beat-up "junk heap," at first he thought the reservation must have no people living on it. Then he began to spot Navajo children tending sheep, a lone Navajo rider, a Navajo trading post. Eventually he discovered that he could learn about the people best at the trading posts. He spent hours in them, at places so remote they didn't appear on maps.

While the trading posts served as social centers, De Grazia soon realized that Navajos traveled long distances to them primarily to trade their wool for necessities.[2] He became captivated by the Navajos' soft voices, their dignified and gracious approach to each other, and their manner of shaking hands. He noticed that they didn't shake hands like they were pumping water, as white men do; instead their handshakes were a soft brushing of the hands, without any show of strength.

He made many trips to the Navajo Reservation, sometimes as an artist, others just to enjoy the tranquility and peace that he needed. Then he began to see the land he loved changing—and not for the better. "Now the wagon tracks I first knew are hard-surfaced highways—sleek and slick and fast. The pickup truck is replacing the wagon. This they tell me is a sign of progress. It is a way of life, which I have found simple and noble at the same time, [that is] disappearing."[3]

On one trip De Grazia painted nothing but wagons because he feared they would be replaced by a different kind of wagon—a station wagon. He sought to capture the spirit of the wagons. "Funny how the wagon has come to mean so much to me," he said. "With Indians and horses, with no Indians, overcrowded with many Indians. I love the wagon. The Indian loved it too, when he learned from the early Americans to use it."[4]

De Grazia traveled to other reservations as well. He felt at home on them. "I never felt that I was better than an Indian. And I'm sure an Indian never felt he was better than me."[5] Long trips to witness tribal ceremonies became common. He often traveled six or seven hundred miles to see an Indian fiesta, only to find it had been postponed. "That's why I have to charge so much for my paintings," he joked.[6]

He would study the Indians, taking care not to offend them. The corn dances, deer dances, hoop dances, footraces, chicken pulls, rabbit hunts, and greased pole contests all showed up in some of his best paintings.[7] "I try to convey an instant freeze," he said, "a moment, capture a thought or mood in color. But I always try to go beyond the intellect. I want the onlooker to participate—to be part of the painting. It should be an emotional experience."[8]

As writer Adina Wingate pointed out, "He knows and understands the Indians and the land he chooses to depict, and in this there is a deep abiding respect for the cultural heritage and the ceremony that embellishes their lives."[9] As do the Indians, De Grazia believed that human beings and nature should be in harmony.

Once in 1967 a young Indian woman with three teenaged stepchildren and five younger children of her own spotted an older man dressed liked a prospector at a Veterans Day parade on the San Carlos Apache Reservation. She didn't recognize him, but she took note of him because of the way he dressed and the fact that he drove

a white Jeep with four new tires, which meant he had cash. The woman discovered that the Apaches knew the stranger as the Man with Strange-colored Eyes (they were blue-green). He passed out bags of candy to the children, tobacco to the elder men, and hand lotion to the elder women. He spoke the Apache language, always in a soft tone. In their culture, to do otherwise would have been rude.[10]

After a while the Indian woman saw the man standing nearby watching the parade. The cradleboard in which she carried her youngest child interested him. She explained the cradleboard to him, and he gave her children some candy. Then he turned and walked off down the street.

She asked questions about the mysterious visitor, only to learn that the Indians knew little about him, other than that he often came to the reservation to observe them in their daily lives, always acted polite, and seemed very observant. He would inquire about shapes, materials, and colors. They thought his name was Deh-ga or Dehgrazh. The Indian woman with the eight children, Carol Locust, never forgot him.

The paths of Ted De Grazia and Carol Locust would cross again four years later in Tucson, where they would begin a long, happy relationship.[11]

Taos Pueblo, one of De Grazia's favorite places, was constructed between AD 1000 and 1450. Today about 150 people live in the pueblo, at an elevation of 7,200 feet, with about 1,700 tribal members residing elsewhere on the 99,000-acre reservation.[12]

De Grazia never painted while visiting a reservation. "I would not so dishonor my friends to do that," he said. He would study the Indians, burning images into his almost photographic memory. Then he would recall the images when he returned to his easel back home, and if he thought he'd gotten it wrong, he would go back again.[13] He portrayed Indians in dazzling colors, leaving faces blank. That way viewers could imagine their own emotions in the Indians' faces.[14]

"A face with details becomes that face and no other," De Grazia said. "But a face with no detail becomes the face of anyone, any child, a face the person looking at it adds to the picture. When people add faces of their children or grandchildren, or of themselves when they were young, it makes the picture come alive."[15]

Not all Indians were enchanted with De Grazia's work. Juan Noble Garcia, a Papago, wrote a letter to the editor, published in the *Arizona Daily Star* in 1973, that said, "Anyone who has observed us in various stages of work and leisure activities knows we are not pale, pastel puffs. . . . More important, we are not faceless elves. . . . This is really a plea to Ted De Grazia to put his talent to work more effectively by depicting the Indian with the same truthfulness and understanding he displayed in his earlier Orozco–Diego Rivera period, where his colors and moods were forceful and moving, and where the personality and character of those he portrayed were executed with dignity and feeling."[16]

Despite Garcia's plea, there was no going back for De Grazia.

Again Marion wrote verse about those days:

> *The many dollars*
> *Did not change*
> *His way of living*
> *Never a sign of ostentation*
> *He was happy*
> *When he was*
> *With his Indian friends*
> *They were basic*
> *They were real* [17]

De Grazia used his paintings to reflect—as he saw it—the Indians' fast-disappearing way of life. They were more than subjects for paintings. "I have always considered them my neighbors and my friends," he said.[18] He often professed that he would rather share a meal with an Indian than with a big-shot banker or lawyer. As Rick Brown said, "He would not be the type of guy that would go next door to a . . . neighbor and they'd chew the fat or they'd watch a ballgame . . . his friends were the Indians, the Mexicans."[19]

Tucson anesthesiologist Fred Landeen said De Grazia liked Indians because they were "very simple people, as he was a simple person. . . . He could sit down with them and converse with them in [their] language, and then he would do some paintings, and they would absolutely trust him. And I think it was the simplicity in their lifestyles—both his and theirs—that led them to be really good friends."[20]

De Grazia worried about the fate of his beloved Indians and their culture. "This 'Vanishing American' did not vanish before the onslaught of the U.S. Cavalry but is vanishing before the inexorable influence of the white man's civilization," he said. "All over the Southwest the Indians are changing; call it progress if you will—progress to bring the Indian a better way of life. Yet it saddens me when I see a juke box in a Hopi trading post or hear about a mammoth supermarket soon to be constructed at Window Rock [New Mexico], the capital of the Navajo nation. If God will just give me the strength and time I hope to capture on canvas the vestiges of the old and more colorful way of life of our Indians that still exists."[21] This has, indeed, become part of De Grazia's legacy. On another occasion he remarked, "The Indians' spirit has been broken. It was broken years ago. We've kept them subdued. They need to be educated in what they want to do and then let them pursue what they want."[22]

He noted the evolution of a new generation of Indians, "one in full regalia, with a new car and a wrist watch. The Navajos don't speak Navajo anymore, the Hopis are hoping, the Yaquis are indifferent, and the Papagos couldn't care less. I liked Indians a hell of a lot better when they were still Indians, before they became Native Americans."[23]

De Grazia painted the Indians as people living in a colorful, simple world complicated by white people. He tried to show them in a different light than Americans were accustomed to seeing in the movies and reading about in Western novels.[24]

"I don't know why I paint Indians. Maybe I'm afraid Indians are going to vanish and I want to be around to fill my eyes. It's like waiting for death. I know it's coming, so I know that someday the Indians will be no more. Maybe it's because I feel good around them, and often wish I were one of them."[25]

Some of De Grazia's best paintings portrayed the Christian Madonna and angels as Indians. "Everyone has angels," he said, "and I figured that one of the oldest cultures in our nation surely has them also."[26]

He often said that not all Indians are alike, but it is difficult to tell that from his paintings. "When I paint Indians, I paint them collectively, all Indians as one. But when I speak to Indians, I always speak to them as individuals."[27] He noted that Indians from different tribes have different features, are built differently, and have different skin-color pigmentations. "Once when I was in New York, Doubleday

asked me to illustrate something to do with the Plains Indians. I said I didn't know anything about Plains Indians. They said all I had to do was put feathers on their backs."[28]

He fumed about the way the government treated Indians. "A long time ago they used to say the only good Indian was a dead Indian," he said. "I love Indians—real Indians, Indians who aren't associated with organizations that have a lot of fancy initials in front of their names." Despite more than one hundred years of trying to help the Indian, all the government had done, De Grazia said, "is add more white people to the government payroll to take care of them."[29]

At times Indians came to him to borrow money. "Nothing makes me madder than to lend money to somebody and not get paid back," he said. So he put them to work digging a hole. "How deep?" an Indian asked. "About five bucks worth," De Grazia replied. Then the next Indian would come along to borrow money, and De Grazia would have him fill up the hole. "My feeling is that they're earning their money, even though I don't need the damn hole, and that's good. If I were the head man in Washington, I'd give money to nobody. I'd have a trench that ran from the Pacific to the Atlantic. And I'd have a Department of Picks and Shovels."[30]

De Grazia's love of Indians led him to attempt to preserve their culture through books as well as paintings. His texts are historically accurate; his colorful illustrations bring them to life. In 1968, the University of Arizona Press published one of his most popular books, *De Grazia Paints the Yaqui Easter*. It's ninety-three pages long, forty of them illustrations depicting the forty days of Lent. In his research De Grazia watched all forty days of the Yaqui Easter ceremony and then painted them from memory.[31] The book illustrates how the Yaquis blended Spanish Catholicism with Indian tribal ceremony and tradition. It depicts a celebration that is not entirely Catholic or pagan, "but it is sacred. There is an excitement attuned to both. . . . The Indians are indifferent about it. They go on with their bells and rattles and dance merrily along. Mostly in the night time. Then the celebration goes into the day. . . . They adapted the story and stylized it to fit their personality—always full of variations. I never ask because it's none of my business. I just watch."[32]

It speaks to the trust and admiration the Yaquis had for De Grazia that they allowed him to witness some of their most sacred rituals,

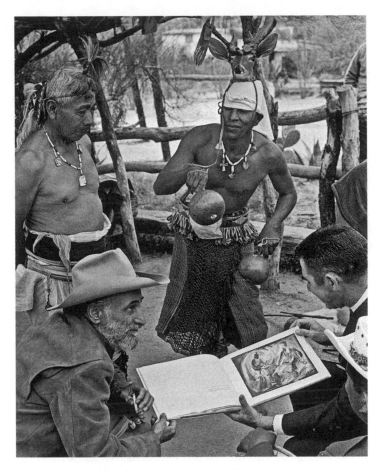

Figure 15. De Grazia shows his book *Yaqui Easter* to a
friend while a Yaqui deer dancer and another dancer look on.

most of which are never made public. It was his sensitivity to their
centuries-old traditions that helped win the Yaquis' confidence.
De Grazia often said the Yaquis were among his closest friends. He
gave them money, bailed them out of jail, respected their privacy,
and gave them jobs. De Grazia probably could not have completed
the numerous buildings on the Gallery in the Sun property without
the Yaquis' willingness to work for and with him.

De Grazia researched his topics firsthand, rarely relying on second-
ary sources. In early 1970, for example, De Grazia made seven trips
in four years to visit the Seri Indians along the west coast of Mexico

to learn about their way of life. Once he took along with him his wife Marion, reporter Dodie Gust, and Tom Galvin, newsman for NBC's *Today Show*.[33] Galvin shot film for the TV show while Gust took photos for a feature article she planned to write.

They took off in a camper at 5 a.m. and arrived a day later in one of several camps inhabited by about three hundred Seri. There, the crew shared meals of turtle and clams with the Seri before hauling out a transistor radio, a lantern, a flashlight, flour, sugar, coffee, and lard that De Grazia had brought along to trade for photographs.

The Seri lived in homes built of ocotillo wood along the waterfront. They had dirt floors and no tables, shelves, beds, or chairs. "They never got off the ground," De Grazia said. "Isn't that wonderful? No complications." De Grazia made some sketches, Galvin shot some film, Gust snapped some photos, and a couple of days later they headed home.[34] That trip resulted in the publication of De Grazia's sixty-three-page book *The Seri Indians: A Primitive People of Tiburon Island in the Gulf of California*.

On one of his later trips to visit the Seri, De Grazia was uncertain why he was going. He had become moody and introspective and wanted to get away from his studio "to recharge his motors." On this trip he took his son, Nick, then in his late thirties. The Seri remembered De Grazia, of course; they called him El Viejo (Old Man) because of the gray in his beard, and they greeted him warmly.

For De Grazia the visit included the same activities he had enjoyed on previous visits: mingling with the Seri, trading goods, eating native foods, gathering images in his mind.[35] But Nick argued against spending the night with the Seri. He wanted to drive back to Kino Bay to stay in a hotel, complaining that he disliked the chiggers, fleas, scorpions, centipedes, and tarantulas. Also, Nick had heard hints about cannibalism in the Seris' past. "They could kill us all," he said, "roll the car into the water, and nobody would ever know we'd been here." In the end he stuck it out, anyway.[36]

De Grazia took people with him almost every time he visited the Seri on Tiburon Island, other places in Mexico, and the Southwest, including Dick Frontain, who was also a freelance photographer. Frontain and Shorty Thorn would do some of the driving when De Grazia became ill or drunk.[37]

De Grazia once traveled to Old Town in San Diego for an autograph party for the Seri book. He told a gullible *San Diego Sentinel* reporter that he wrote and illustrated the book because he had fathered two young boys with a Seri woman. He told her the boys' names were Manuelito, born in 1945, and Josélito, born in 1948. De Grazia told the reporter that Manuelito was "half Seri, half De Grazia" and that he knew the boy was his son "by the profile." He then turned sideways to show the reporter his "long, curving, Etruscan nose." He claimed he planned to bring Manuelito back to the United States to live with him, but no one ever saw the boy.[38]

In his book, he wrote that he had discovered the Seri were not a vanishing tribe, as some believed; rather, "they are just small in numbers." He said these "handsome" people were becoming more civilized, "barely moving, but nonetheless catching up to the twentieth century."[39]

In 1975 he self-published *De Grazia Paints the Papago Indian Legends*, about the Papago creation myth: the monster of Quitovac, the Eagle-man, and Ho'ok, the witch. (The tribe changed its name from Papago, which means "bean eaters," to Tohono O'odham, "desert people," in 1986.) The paintings didn't sit well with the Papagos. "I don't know how he got his information," said tribal lawyer Hilda Manuel. "He did it without coming to the tribe first." She called it sacrilegious to use Papago heritage for personal gain as De Grazia had. "I don't think any outsider or non-Papago who doesn't have an appreciation or understand a lot of things that are sacred to the people here has any business writing about anything just to make a dollar."[40] Nonetheless, in 2011 De Grazia's paintings of the tribe's legends were exhibited at the Tohono O'odham's cultural center outside Sells, Arizona.

De Grazia used lithographs in 1976 to illustrate *De Grazia Paints the Apache Indians and Myths of the Chiricahua Apaches*, a fifty-six-page self-published book. In a review in the *Arizona Daily Star*, Dick Frontain called it one of the most handsome works that De Grazia had done in twenty-five years.[41] The book shows through text and illustrations how the Apaches lived before the coming of the Europeans and how he felt they lived through their legends. De Grazia said he learned the stories "out of many good long talks with my Apache friends."[42]

10

His Fame Grows

I never expected to hit the jackpot.
I never thought I'd make it big.
—De Grazia[1]

DE GRAZIA VISITED NEW YORK for the first time in 1947. He didn't like it much. In an autobiographical sketch published in 1966, he wrote: "1947—His first trip to New York to look it over—NO GOOD." That feeling didn't diminish after several other trips to the Big Apple on business. He wrote in the sketch about another trip in 1952, "still was no good;" and a trip in 1960 left him feeling that "the call of the desert was stronger."[2] He didn't want to go anywhere anymore except Indian country or Mexico.

He returned to Mexico City in 1949 and 1959 but said he stayed away from Rivera and Orozco because his career had not taken off.[3] He didn't mention that Orozco had died in 1949 and Rivera, in 1957.

On April 8, 1948, a year after Ted and Marion were married, Marion typed a short note to her husband entitled "Satisfaction," which she signed. It said, "I love you De Grazia. And I want you to be free. So I hereby release you of any claims I may have now or which may arise in the furure [*sic*]. With all my heart I hope that you will be happy."[4]

What the note meant is unclear, but during their early years of marriage De Grazia would take off to Mexico or an Indian reservation for days, even weeks, at a time without telling her when he would return. Book editor Karen Thure said that De Grazia lived "just totally free and didn't really think about her and her feelings a lot."[5]

Marion wrote a similar note to De Grazia, also in 1948 and also entitled, "Satisfaction," acknowledging that she had received ten dollars "together with other good and valuable consideration" from Ted and that she released any claims she had then and in the future "for any or all services rendered to the said Theodore E. De Grazia in any capacity."[6] Again, it is unclear why she wrote either of the notes. She may have been telling De Grazia that she would not stand in the way of his pursuits.

Over the next few years the marriage grew even bumpier. De Grazia once wisecracked that he would try marriage for five years "to see if it takes."[7] On April 30, 1953, six years after they were married, he filed for divorce, accusing Marion of being "guilty of cruel treatment" toward him, "affecting and endangering [his] mental and physical well being." The divorce filing in Pima County Superior Court, prepared by the law firm of Rosenberg and La Vetter, apparently came as no surprise to Marion. She acknowledged receipt of the filing that same day and simply requested that her maiden name of Sheret be restored.[8] Later she wrote:

> *The wall is thin*
> *easily shattered.*
> *each side*
> *know not*
> *what they are doing*
> *if they did*
> *the wall would be*
> *a lovely veil*
> *for them to wear*
> *as they dance*
> *in harmony.*[9]

Nothing came of the divorce complaint, apparently because De Grazia worried that the court would award Marion half of their property, and especially since Marion had clearly helped him grow his lucrative business. He had said jokingly more than once that he didn't want his wife running off with a truck driver who would benefit from his hard work.[10]

Marion's friend Ada P. McCormick, publisher of a magazine called *LETTER*, which gave voice to humanitarian causes, typed a short

note to Marion saying that she had read about the divorce complaint in the *Arizona Daily Star*. "You have done so much to build up that business," McCormick wrote. "Perhaps you will be like Mr. and Mrs. Knopf [the book publishers] who are divorced and continue to work in the same room in the same business partnership." Then she wrote by hand at the bottom, "I wish life could be easier for you."[11]

Through it all, De Grazia often told friends that "Marion has kept me straight. Until Marion I was the most unlikely guy in the world to make a living."[12] She definitely proved to be a stabilizing force in his life. "Marion kept their life together, I believe that," said Fred Landeen. "Ted was a very, very . . . volatile person, and I think Marion tolerated a lot of his volatility, maintained a great household."[13]

That same year, 1953, De Grazia mailed a letter on June 10 to Marion—crossing out "Marion" and writing "Mary"—while on an unexplained train trip to Guadalajara, Mexico. The train was hot, with nothing but a fan to cool the air. "I have been living with myself since I left you and have done a lot of thinking," he wrote. He said he appreciated Marion's contributions to construction on their property. "In my inner mind as I see what you and I have generated [it] looks very beautiful. You have done it and I have helped you. The new little color house is so beautiful from here. I can see u [*sic*] in it busy around making it more beautiful. . . . The strongest impression around it is you. You alone have found the imagination to make it so. . . . May I hope you miss me and too I hope you can feel my presence around you and the place. I miss you and love you." He added in a postscript: "Last night I saw Venus, our star."[14]

A handwritten will dated May 29, 1958, that De Grazia wrote adds to the mystery surrounding their relationship in those years. The will, which was not witnessed, left all of his estate to his brother Greg and Greg's wife, Grace. He said he did this "knowing full well that my brother and wife will take care of my wife Marion and my children and it is my wish that they do with my paintings and estate whatever and whichever they wish."[15]

Marion never wavered in her desire to see De Grazia achieve his goals, often at her own expense. When she could have been working on her own art, she instead ran the business and household. "I was shipping clerk, secretary, salesgirl, cook, everything," she told a *Tucson Daily Citizen* reporter in 1966.[16] On another occasion Marion

Figure 16. De Grazia shows jewelry to a young Indian girl, one who probably posed for his paintings.

said simply, "I worked, worked, worked, worked. Work, work, work, that's what it was all about: work, work, work."[17]

De Grazia once had director's chairs installed in the gallery, one of which was labeled "De Grazia," the other, "De Grazia's boss."[18] Marion said one reason De Grazia liked her was that she wasn't "a fishwife. I didn't holler at him, 'What the hell are you doing? You crazy?' I didn't say anything like that."[19]

De Grazia reflected years later that "when you have become a painter, you will have paid for it dearly. Not in money. The price comes out of your soul, you pay with your very hide." A student once asked him how to become a painter. De Grazia replied, "First you just grow a beard. Then you must wait for the beard to turn grey. And then—maybe—you will become a painter."[20]

In 1948, sixteen-year-old Travis Edmonson stopped by the studio to watch De Grazia paint. They struck up a friendship that lasted long after Edmonson teamed up with Bud Dashiell to become

the acclaimed folk-singing duo of Bud and Travis. As De Grazia painted a picture of a horse, Edmonson looked on in wonder. When De Grazia had finished, he asked Edmonson if he liked the painting. The teenager replied that he did. De Grazia then said, "That's you, a young bronco," as he gave it to the astonished boy.[21]

As their friendship grew, De Grazia explained his theory about the relationship between music and color. Once he told Edmonson, "Go ahead and sing something." As Edmonson began to sing in Spanish, De Grazia whipped out a piece of paper and a pen and began to sketch. Edmonson called his song a "strong piece of music, . . . and in the twinkling of an eye I was able to see the magnitude of the man and how successful he was in getting across to people."[22]

In the mid- to late 1960s Edmonson found himself down on his luck. "I was dead broke, had no job, no nothin', and I went up and knocked on his door on Swan [in the foothills], and I said, 'I'll make a deal with you. I'll write a symphony on you if you'll give me a place to sleep.'" De Grazia put him up in one of the small apartments on the property, and Edmonson knuckled down to write the Arizona Symphony, which he finished in the early 1970s.[23]

In the February 1949 issue of *Harper's Magazine*, writer Russell Lynes noted in an article entitled "Highbrow, Lowbrow, Middle-brow" that "social change in America had evolved to the point where . . . prestige had finally come to be based more on taste than on wealth and breeding" and that "millionaires could be low-brows in cultural affinity while highbrows tended to be in 'ill-paid professions, notably the academic.'" In the midst of this evolving snobbery and pretension, De Grazia tried to make his way as an artist.[24]

During this period the basic subjects of De Grazia's path to success—the "cutesy," round-eyed angels and the desert Indian—bore fruit, bringing him attention at last, after years of painting.

He began to sell signed and numbered prints to make his artwork less expensive for the average person. The idea to do this came to him in January 1949, during a monthlong exhibit of twenty of his paintings at the Mid-Twentieth Century art gallery in Hollywood.[25] There he discovered a shop that he thought might reproduce his paintings as lithographs. He gathered up some of his works and took them to show shop owner Lynton Kistler. "You know," De Grazia said, "if you print these, I think I can sell them." Kistler demonstrated

Figure 17. Ted and Marion De Grazia work on pottery at the Campbell studio.

how he produced lithographs. De Grazia asked how much each print would cost. Kistler told him one dollar. "Well in that case," De Grazia said, "I can afford about fifteen." Kistler got a chuckle out of that and offered to print the paintings with the promise that De Grazia would pay him when he sold the prints. De Grazia returned to Tucson, and, "sure enough," he said, "I began to sell prints quite successfully." In fact, money started pouring in.[26]

About that time De Grazia made important changes in his style, abandoning the paintbrush and instead adopting a palette knife. Use of the palette knife allowed "sways and bends on command," he said. "It swirls like a ballet dancer and then stops in a flash when you tell it. It takes a long time to learn how to use a palette knife without scraping your knuckles against the canvas."[27] He also virtually eliminated all faces of adults and began using small dots and eyes for

children's faces.[28] "Children—they are all over my canvases. You see these beautiful black eyes looking at you with awe."[29]

A woman asked him once why his paintings had no faces. He told her that he dropped out of painting class the day they taught faces. She shook her head and said sadly, "Isn't it a shame. One more day."[30]

De Grazia felt that by drawing faceless figures he was creating a new style. "Every artist must contribute something of his own to the world of art," he said. "He must also have a recognizable style so that once you see it one doesn't forget it. I don't need a facial expression to convey the mood of my paintings. Mood can be created in the hunch of the shoulders or the toss of the head—in surrounding colors or background."[31] He also found that for maximum drama and emotional appeal seven colors worked best: brown, black, vermilion, blue, lemon yellow, orange yellow, and brown yellow.

Jack Sheaffer, a longtime *Arizona Daily Star* photographer, became one of De Grazia's most ardent advocates. Sheaffer grew particularly vocal when critics said De Grazia couldn't paint faces. De Grazia had once copied in oil a portrait photo that Sheaffer had shot. Sheaffer said the face in the painting looked as real as the photograph. But De Grazia had told him he couldn't make a living as a portrait artist.[32]

Instinctive self-promoter that he was, in the 1940s De Grazia volunteered to allow the Sunshine Club, a group organized to promote Tucson, to put on an art show, with proceeds going to the club. He also allowed his paintings to be reproduced in the club's advertising. He told newspaper reporters that he hoped his paintings would promote the cultural aspects of Tucson—not to mention the artwork of one Ted De Grazia.[33]

Sheaffer said he had known four self-promoters in his life: the light heavyweight boxing champion Archie Moore, daredevil Evel Knievel, golfer Lee Trevino—and De Grazia. "They would seek out the press, or good photographers or that, so they could keep their publicity going," he said.[34]

One day in the late 1940s, when his finances were tight, De Grazia hatched a scheme with Bud Jacobson, a university law student who had gone to school with the twin daughters of James O. McKinsey, chairman of the board of the Marshall Field's department store in Chicago. The plan required that De Grazia make hand-painted

Figure 18. Ted with a different kind of kiln.

dinner plates incorporating Toltec Indian designs. Jacobson then sent these plates to the twins, who showed them to their father. "Mr. McKinsey apparently showed them to the right people at Marshall Field and, to the total astonishment of both Ted and myself, we sold a couple of dozen of those plates for . . . a thousand dollars a dozen!" It turned out McKinsey also knew buyers at Wanamaker's department store in Philadelphia, "so he sent these samples on to Wanamaker's and sold another couple dozen plates at the same price. I don't have any idea what Field or Wanamaker's charged the public for these things, but each *was* an original, each *was* signed, and each was a little different." De Grazia used the proceeds from these sales to buy new gas and electric kilns for his Campbell Avenue studio.[35]

In 1948, a University of Arizona law student named Robert F. Miller and his wife, Mary, visited De Grazia's studio. Mary fell in love with an oil painting called *Little Boy on a Carousel*. Miller didn't have a lot of money, so he struck up a deal with De Grazia to buy the painting in exchange for a .45 automatic pistol, some twenty-dollar gold pieces that came from his father-in-law, and some steak knives. The deal included an agreement that Miller could buy back the pistol, gold pieces, and steak knives when he could afford to, which he did. In 1994 he had the painting appraised before donating it to the Gallery in the Sun. The appraisal came in at $16,500. De Grazia had asked $300 for it.[36]

Despite his growing popularity, De Grazia became so discouraged in the late 1940s that he thought of abandoning painting and applying to work on a project aimed at stamping out hoof-and-mouth disease. The job paid $6,000 a year, a good salary in those days. De Grazia told Raymond Carlson, editor of *Arizona Highways*, that he needed the job just to survive. About that time the magazine came out with pictures of two De Grazia paintings. An airline company president liked the paintings so much that he offered De Grazia $1,000 for each. But the paintings belonged to Carlson. De Grazia wanted to buy them back from Carlson to sell to the executive. Carlson refused and told him that if someone wanted to pay that kind of money for his paintings, De Grazia should not give up painting. "And that," Carlson said, "is how *Arizona Highways* saved Ted De Grazia from the hoof-and-mouth disease."[37]

De Grazia's fortunes took a big turn for the better in the summer of 1949, when engineer-turned-art-dealer Buck Saunders and his wife, Leobarda, visited De Grazia's gallery. They had just opened the Trading Post at 17 North Brown Avenue in Scottsdale, Arizona. The town, which eventually became a major tourist attraction, at that time had a population of twenty-five hundred and sat in the middle of the desert, with little between it and Phoenix.

The Saunderses had heard about De Grazia for several years, but an article in the March 1949 issue of *Arizona Highways* piqued their curiosity. They also had seen ceramics that De Grazia had painted in several friends' homes. The Saunderses wanted to sell them in their

gallery along with a few of his prints. De Grazia agreed, and he and Buck Saunders shook hands—the only "contract" they ever had.[38]

The ceramics and prints sold so well that customers started seeking De Grazia originals, so the Saunderses set up a one-man show on February 5, 1950. The night before the show, De Grazia repainted the walls of the Saunderses' gallery with colors he thought were better suited to show off his artwork. Then he hung his paintings, the most expensive of which carried a price tag of $350. The show proved to be a tremendous success, with an estimated one thousand to fifteen hundred people turning out.

Maggie Wilson, a young newspaper reporter who covered the event, recalled that De Grazia had gone beforehand to Nogales, Sonora, Mexico, to buy tequila—which cost much less than in Arizona—to put in a punch. At that time, wealthy women would visit Elizabeth Arden's Maine Chance Spa in Scottsdale to lose weight or dry out from too much drinking. Several of the women pulled up in limousines in front of the Saunderses' gallery. When word got out about the women, dozens of other people who were curious to see them showed up and visited the gallery as well.

The tequila punch proved to be so popular that the Saunderses had to make batch after batch. Wilson recalled that "the whole town of Scottsdale ran out of ice. Buck and Leo[barda] were running back and forth to the Pink Pony, or whatever was open, begging ice." Wilson said flashbulbs were "smashed into the concrete floors, the walls were practically bare, and one would have to suggest that that had been a very successful show."[39]

At day's end De Grazia pocketed $1,500 for his artwork—more than $14,000 in 2011 dollars. The show's success started a business relationship between De Grazia and Saunderses that lasted thirty years. They also became good friends.[40]

"You know, artists come into my gallery all the time wanting me to sell their work, but they'll sneer at Ted's stuff and tell me it's commercial," Buck Saunders said years later. "So I reply, 'Then what the hell are you doing here?' I guess those guys think art is for the select few, and it's no damn good if plain people everywhere desire it and love it. I said thirty years ago, and I still say, that De Grazia is one of the few hard-working, really creative artists America has

produced in this century. He paints emotion and feelings, not the formula stuff of the academicians."

Saunders also said that he had met many famous artists in his years as a gallery owner, but he admired De Grazia the most. "I don't think people have ever truly appreciated this man. He was a brilliant artist. . . . A lot of people have criticized De Grazia for all his 'gadgetries' as they call it. He has never been appreciated by the academician or by the art world. They don't understand the amount of creativity that the man had."[41]

In 1949, De Grazia traveled to Altar Valley, a forty-five-mile stretch of land southwest of Tucson and north of Sasabe, Arizona, near the border with Mexico. He walked where Father Eusebio Kino, a Roman Catholic priest and an Italian, once walked and rode in the late 1600s and early 1700s on his way to building twenty-four missions in what is now the Southwestern United States and northern Mexico as refuges for Indians. "He was a cowboy of God," De Grazia said.[42]

He spoke at length about Father Kino's missions with the Indians living in Altar Valley, gathering research for a book. While there De Grazia also had a dream: that he, too, would build a mission, a tribute to the Virgin of Guadalupe, in the Catalina Foothills of Tucson. He would use native materials, much as Father Kino did when he built his missions. Fulfillment of that dream didn't come until 1954, but fulfill it he did.[43]

11

Coming into His Own

He seems to go into an orgasm of creation,
becoming as a man possessed of a demon.
—*Loda Mae Davis*[1]

DURING THE EARLY YEARS of Ted and Marion's marriage, they
traveled together throughout northern Mexico and the Indian coun-
try of Arizona and New Mexico. His fascination with the desert as
well as its people led him to write in a journal that the "desert is
spiritual, mysterious and religious. It is a big dream around a dream.
Walk away from people into the desert, and soon you will find a
deadly silence, loneliness, a vast emptiness. It is almost frightening.
Then suddenly, like magic, you are not alone. Around you is felt a
stirring of life, you have a feeling of a living desert, a very old desert."[2]

The desert provided copious creative material for De Grazia's lively
imagination. He used the ends of the arms of dying saguaro cacti,
for example, to make bowls. He would place each of the ends into a
mold filled with plaster of paris. After the plaster dried, he scooped
out the saguaro, which left its imprint in the mold. He then poured
liquid potter's clay, which must be fired at 2,000 degrees Fahrenheit,
into the mold. As soon as the clay dried enough to pull away from
the mold's sides, it was ready to be taken out of the mold. De Grazia
painted the bowls with pigments he made himself, applying them
with a dime-store brush. He also made his own glaze—pulverized
glass in a water solution.[3] De Grazia made most of his meager living in
the early years peddling this pottery, until his paintings began to sell.[4]

Figure 19. De Grazia created molds out of the ends of saguaro cactus to make bowls.

Once he took several of the saguaro bowls to a Junior Chamber of Commerce function in Old Tucson at which craftspeople sold their wares. Buyers flocked to the room where De Grazia's ceramics were displayed. Chamber member John Alexander, De Grazia's old friend from his Bisbee days, saw what looked like a Mexican dressed "like a bum." Then he realized that the "bum" was De Grazia. "Ted, what in the heck happened to you? You look like you came from Mexico out of one of the fields or someplace down there." De Grazia looked up and said, "Sh, John, don't talk so loud. I found out this [attire] sells the stuff. Tourists buy this stuff."[5]

During this time De Grazia also began experimenting with hand-painted ceramic tiles depicting bullfighting, views of a mountain, and Indian symbols.[6] The tiles became a huge moneymaker in later years.

As he had in childhood, De Grazia continued to play with making pigments out of whatever he found around him in nature. In one case he used cochineal, the dried bodies of tiny, black, soft-bodied female insects that cluster on prickly-pear cactus pads. Cochineal nymphs secrete a waxy substance over their bodies that appears on host cacti

Figure 20. De Grazia gets ready to fire bowls in a kiln.

pads as a spongy, white, weblike covering. De Grazia roasted or boiled the insects down. Once dried, he put them in water, and a deep pink color came out. "Finally you boil the water away or let it evaporate," De Grazia said. "Presto. De Grazia pink. . . . It is a beautiful color, and women can't resist it."[7] De Grazia can't take credit for discovering how to manufacture the color, however. Cochineal has been used since the fifteenth century to make dyes and is still used today to make food coloring and cosmetics.[8]

"You could never make a living [using] the stuff," he said. "It just takes much too long to gather from the prickly pear. An Indian friend and I spent an entire day a few weeks ago collecting it. . . . We worked hard, and all we got was about four ounces worth."[9] Today, farms dedicated to raising the insects use a process that makes the gathering easier.[10]

In October 1951, De Grazia had a show at a Beverly Hills gallery that critics raved about. "Seldom have I been so excited over the work

Figure 21. De Grazia carefully scrapes away cochineal from a prickly pear cactus.

of a new artist as when I first set eyes on paintings by De Grazia," said Gladys Robinson, the wife of actor Edward G. Robinson and herself an artist as well as an actress. "He captures the elusive and exotic charm of Rivera and [Mexican artist José Miguel] Covarrubias but retains his own strong personality." She noted that she had recently taken some of De Grazia's paintings with her to Paris, where they were enthusiastically received. "I am sure that with his scope *Señor* De Grazia will capture a permanent place for his work in the art world." Mrs. Robinson's addressing De Grazia as "señor" wasn't the first time, nor would it be the last, for him to be mistaken as someone of Mexican descent. He didn't object.[11]

Alfred Frankenstein of the *San Francisco Chronicle* admired De Grazia's work, as well. He wrote after a San Francisco reception

for De Grazia in the 1950s: "In a time when art feels so much called upon to sound the epic note and 'disturbing' has become one of the jargon words to connote success, it is especially pleasant to find a painter who is neither epical or disturbing, who is very sensitive to the material of art and can be completely delightful."[12]

But De Grazia didn't think much of such rave reviews from California critics. Upon his return to Tucson he told a reporter for the *Tucson Daily Citizen*, "They are nothing but a bunch of phoneys. . . . I'm going to stay here and paint, and Hollywood can come over here or it can stay there. Even the air is phoney."[13] He never stuck to that threat, though, repeatedly going to California over the years for shows.

Artist Ross Santee gave De Grazia this advice: "When you put your name on any work, that is a piece of your hide up there for anyone to see and like or hate, so only paint and show what is really you and then accept what the public says. Ignore the critics and professors. They can't sell, so they gripe."[14]

During the decade of the 1950s De Grazia traveled off and on throughout Mexico, even dipping down into Guatemala. Because of increasing demand for his work, he began experimenting with serigraphs, also known as silk screens, in order to do his own printing and thereby enhance his income while also creating affordable art. He focused on Mexicans and Guatemalans, drawing sketches on silk and then squeezing the color through the silk onto paper. He soon tired of them, though, and moved on.[15]

During the same decade De Grazia earned acclaim for his original patio dresses on which he hand-painted Yaqui-, Apache-, and Papago-inspired designs. The dresses, set off with jewelry that De Grazia also designed, proved to be a big hit, selling for $5.98 and $7.98 at Steinfeld department store's annual "parade of fashion" in downtown Tucson. Word of the unusual dresses eventually reached the New York textile world, resulting in eight of De Grazia's Indian-inspired designs being reproduced on circle skirts that were sold nationwide.[16] Abe Blumberg, a representative of a New York textile company, said, "I don't think the American woman has seen anything like it before. And I'm sure they will find the scenes and the colors irresistible."[17] An article about the skirts appeared in *Women's Wear Daily*, which noted that Levy's department store in Tucson sold one hundred of them in the first two hours after they went on sale. Having De Grazia show up to autograph the

skirts when Levy's opened that day no doubt helped encourage sales. Levy's received the very first shipment of the skirts, specially flown in. The *Women's Wear Daily* article featured photos of two women, one of them De Grazia's daughter Lucia, wearing the skirts.[18]

Between 1949 and 1953 a freelance photographer, Charles W. Herbert, took 16mm movies of De Grazia that were shown in a seven-minute segment on NBC TV's popular program *Watch the World*. This gave De Grazia the national exposure he craved. The grainy black-and-white segment from the early years of television showed him making ceramics, painting, and panning for gold. It also showed cowgirls shopping in Steinfeld's department store for De Grazia's patio dresses.[19]

The next fall, buyers from Saint Louis, Missouri, department stores descended upon Tucson to purchase western wear, some of which De Grazia designed. Said one buyer, "I have no doubt that the colorful, exciting and sound designs you are producing here will have great attention for eastern women." One of the department stores planned to build a replica of De Grazia's studio in its front window to attract attention to the artist's skirts. "I'm excited and pleased with what I've found here," the buyer said. A thrilled De Grazia remarked that the designs "are timeless . . . and should fit anywhere. The colors are the true colors of the desert and not spoiled by man. Maybe that's why we enjoy them so."[20]

De Grazia also found time in 1952 to put together a twelve-page booklet called *The Flute Player*, inspired by the ancient Hohokam Indians. The illustrations featured a sunflower dance, a yucca dance, a coyote dance, and a dance of death. Influential archeologist Emil Haury, head of the anthropology department at the University of Arizona, praised De Grazia's use of pottery fragments to develop the dance depictions. "As an archaeologist, I am glad to see that kind of notice given to materials which the professional is forced to present in objective terms." The booklet launched De Grazia's lucrative and extensive venture into publishing, in particular self-publishing under the Gallery in the Sun imprint.[21]

Loda Mae Davis, dean of women at the University of California, Riverside, became one of De Grazia's boosters after seeing some of his art. She wrote several articles about his work. "Watching De Grazia at work is an amazing experience," she wrote in one article. "The speed with which a painting blooms before your eyes is a mystery

to anyone not familiar with the spontaneity and speed with which genius works. . . . He shuns people and isolates himself in his studio. He paints from his mind, not from models. Although he has a penetrating intellect, everything he creates is dominated by his emotions. With the simple honesty of an unspoiled child, he sees life without its veils, but with its soul."[22]

De Grazia's paintings started to change in the late 1940s and early '50s, and critics noticed. Byrd Stanley, writing in the *Tucson Daily Citizen*, observed that De Grazia's paintings were becoming "lighter and happier and occasionally ethereal." The remarks came as De Grazia opened his first show in 1952 at his Tucson studio. The new paintings showcased the mostly faceless Mexican children who became his trademark, doing everyday tasks among tropical flowers. One showed three children walking single file, the two little girls carrying flowers while the boy held a rooster. Another featured a flower market with a tentlike canvas top and small wagons overflowing with flowers.

Stanley called the new work "smoother, and his palette is thinner, the colors much more delicate. . . . Perhaps there is less strength here. But why should I begrudge an artist a tender, happy summer mood?"[23]

De Grazia may have thought he was overdoing it with paintings of children. "For a long time I said I was not going to paint any children," he said. "Then I go to Guatemala and standing on a corner is beautiful little girl about six or seven years old boiling coffee. I like that beloved little girl, and I just had to paint children again."[24] In the words of Marion:

> *I was thinking*
> *that if we had marched*
> *down the aisle*
> *with a flower boy*
> *and a flower girl*
> *they would have gone away.*
> *But since they did not*
> *They came looking for us* [25]

De Grazia revealed his charitable side as years rolled by and money poured in. Once he a made a huge ceramic bowl decorated with depictions of children. When he gave it to an aide of a group helping to raise money for a children's home near an Indian reservation, she

Grazia it would bring in hundreds of dollars. De Grazia took the bowl back from her and smashed it to the ground before the astonished woman. "Now it will bring thousands," he said. A writer for *Arizona Highways* wrote an article about the incident. As a result of the publicity, people from all over the world sent in money for a shard of the bowl, and donations eventually reached $100,000.[26]

De Grazia also helped people very privately. He bailed his Indian friends out of jail. He made mortgage payments, paid for scholarships, and helped out with hospital bills.[27] "I know scores of Yaquis, Papagos, and Apaches who would be dead or uneducated if it were not for Ted's generosity," said Dick Frontain. "And it was those people who gave Ted his happiest moments."[28]

Once in Mexico he met a couple who were expecting their first child. They wanted to have the baby in the United States so it would have dual citizenship. De Grazia told them to cross the border to have the baby and to tell hospital personnel that he would pay the bill. "Hell, it was nothing to me," he said. "But having American citizenship might mean a lot to that kid, might be a needed break later on."[29]

He also paid all expenses for Raymond Carlson, the longtime friend who had launched De Grazia's career through *Arizona Highways*, when the impoverished Carlson had to move into a nursing home in 1971, suffering from alcohol-induced dementia. Carlson died in 1983 at the age of seventy-six, five months after De Grazia. De Grazia had previously set up a $60,000 trust fund in Carlson's name to pay for his care.[30]

In 1961 De Grazia offered to help Delia Figueroa, a tenant in his North Campbell Avenue complex, whose seventeen-year-old son had drowned. "Delia, if you ever need money, I have some saved for special occasions like this. I have it." Although Figueroa did not need the financial help, she said she never forgot De Grazia's offer.[31]

As a special guest at a Christmas luncheon put on by the Heard Museum Guild in Phoenix, De Grazia did a "one-minute scratch" that the guild auctioned off. He drew an angel, "bzzzzt, that fast, put a little color around it, used his favorite pink in it, and the bidding went up and up," said guild member Louise DeWald. She couldn't recall how high the bidding went, but she did remember that people remarked how they couldn't believe anyone would spend that much money on a painting done so fast. "I saw him do that two or three times for a good cause," DeWald said.[32]

De Grazia donated more than paintings and money to organizations. He gave time as well. He visited Tucson schools on many occasions, for example, and painted pictures to music. Fred Landeen said the children loved him. "He was so easy. And they'd sit around on the floor and talk." School officials often requested De Grazia's presence in their classrooms, and he accepted, not wanting to disappoint the children, Landeen said.[33] An elementary school in the Marana district just north of Tucson is named in De Grazia's honor.

De Grazia never ran short of his ever-ready supply of ego—and sarcasm. When he became a critic himself, taking on local painters in a July 7, 1952, *Tucson Daily Citizen* column, the headline read, "Artist De Grazia Thinks Painters Should Paint." Writing in the third person, De Grazia said painters should be painting, not talking. "De Grazia has no time to discuss painting. De Grazia is busy painting." He said most Tucson painters were tired. "They're so tired they have lost their virility." With a touch of braggadocio and prophecy, he said he was "the only painter around here whose work will live. All the other painters and their canvases will be gone and forgotten long before De Grazia is gone. He'll never be forgotten."

Then he hurled a not-so-veiled threat about lack of acceptance by his own hometown. He said he didn't believe in jury selection for art exhibits; he would never submit to one, and the "Lord is the only true judge of his work. If De Grazia isn't recognized at home then he will go somewhere else. They're plenty glad to see his shows other places." He claimed that he preferred to avoid the humiliation of submitting his work, only to have it rejected by a jury whose members he didn't respect.[34]

In the 1950s, a more prosperous America began taking to the road to search out adventures on newly built highways stretching from coast to coast. Gorgeous pictures of Arizona's scenic beauty in *Arizona Highways* fueled the state's burgeoning tourist industry, with the bonus of occasional features on De Grazia's paintings and illustrations. He knew he could sell more paintings if he could tap into the growing market created by Tucson's influx of vacationing visitors.

For the tourist trade, De Grazia made available a wide array of lithographs that the visitors could afford. He even created and sold inexpensive ceramics and knickknacks like magnets as souvenirs for

people stretching their budgets during summer vacations. His ceramics grew in demand so much they eventually were cast in Japan and sent to De Grazia, who put his name on them.[35]

One incident convinced De Grazia to make his work so affordable that even a child could own it. In Rosita's restaurant in the Campbell Avenue complex one day, he noticed a little girl gazing with longing at his paintings on the wall. He heard her mother tell her that she could either have lunch or the painting but not both. De Grazia didn't want her to miss her lunch, so he gave her the painting.[36]

He went so far as to have playing cards and jigsaw puzzles made with his art on them. "If people like it, it's going to make them happy playing bridge while they're looking at my art. What's wrong with it?"[37] The inexpensive souvenirs paid off handsomely, as sales mounted to tens of thousands of easy dollars. "Those who knew Ted De Grazia are aware of his philosophy that art in any form, no matter how simple, produced a creative partnership with the public," said a winter 2003 newsletter from the Gallery in the Sun reminiscing on that time.[38]

A young man surprised De Grazia one day when he approached the artist at work in his ceramic studio. He told De Grazia that he—meaning De Grazia—might need art lessons. The young man said he represented the Famous Artists' School and proceeded to try to sell De Grazia on how he could become a famous artist. He told De Grazia that if he were an artist he wouldn't be stirring a bucket of clay. Then De Grazia asked him, "Why did you happen to call on me?" The young man handed him a card that had been sent to him, which said De Grazia needed some art lessons. "Right away," De Grazia said, "I recognized my wife's handwriting on the card. So that was it. My wife was playing one of her jokes on me."[39]

In the mid-1950s a freelance writer for *Newsweek* magazine, Bud DeWald, traveled from Phoenix to Tucson to do a story on De Grazia. He brought along his wife, Louise. They spent a day at De Grazia's studio while Bud interviewed him about his life and work. De Grazia came up with all the usual fare—long years at the university, the struggles to be recognized, the work with Rivera and Orozco.

He also threw in a couple of his improbable anecdotes.

One had him taking a break from the university—one of many—to travel around Mexico. He had grown a beard, he said, and wore a

crucifix around his neck. A small tribe saw him as the reincarnation of Jesus Christ. Supposedly the chief, flattered that Jesus would come to his tribe, gave De Grazia his daughter as a wife and set him up as a god. De Grazia claimed the tribe held him captive for six weeks. He wanted to break away but feared they would recapture him, and he didn't know what they might do. Then, he said, a small group of American hunters rescued him.[40]

Another story had it that when De Grazia told his first wife-to-be's father that he painted, Nick Diamos replied, "Good, I need someone to paint the walls." De Grazia, hating the idea of himself as a common house painter, did it anyway—painting each wall a different color. "And that took care of that. He was out of there," Louise DeWald recalled De Grazia saying.[41]

De Grazia also told the DeWalds the whopper that he had experimented at his North Campbell Avenue gallery with what he called "aviculture." He claimed to be feeding chickens that were running around the studio a specially prepared ration with dye in it so the chickens would lay predyed Easter eggs. "Then I won't have to have the mess of boiling up those eggs," he said.[42]

A skeptical Bud DeWald left that yarn out of his article, but *Newsweek* editors cut his long story about De Grazia's life to about two inches, accompanied by De Grazia's picture. De Grazia ripped out the article, pasted it to a bigger piece of paper, wrote, "Phooey," at the bottom, and mailed it to the DeWalds. Bud "was as mad as Ted was, and normally he had enough perception, having worked around the country, of what *Newsweek* would want, but they just—they didn't think he was big news," Louise said. The next time the DeWalds approached De Grazia about a story, he dismissed them with, "Well, I don't know. I've said everything I need to say to you. Just look at your notes." As things evolved, though, the DeWalds eventually became good friends of the De Grazias.[43]

12

On a Mission

Religion now-a-days is intellectual and
not spiritual—and that I think is bad.
—*De Grazia*[1]

BY THE EARLY 1950S, Tucson's rapid growth so aggravated De Grazia that he wanted to get out of the "crowded" city closing in on him and into the open spaces of the Santa Catalina Mountains north of the city.

From that momentous day in Altar Valley when he had first dreamed about building a mission, he had spent hours hiking throughout the Catalina Foothills looking for the right spot for it. He wanted to build a mission like the small shrines he often found in Mexican towns and villages.[2] He finally found the place, ten acres off Pontatoc Road along what is now Swan Road. He paid $2,300 for the land, which was divided by a small wash, and began construction in the spring of 1952.[3] Marion wrote of his relationship with the land:

> *The desert was all his as far as the eye could see.*
> *There it was beautiful.*
> *It was quiet. He did not disturb the desert.*
> *He became a part of it.*[4]

On December 12, 1952, De Grazia and his Indian friends paid their first tribute to Our Lady of Guadalupe with a small celebration. After placing candles along the unfinished mission walls, they played music and feasted on tamales and tequila.[5]

A year later, De Grazia said the mission would soon be completed, "if I have enough time and money and energy and if Uncle Sam leaves me alone." De Grazia used natural materials to construct the mission—some of it rocks from Morenci—much as craftsmen from centuries earlier had done.

Water was scarce on the foothills site, except for rainwater De Grazia managed to collect. To make adobe for the walls, he used his beat-up, rusty Model A with a rumble seat to haul water in fifty-gallon barrels from his Campbell studio. He followed Campbell to River Road; drove four miles east to Pontatoc Road; then took a dirt road. After that he drove his own road, which he'd had to create, to get to his property. He called it the Iron Door Mine Road.[6] He even posted signs with his name on them that pointed toward his property.[7] Visitors had to bring five gallons of water every time they came to the site. "There were no amenities there at all," said Fred Landeen.[8]

Years later, Karen Thure, a freelance writer, and her husband visited the Swan Road gallery. "God, those studios were uncomfortable. . . . I mean, little mice running around the place, and dust and

Figure 22. De Grazia hauled wood and water to his Swan Road site in the rumble seat of his Ford.

cobwebs . . . not just filthy but definitely debris and the helter-skelter detritus of a brilliant mind that didn't care about all the detail. . . . It was all very impulsive the way he lived."[9]

No church ever consecrated De Grazia's mission. He was a religious man—but not a churchgoing one. He saw God in the world around him. God "is a man whom I worship," De Grazia said. "I admire his righteousness. I take and ask for no favors from him."[10] Later he would say, "Personally I will accept what God deals to me without question. I pray because I was taught to pray. I pray my way, not the way they teach. I pray inside of me. I believe everybody prays. But I don't ask favors. In other words, I don't want Him to spare me while others must suffer."[11]

Rick Brown said that while he thought De Grazia was a very religious man, he had his "own things that he believed."[12] Rita Davenport, who wrote a cookbook that De Grazia illustrated in 1973, agreed that he had a "religiosity" about him. "I just know he believed in God and he was very spiritual and that's the reason he built" the mission, she said. "He built that to thank God for what he'd done, to give back some of the blessings."[13]

De Grazia built the mission in honor of Our Lady of Guadalupe, the Roman Catholic icon of the Virgin Mary. Our Lady of Guadalupe is the patroness of the Americas; she is also a traditional and powerful symbol for Mexicans and Mexican-Americans. De Grazia later called the mission his most durable and important piece of art.[14] "The mission will have no functional purpose," he said. "It will be a place of beauty where I can go and hide."[15] As Marion observed:

The city down in the valley with all of the easy ways of living and building were not there. It was make it on your own. Making it on your own is significant. It is unique. Fortunately, the city planners had not made their way into the foothills.[16]

De Grazia's Yaqui friends, who knew how to make adobe, helped him with the construction, for which he drew up no plans. He and Don José Miranda, Chief Loretto, and Juan Nuñez-Opara would strip to the waist and work in the broiling sun, sweat dripping from every pore. They would stop for a lunch of beans and tortillas washed down with tequila; De Grazia claimed that the liquor kept them

Figure 23. De Grazia shovels "mud" while building the mission.

cool.[17] He gave the Yaquis a hut to stay in. At times they caught desert tortoises and made soup out of them.[18]

They managed to finish the eighteen-by-forty-foot chapel around Easter 1954, almost two years after work started. The building has walls of plastered adobe with candle niches and no windows, except for a small window with an exposed lintel in the bell tower. The belfry is crowned by a large cross of saguaro ribs.

De Grazia painted murals on the inside walls using contemporary Indians and Mexicans as models. Joining angels and the Virgin of Guadalupe are a clown, a cockfight, Father Eusebio Kino on a horse,

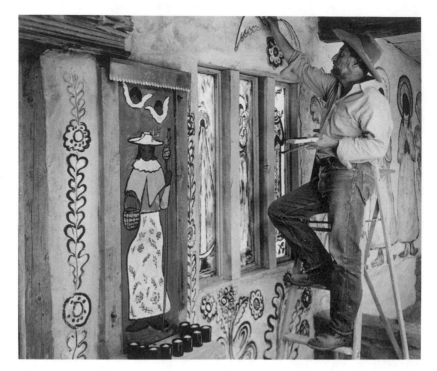

Figure 24. De Grazia paints a mural on a mission wall.

a Yaqui deer dancer, and musicians and children with candles and
flowers. "The mural paintings are intrinsic to the Mission and trans-
form the building into an art-historical document of irreplaceable
significance," a National Park Service representative wrote while eval-
uating the De Grazia campus for inclusion in the National Register
of Historic Places.[19]

De Grazia welcomed visitors to the mission as long as they left
the desert alone. He wasn't sure what the mission's future might
be—for weddings, perhaps. Today, more than sixty years later, over
one hundred weddings a year are held in the mission.[20]

The mission has an opening in the roof to "let in God"—and the
sun and rain. It opened to the sky, De Grazia said, because "you can't
close up God in a stuffy room."[21] Hand-hewn mesquite benches and
a built-in adobe bench stretch the length of the mission's east wall.
Cement and river rock make up the floor. De Grazia also painted a
brightly colored and youthful Juan Diego, who in 1531 built the first

church to Our Lady of Guadalupe, at the age of fifty-seven. "I think of him as a youngster, so that's the way I paint him," he said.[22]

Author La Verne Harrell Clark remembered that one evening about five o'clock, as she and her husband, L. D. Clark, were sitting with Marion and Ted on a patio near the mission, De Grazia told her to look up at a particular rock in the Catalinas. He asked her what she saw. "You could see the Virgin there [in that rock], or you could make it out," she said. Years later she was attending De Grazia's funeral in the same place. When the service ended about five o'clock, she looked up again at the rock and saw the Virgin, and "I thought of that."[23]

Despite the mission's location in the rough desert foothills, people would visit this curiosity in the middle of nowhere. Guests from a nearby dude ranch called the Flying V rode horses to the site. "You'd be surprised how many people found their way up there, all kinds of people," Marion said.[24]

De Grazia put a coin box near the entrance to the mission where visitors often left money, which he gave to a priest in a South Tucson church. Several times the artist asked the priest to visit the mission, but the priest never found the time. "Father, don't you really want to see where this money is coming from?" De Grazia asked. The priest still didn't come. Finally, De Grazia decided to put the money in a bank account in the name of the Virgin of Guadalupe. "When I need to spend some of that money I just ask her, and since she doesn't say anything I know it's all right," he said.[25]

For fifteen years after the mission opened, De Grazia lighted candles in and around the chapel on December 11, the eve of the anniversary of the patron saint's appearance. The event brought such hordes of people that police had to be brought in to control traffic. Since the visitors acted as though they were at a party instead of celebrating the true meaning of the feast day, De Grazia canceled future commemorations in 1975. After complaints that he couldn't end a tradition, De Grazia remarked, "If I started a tradition I sure as hell could break it."[26] Today, every December, the DeGrazia Foundation once again celebrates La Fiesta de Guadalupe, with Yaqui dancers, music, and food.

The mission caught the notice of the prestigious publication *Architectural Record*. In its December 1957 edition, under the headline of "The Power of Positive Space," the article noted, "Only infrequently

have we organized spaces for worship as powerful as the richly sim-
ple Mission of Guadalupe recently completed in Arizona by Indian
worshippers under the direction of painter Ettore de Grazia."[27] As
Marion mused:

> *Dreams may be fleeting. Dreams may be reality.*
> *Blessed be the dreams whose dreams realized enhance our lives.*[28]

The mission was the first of fifteen structures that De Grazia even-
tually built on the foothills property, which has ended up on the
National Register of Historic Places, and plays host to thousands of
visitors a year.

De Grazia later built a home near the mission where he could live
far from the studio at Campbell and Prince, which over time had
begun to hem him in. Again he solicited the help of his Yaqui friends,
and together they put up three separate spaces that totaled 1,754
square feet under one roof. The 821-square-foot house, consisting
of a bedroom, a kitchen, and a main living area featuring a beehive
fireplace for heat, became the De Grazias' residence from 1952 to
1965. The interior walls were covered with stucco and painted with
a series of overlaid colors. "I use plaster with rough gravel—heavy
on the cement and not much lime," De Grazia wrote in *Mountain
States Architecture* magazine in 1966. "This produces a severe tex-
ture. Then, while the plaster is still wet, I paint it with at least three
colors, sometimes as many as six. Colors are used to achieve the
counterpart of the structure, to soften the walls. The result is that
they come alive. They sing and exude beauty."[29]

De Grazia built the 714-square-foot Little Gallery, which is part of
the overall structure and fits in with its architectural style, as a studio
and exhibition space for guest artists. Today, it is still used for that
purpose. The gallery is thirty-five feet long, twelve feet across the
front, and six feet wide at the rear. The configuration allows art to
be hung in a manner that attracts maximum attention.

The third structure under the umbrella of the building was Ber-
nardino's Hideaway, so named and built for the Yaqui Bernardino
Valencia, who often provided flute music for the artist's painting and
autograph parties. Known commonly by his first name, Bernardino
rarely stayed in the 160-square-foot studio, however.

In 1954 De Grazia used concrete block, railroad ties, and mortar to build a 453-square-foot ceramics studio behind his house. That same year he constructed the Island House for his drinking buddy, Ross Santee, an acclaimed painter in his own right. "When Ross Santee is with other artists, he always calls himself a writer, not a painter," De Grazia said. "But he's a painter through and through, a fine painter, and a true *amigo*."[30]

The 700-square-foot house rested on high ground in the middle of a wash that filled with rapidly moving water during summer thunderstorms. The house had three rooms and a beehive fireplace. *Arizona Highways* writer Maggie Wilson called the house a work of art. "Some of the windows were decorated with De Grazia's early stained glass; the dishes were De Grazia creations of brown with an inside glaze of turquoise blue; the shower stall was painted all around with larger-than-life angels and wind bells. It was a little house so imbued with artistic creativity it could raise one's spirits just to be

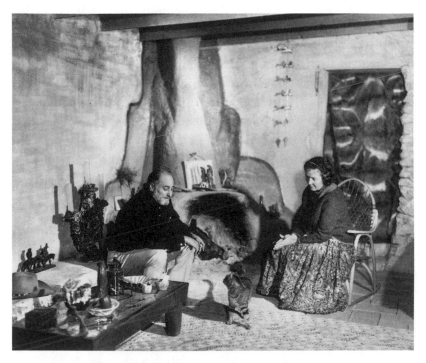

Figure 25. Ted and Marion relax by the fireplace in the first home on the Swan Road property.

there."[31] The dilapidated house was razed years later after it became an attractive nuisance.

In 1955 De Grazia built a 422-square-foot structure originally intended to serve as a workshop but later remodeled into a guest-house with living quarters, kitchen, bathroom, and beehive fireplace. The house eventually became known as Brian's House, named for Brian Domino, a seventh-grade boy De Grazia met in mid-1977. Domino sold newspapers near a hardware store down the hill from the De Grazia property at North Swan Road and East Skyline Drive. One day De Grazia bought a paper from the boy, who afterward told his parents, "I think I sold a paper to someone famous today."[32]

Domino was selling newspapers to try to raise $3,000 to buy a computer. His father, a psychology professor at the University of Arizona, said he would put up half of the money for the computer if Brian raised the rest. Brian's willingness to work for what he wanted so impressed De Grazia that he offered the boy a job sweeping floors at the Gallery in the Sun for $2 an hour.

Later, Domino moved into the guesthouse while attending the University of Arizona. De Grazia let him stay rent free because he liked having someone on the property when he and Marion were away. De Grazia might even have thought of Domino as a second son; the young man's Italian heritage didn't hurt the chance of his being regarded that way. De Grazia certainly became a grandfather figure to Domino. The young man had a grandfather who lived on the East Coast, but he said he had "no language in common with the other." He said he loved his maternal and paternal grandfathers, but De Grazia "filled an important gap in my life."[33]

Domino also had a close relationship with Marion, which is some-what surprising in that she didn't care for boys. After De Grazia's death she wrote in her poetic musings four rather strange "letters" that were addressed to her and "signed" by Domino.[34] Today Brian Domino is an associate professor of philosophy at Miami University of Ohio.

Next on the property came the Ghost House in 1956, so called because it was supposedly haunted: a two-room, L-shaped, 753-square-foot structure used for producing wax sculptures. It later became another guesthouse. Marion observed:

*The building did not cease. There were more studios, a place to
live, and of course more doors, doors, doors. It seemed an obsession.
Maybe the first doors in his life enclosed him. These many doors were
open. Never enclose a creative one.*[35]

In 1960 De Grazia built the Gate House at the entrance to the
property. It eventually served as a residence for his son, Nick. The
house was tiny, all of 480 square feet, divided into four rooms and
with a beehive fireplace.

Living so close to each other must have been difficult for father
and son, as they had become estranged after Ted's and Alexandra's
divorce. In 1961 Nick, twenty-one, apparently moved into the Gate
House after a run-in with the law. He had been placed in the Pima
County Hospital's psychiatric ward for observation after he beat his
five-week-old daughter, Michelle, with a belt. He also hit the baby's
mother, Andrea, and his own mother, Alexandra, in the face.

Nick escaped from the ward wearing only pajamas and slippers.
After his apprehension three days later, he became a patient at the
Arizona State Hospital in Phoenix. When he was released in Septem-
ber, he returned home. Shortly thereafter police arrested him again
on charges that he beat his wife with a shoe and forced her to shave
her head. He apparently had become angry because their then five-
month-old daughter cried when he played with her. He was booked
into Pima County Jail and held on $1,000 bail.

On November 21, Superior Court Judge Herbert F. Krucker placed
Nick on probation for four years on condition that he live with his
father. A court-appointed attorney, Lew Murphy, later to become
Tucson's mayor, represented Nick. Psychiatric reports were mixed,
with one doctor stating that Nick needed psychiatric treatment and
another calling him emotionally immature. Nick's mother thought
he was psychotic, while his father did not. In five news stories in the
Arizona Daily Star and the *Tucson Daily Citizen*, only one named
Nick's father, with a passing reference to "the artist, Ted De Grazia."[36]

Nick De Grazia apparently stayed out of trouble with the law
the rest of his life, although he exhibited a drinking problem over
the years. He and Andrea divorced in 1976. He never held a steady
job, seeming to lack the drive, ambition, discipline, and intellectual

curiosity of his father. Ted found that very frustrating.[37] Nick tried boxing as well as rodeo riding, with modest success. He claimed he could have been good as a boxer, exaggerating in a manner much like his father's that "there'd be a lot of world champions that you never would have heard of, because I would have stomped them before round five."[38]

In the spring of 1964 Nick cast seven bronze figures, each five and a half inches by eight inches, of rodeo events. He planned to make twenty copies of each one and sell them for $400 apiece.[39] His father paid to have them cast. He also wrote and illustrated a coloring book for children called *Little Indian Coloring Book*, published by Bushroe Enterprises in 1964. His sister, Kathy Bushroe, and her husband apparently financed the book. He also illustrated *La Posada: A Christmas Story*, a thirty-two-page book written by James H. Fraser and published by Northland Press of Flagstaff, Arizona.

Nick and his father never patched up their differences. In March 1980, when Ted kicked Nick out of an apartment in the old studio because it needed major repairs, an embittered Nick pleaded with his father to let him remain there. "Hey, back off," he told Ted. "We'll both benefit from [letting me stay]. You won't look like a scrooge, and I'll have a place to stay." But Ted said he didn't care.[40]

Nick believed he was evicted because he couldn't pay the $125 monthly rent. Ted said he gave his son money. "Everybody gets money from me," he said, adding that Nick "can stay with me, or he can stay in his car. A lot of people live in cars. What's so unusual about that?" Nick replied, "My father is ruining my chances to make a living. We've never been on good terms. All dad wants to do is sign autographs and meet people with money."

Nick found living in his father's shadow extremely difficult. "People know you for it. Somebody'll say, 'Don't paint like your dad—do Western art.' So I do Western art for a while. Then they start saying, 'Why don't you paint like your dad?'" When he did paint like his father, he said, De Grazia told him to stop. "He said I was making it hard for him to make a living. I guess he wants to go down in history as the Great Zucchini himself. He wants to live another million years through his artwork. But he's had his chance. I'm [forty-two] years old. It's time for me to do something."[41]

Ted De Grazia's early hardscrabble life made him appreciate the value of money and hard work, but he could never bring Nick around to that kind of thinking. Ted "knew what money was, how hard it was to come by," said Delia Figueroa. "He didn't want to show Nick that because he had money that it was going to be easy for him."[42]

Nick did stay in his car until a friend offered him a studio apartment off West Drachman Street, rent free, for a year. "I found Nick sleeping in his car in the cold," said Alberto Contreras. "It was the lowest point he had ever reached. Tears were rolling down his cheeks, but he was still *macho*."[43]

Two days after Ted died, Nick told a reporter, "He could be a very little man about these things, very childish. . . . This is what I didn't like about him." Nick said his father taught him to paint, but "he didn't want to see me make it. I think he was jealous. He wanted to be the first and last word in the art world. He wouldn't do anything to help me." Nick often painted pictures that resembled his father's work and signed them like his father with the distinctive De Grazia scrawl in hopes of bringing a better price.

At age forty-two Nick De Grazia told a newspaper reporter that he had quit drinking and smoking and talked again of pursuing a boxing career. He closed off the interview by saying he doubted he would go to his father's funeral. "I figure I'd be a hypocrite if I did go. He wasn't anybody I was close to."[44]

Nick De Grazia died January 15, 2001, at the age of sixty-one. He never got out of his father's shadow.

The publicity De Grazia received for evicting Nick troubled him. He said it invaded his privacy. "When I threw my son out, the news made front page reading on newspapers all over the country." That was an exaggeration, of course, but it was covered extensively by Tucson newspapers, and the Associated Press sent an article out on its national wire. "What is the importance of correcting your offspring— most people do it on a daily basis no matter how old their child is. . . . I like to think I'm a human being and I can make as many mistakes as the other guy, even though people think I am supposed to be perfect. . . . The most important thing in my life is my work. While work is important to me, I can't go anywhere as a human being without being recognized. I am willing to pay the price of being a human

being, but not of being a celebrity. . . . The image people have of me
is that I am a big shot, but I don't care what people think anymore.
People don't know the real Ted De Grazia, but it doesn't matter. I
am getting more outspoken the older I get, a right of old people."[45]

Once the De Grazias' living quarters were built, it was time again for
a celebration. Ted drove to Nogales, Sonora, to purchase alcohol. He
mixed it with raspberry, cherry, and lime flavors to make a "powerful
punch." Marion De Grazia said years later, "It's just lucky he didn't
[end] up in jail, poisoning people."[46]

Bob McKusick had helped De Grazia with the building and had
even lived in the house with his wife, Charmion, until De Grazia
moved in. About 150 people attended the celebration. Charmion,
who had mixed the potent punch, managed to get a taste after serv-
ing guests their drinks. "A searing pain shot from her feet to the
top of her head," Bob McKusick said. "Belatedly, she realized the
colored liquid was pure ethyl alcohol." He remembered that it was
an "extremely jovial party." The next day, when the McKusicks drove
into town, they saw tire tracks all over the desert, but "no one had
a hangover, and no one had an accident."[47]

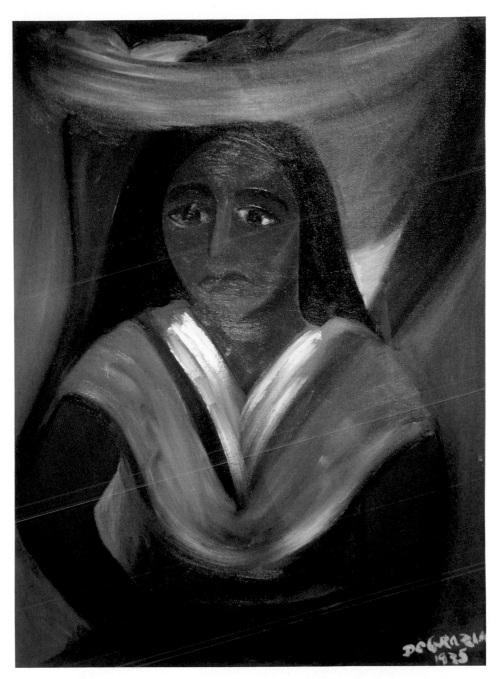

Plate 1. *Alone* (1935).

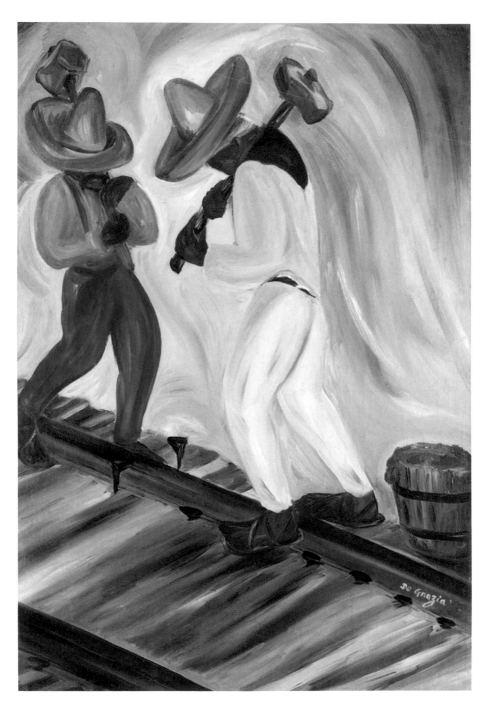

Plate 2. *Working on the Railroad* (1939).

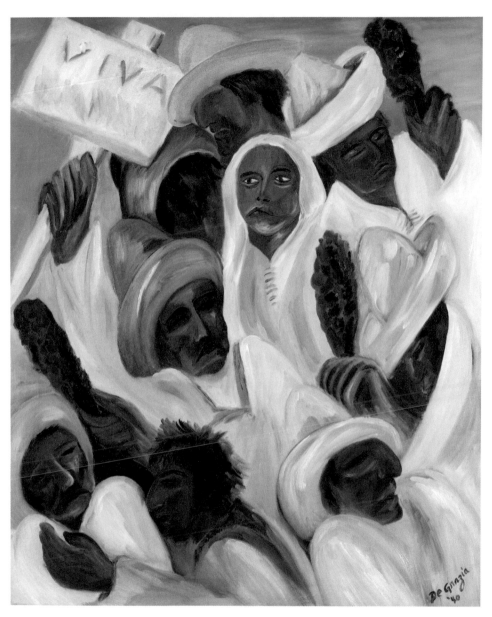

Plate 3. *Viva* (1940).

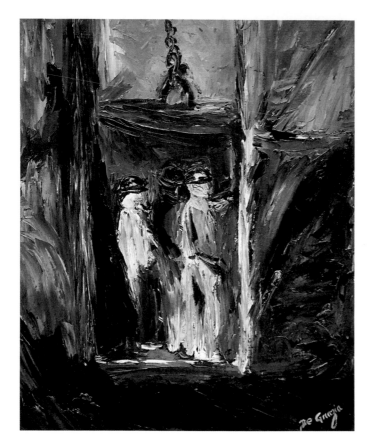

Plate 4. *Miners* (1941).

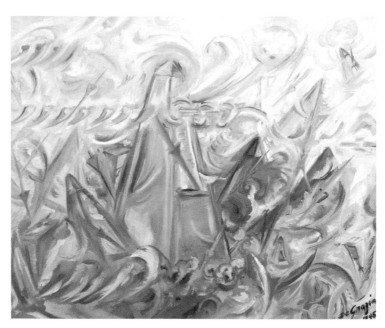

Plate 5. *Beethoven's 8th* (1945).

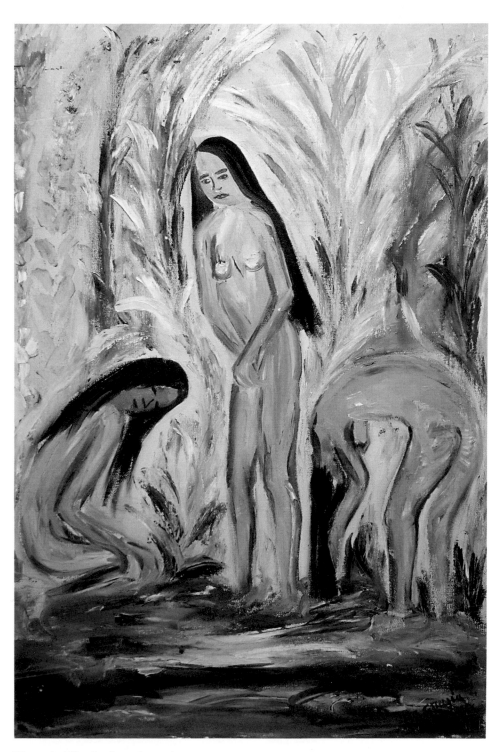

Plate 6. *The Bathers* (1947).

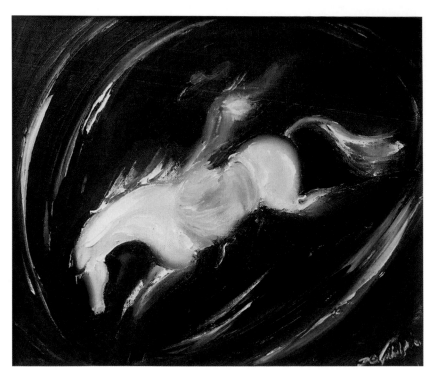

Plate 7. *Bucking Bronco* (1956).

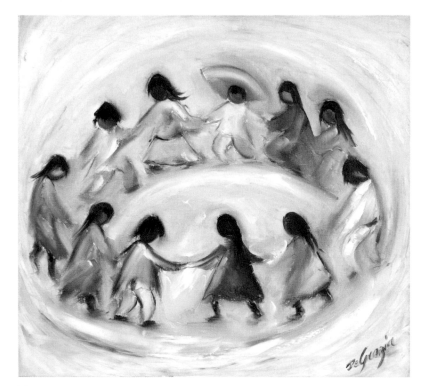

Plate 8.
Los Niños
(1957).

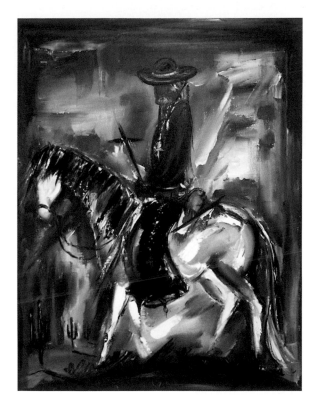

Plate 9. *Father Kino* (1960).

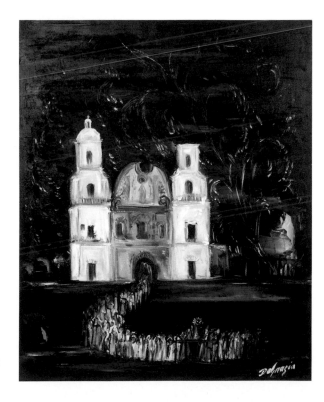

Plate 10. *Fiesta at San Xavier* (1960).

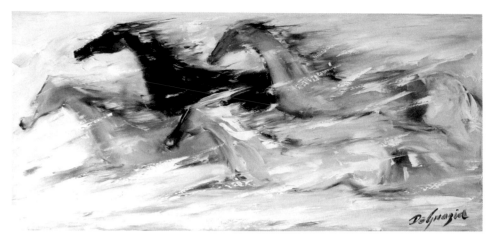

Plate 11. *Free as the Wind* (1961).

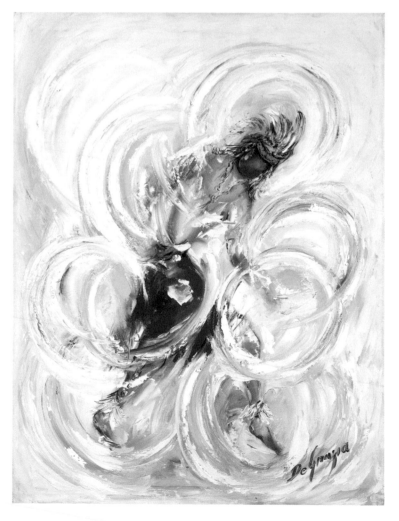

Plate 12.
Hoop Dancer
(1962).

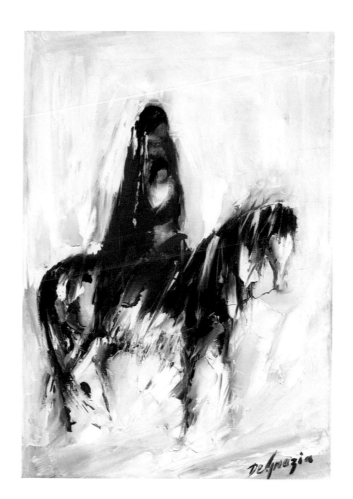

Plate 13. *Morning Ride* (1963).

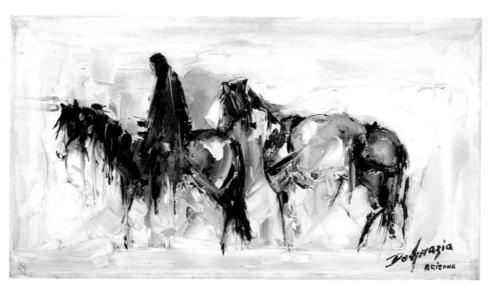

Plate 14. *Alone* (1964).

Plate 15. *Wind from the East* (1964).

Plate 16. *Don Quijote* (1965).

Plate 17. *Self-Portrait* (1965).

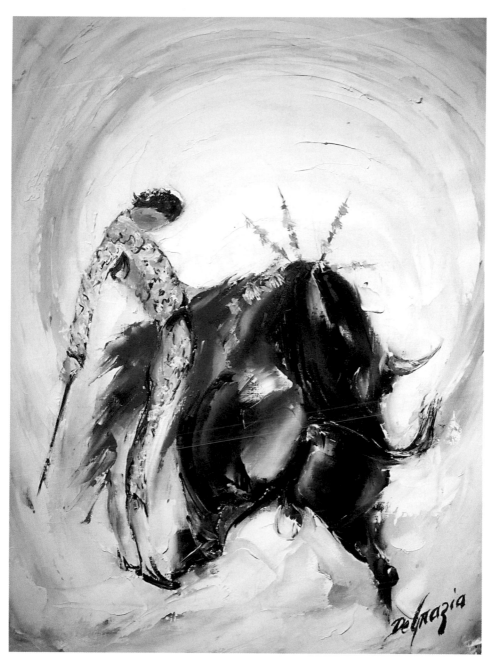

Plate 18. *Classical Natural* (1966).

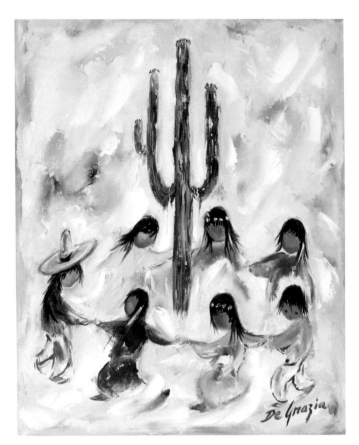

Plate 19.
Saguaro Dancers
(1972).

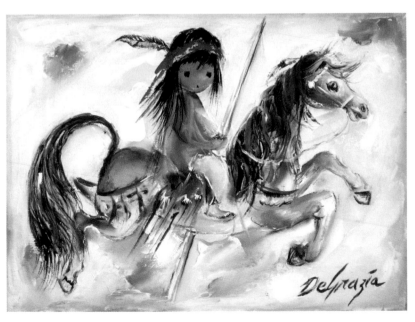

Plate 20. *Merry Little Indian* (1972).

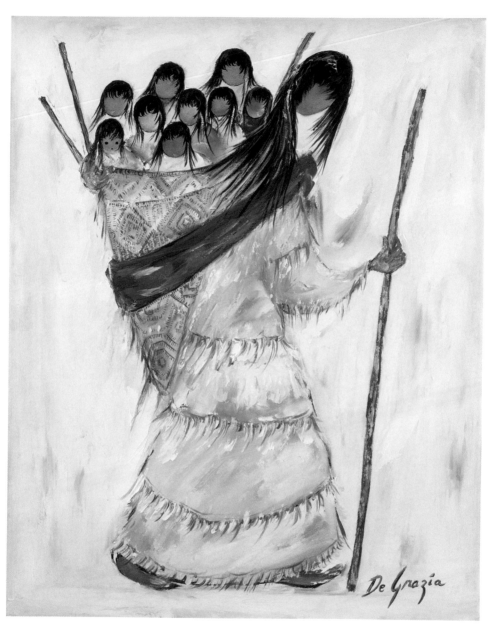

Plate 21. *Ho'ok* (1975).

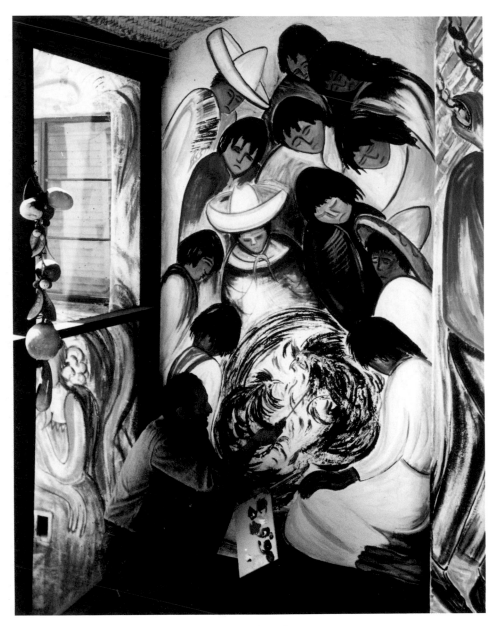

Plate 22. Ted painting a mural in the mid- to late 1940s.

13

On New York City, Booze, and Commercialism

De Grazia's had the right idea all along. His whole
idea was to bring some beauty into the lives of
people who can't afford original artworks.
—*famed Navajo artist R. C. Gorman*[1]

DE GRAZIA TRAVELED TO New York City in the 1950s to show off
his collection and find out "whether I'm any damn good or not as
an artist." But, he said, "I didn't come here to stand in line, and I'm
not going knocking on doors. I'm just going to find out whether
I'm good enough for a gallery here to take my paintings for sale so
I can go farther into the mountains and look for gold, and dream."

He didn't have much luck.

One reason: his appearance no doubt shocked genteel New York
gallery owners. United Press reporter H. D. Quigg noted De Grazia's
sunburned, copper-colored skin, his black beard flecked with gray,
and a face that "looked like a medieval painting of an Italian saint,
surmounted by a whopper of a Navajo Indian hat, greasy with wear
but banded with half a pound of wrought silver." He wore ornate
boots, dungarees, and a solid red shirt. The boots helped him appear
taller than his five-foot seven-inch frame.[2]

No way would he dress differently, even though at home he
donned starched and ironed Levis and maybe a bolo tie for formal
events. He claimed that he changed shirts once a week. Marion once

counted forty shirts in his closet. "What the hell am I going to do with forty shirts?" he asked. On another occasion he said, "I have enough shirts to go a whole year, if I only choose one shirt a week. My shirts are always made long enough to go almost to my knees, because I also use them as night shirts."[3]

He once claimed his crusty hat was ten years old. "I rolled over in my car with it."[4] He also kept a red handkerchief in his back pocket to blow his nose or wipe perspiration caused by the hot Arizona sun off his forehead. Once on NBC's *Today Show*, at the end of a fourteen-minute interview with newsman Tom Galvin, De Grazia pulled out his hand-kerchief and blew his nose. That colorful and down-to-earth scene remained in the interview in the national broadcast.[5]

Dressed in his usual attire, De Grazia once went to buy a car in Tucson, but a salesman ignored him because he looked like a bum. Finally De Grazia walked out, went down the street to a different dealer, and paid cash for a new car. Driving by the first car dealership, he saw the salesman out front and gave him the finger.[6]

When his daughter Lucia prepared for her wedding in April 1958, she pleaded with her father to wear a tuxedo to her wedding. He balked. He didn't want to wear a "monkey suit," just his usual garb.[7] He also complained to Delia Figueroa about having to wear a tux to the wedding of his youngest daughter, Kathy, in November 1960. "Delia, they want me to put on a tuxedo, and I cannot see putting on a tuxedo. I will not do it," he insisted. But come wedding day he wore the fancy garb, even though the pants were too long. He looked over at Figueroa with a twinkle in his eye that said, "Well, I did it."[8]

The outrageous lies about De Grazia began to surface in the 1950s. Did he really have six wives? Father dozens of children? Drink prodigiously? Carry on countless affairs? He sidestepped them all, letting them linger in people's minds because he believed artists profited from developing a reputation for eccentricity.

He once said that for an artist to be successful he had to have three traits: a style that could be recognized one hundred feet away; a steady supply of his work; and a mystique about himself.[9] He worked on creating that mystique as much as he did any of his artwork.

In one story he cultivated, he portrayed himself as a hard-drinking man. He rarely passed up a drink, but he was anything but a drunken

artist. No doubt he got drunk on many occasions, especially with his cadre of offbeat friends. But his stepson, Hal Grieve, said he didn't drink nearly as much as people thought he did. "He used to like to . . . embellish that legend of being a big-time drinker, but he never was," Grieve said. "He would drink, he would get a little tipsy, but he was never a two-fisted drinker . . . by any means."[10]

On the other hand, Karen Thure recalled the time when De Grazia telephoned from a bar on Tucson's south side, asking her husband to pick him up. He had been drinking with Yaqui friends. "My God, you'd swear you weren't going to come out alive. It just was one of those really, really raucous places where people fought in the parking lot with knives. And he loved those places, too, so you just never knew what you were going to find."[11]

Rick Brown remembered when De Grazia signed autographs for fans at a Hallmark store operated by his parents. None of the Browns drank, so no one thought about getting De Grazia a bottle of whiskey. When the omission became apparent, Rick Brown ran to the nearest liquor store and bought a pint of Old Crow. De Grazia quickly polished that off and then handed Brown a note that said, "This was not big enough." Brown took the empty bottle home as a keepsake.[12]

In another incident, De Grazia agreed to sign some of his ceramics, books, paintings, and sundry other products at Goldwater's department store in Phoenix just before Christmas. Legions of fans stood in long lines to get his autograph. He once remarked, "They open the doors. I see the crowd heading for me, and I'm wondering where the hell I can run."[13] Bernardino played a flute and beat a drum alongside him. One of his traveling companions, Cassandra Prescott, noted that Bernardino could play the flute nonstop for three hours. She loved Indian flute music, but after three hours of it "I was like a maniac, and so were other people who'd stood in line for a long time."[14]

(Despite his constant yearning for publicity, De Grazia never exploited his Indian friends. When he was invited to appear on Johnny Carson's *Tonight Show*, a representative asked him to bring along some Indians. "They could dance. We could have some fun with them," he was told. De Grazia refused, and he never appeared with Carson.)[15]

Figure 26. Yaqui Bernardino played flute at numerous De Grazia signings throughout the Southwest.

A jug of scotch stood on the signing table at Goldwater's, which bothered some of the workers, who ran to their boss in horror. The boss told them, "Leave that bottle exactly where it is. It's part of him, part of his image, just as the Indian musician is. His fans won't be offended. We'll get more complaints from running a bathing suit ad with a bare midriff than we will from De Grazia's scotch sipping."

Said Goldwater's president, Pam Grant, "If it were anybody else, that bottle of scotch flat would not be allowed. But it's part of his aura. Just one of the little ways he throws convention to the winds."[16]

No one complained. The scheduled three-hour signing lasted seven hours, but despite private protests that he disliked dealing with the throngs of people who wanted to meet him, he told an interviewer for a magazine that he was grateful for his legion of fans. De Grazia never gave in to fatigue. "Tired? I don't even think of it," he said. "These people. Where would I be without them? They made me what I am. It's a kind of love affair between us." A woman in line called him her Christmas angel. "May I have a Christmas kiss?" she asked. When De Grazia obliged, she remarked, "Imagine, a Christmas angel with booze on his breath."[17]

Figure 27. Fans thronged to Goldwater's department store in Phoenix to get De Grazia's signature on artwork and books.

One of De Grazia's biographers, Harry Redl, said he had seen people come up and touch De Grazia at book signings. "I mean, there's almost a religious fervor about it. A lot of people like him. And he does it with paint."[18]

De Grazia often showed up late for stuffy affairs honoring him. He would arrive wearing his usual outfit, maybe one that hadn't been laundered in a day or two; burst into the room; pull out a bottle of whiskey and take a swig; wipe his beard off with a forearm; smile;

and then take his seat at the place of honor. Or he would pick up a drunken Yaqui and take him along to a meeting with executives, then introduce him to the surprised big shots as his financial manager. "It's rather interesting to see how someone handles a situation where the rules don't really count," he would say.[19]

De Grazia worked hard to please the public, turning out commercial art by the truckload. "Name me one artist who wouldn't do the same thing. If they could sell the prints and trinkets, they would do it, too. I would say they're jealous of my success."[20] The commercial side of his painting, however, allowed him to paint some pictures as he pleased, ones that no one could ever call "kitsch." In 1975 he remarked, "Everyone likes you when you're starving. It's a fake thing, this commercialism. An artist knows the dollar as well as anyone."[21] He said all artists start out hoping to make money at their painting. "Those few who get there are always criticized by those who don't."[22]

Interestingly, twenty-nine years after De Grazia's death he is still recognized—at least by the *Arizona Daily Star*—for his kitsch. In a special section on October 30, 2011, "Arizona at 100: The Arts, Business, People, & Places," De Grazia's magnets were listed among the top five kitsch items in Arizona statehood history, along with images of coyotes and Kokopellis. The *Star* left him off the list of the top five artists; Maynard Dixon was the most recognizable name.

Joseph Stacey, who replaced Raymond Carlson as editor of *Arizona Highways* in 1971, wrote about commercialism: "Today, art does not and cannot exist detached from creator and the means to provide him (or her) with food, clothing, shelter, and the means to carry on. Remember, it takes more than talent alone."[23]

In 1973 William Steadman, the director of the University of Arizona Museum of Art, said that De Grazia "makes many great sacrifices for the privilege of doing certain projects when the opportunity arises, and is always [eager] to do illustrations for books and magazines, even commercial designs, because he feels by this means he is able to do the greatest good for the greatest number of people."[24]

Sherrye L. Cohn, who earned a doctorate in art history, perhaps best describes what the viewer gets out of looking at a painting, a process that could well be applied to De Grazia's work. She called the experience "a psychological event—one which is shaped by what

we see and what we bring to the act of seeing. In so doing, it reveals that art is available to anyone who is available to it."[25]

Perhaps only De Grazia could explain his art's popularity well: "Don't underestimate the people. Working people have a simple, uncomplicated lack of pretensions. The simple people recognize humanity. Maybe that's what they see in my work."[26] They are then seeing his work on their terms, not what others think they should see or dislike.

De Grazia earned a lot of money in those days, and he made no excuses. But he also had some strong feelings about art pricing and his commercial appeal.

De Grazia called art pricing a racket, saying he priced his own paintings on the basis of how much he liked them. The process of art pricing, he said, involved the artist's ego, the dealer's greed, and the public's gullibility. "Oh, art pricing is a lot of baloney, all right. If that fella [President] Nixon painted, he'd get a good price for his canvases even if he couldn't paint worth a damn. They'll buy his name. Yeah, many people are buying the name when they buy De Grazia. When you are struggling along and not selling, everyone pats you on the back and says better luck next time; when something clicks and you start selling like mad, they call you a commercial artist. That's what they call me now, and I laugh all the way to the bank."[27]

He lashed out at an *Albuquerque Tribune* reporter in August 1957, railing against "modern art" that could not be understood. "If you can't understand a picture, it's no good. And don't be ashamed to say it means nothing to you. The strength of a country is reflected in its art, and I hate to say what I see in American art today. There is too much that is dead and dishonest. There is a lack of vigor and little sense of direction. We have been kidded long enough by the Picasso gang, by the people who think you have to go somewhere else to paint, by people who make money out of art instead of putting time and pride into it."[28]

In 1957 De Grazia began painting the whimsical, impressionistic, round-eyed angels that he became famous for. Marion described his transition:

> *From the first somber paintings, very strong paintings of death*
> *and the miseries of humans there began to emerge paintings with*

*a less heavy hand. With a light touch began paintings of an
ethereal essence. Miseries lightened into visions of enchantment.
. . . There followed the angels. Angels everywhere. Without angels
there would not be anywhere. With angels to guide him, beautiful
visions were revealed.*[29]

The angels attracted attention. During a two-week show in Las
Vegas, New Mexico, that included paintings of angels, he told the
Albuquerque Tribune that his paintings were his life, "what I have
known and what I feel. . . . To be honest with myself, to express what
I felt inside (which was the most important thing in my life), I knew
I just had to go my way alone. I could not paint merely to please
the public. Having taken my stand, I soon found myself completely
involved in painting. I don't care what the experts say. I paint because
I need to communicate."[30]

The year 1958 proved to be a milestone in De Grazia's career, thanks
to his entering into an agreement with the Hallmark card company
to put his work on Christmas cards. The cards became best sellers,
but after three or four years he grew tired of doing them. "It was
upsetting my income. I was making more money than I wanted, or
needed, so I called up one day and said, 'Please . . . quit my checks.
Just cancel them. I don't want any more checks, and I don't want to
do any more cards.'"[31] On April 23, 2010, the *Phoenix New Times*,
an alternative weekly, derisively referred to De Grazia in a headline
as a "greeting card artist," a description that was a putdown in the
context of his other works.[32]

In 1958 he painted *Los Niños*, a picture of eleven Indian children
dancing in a circle. In 1960 a UNICEF official in New York City
saw the twenty-four-by-twenty-six-inch painting in *Arizona High-
ways*. UNICEF asked to be allowed to put *Los Niños* on greeting
cards, describing the painting as "a sensitive and moving portrayal
of Indian children performing a ceremonial dance."[33] This invitation
put De Grazia in heady company, since UNICEF also asked Rufino
Tamayo of Mexico and France's Marc Chagall for permission to
reproduce their work on greeting cards.

De Grazia painted *Los Niños*, he said, because of his love for chil-
dren. "I seem to go more for the underprivileged ones; I seem to
understand them more." He said the dancing children represented

Figure 28. In New York, actress Celeste Holm and De Grazia publicize his painting *Los Niños,* which UNICEF used on Christmas cards.

unity. "The kids are from different places, and they're all doing very well together."[34] At the time, he said, "I had no idea it would ever be adopted for widespread use, but it is a pleasure to have it reproduced to help the kind of children I painted."[35]

In agreeing to UNICEF's request, De Grazia recognized that publicity would come with sales of the greeting cards. Indeed, it did. The international children's organization sold five million boxes[36] of the cards in eighty-five countries and five languages—English, Spanish, French, Russian, and Chinese. Marion put Ted's feelings about children into these words:

When visitors ask
"how many children
do you have?"
always my answer is
"none."

Because they wouldn't believe me
if I said
a million
maybe a billion
Or a trillion.
Little Children bringing flowers
making music.
Little children
dancing all over the earth
Making people happy.[37]

The value of the *Los Niños* prints and dozens of others that De Grazia contributed to nonprofit organizations over the years totaled more than $10 million in 1960 dollars. At the same time, the paintings he contributed drew enormous attention to his work, which generated even more income.

De Grazia spent two weeks in New York City in August 1960 to publicize UNICEF and *Los Niños*. He appeared on the network shows *Today, Romper Room, Hi Mom,* and *Who Do You Trust?* as well as in a publicity photo with the actress Celeste Holm to launch the greeting card season. In addition, he attended a luncheon at the United Nations as the guest of honor.

He also did interviews with newspapers. During one, he told reporter Ed Wallace of the *World-Telegram,* "I'd rather see my paintings in the homes of working stiffs—than in museums." After De Grazia returned to Tucson, Wallace sent him a packet of letters from *World-Telegram* readers in response to that quote. One of the letters said, "I am a working stiff, and feel I may be able to afford a painting for the first time in fifty years. My walls are bare, but it's never too late to start."[38] Another letter came from Lili Whalen of Jackson Heights, New York, who wrote: "I am one of the faceless ones who could never afford one of your beautiful, mystic paintings— although I have had the temerity to try to copy them."

According to Wallace, some of the letters so touched De Grazia's heart that he and Marion flew to New York in October 1960 to make gifts of his works to the letter writers. Wallace, who called De Grazia the "greatest painter of angels since Michelangelo," wrote that De Grazia and Marion "merely rang . . . doorbells, introduced themselves, and delivered the gifts." Whalen, the lady who tried to

copy his paintings, received one, as did another letter writer, Mrs. Julia Loscalzo of Jackson Heights, whose picture appeared in the *World-Telegram* with De Grazia giving her a painting of three Indian children with angel's wings standing around a baby in a crib.

De Grazia told Wallace that he flew back to New York so soon after the August trip because it gave him "an opportunity to prove what I think about being an artist—the big thing is the pride and time you put into a painting . . . not the money you get out of it." This again typifies De Grazia's genius for self-promotion. While he said that giving the painting to Loscalzo gave him great pleasure, in truth he couldn't have bought the publicity that the gift to her and the others brought him. All the same, he admitted, "I sure don't enjoy [New York] that much. . . . Now I'll go back to the desert and begin painting again."[39] During another trip to New York, the famous gossip columnist Walter Winchell noted that De Grazia "was curious to see a discotheque and went to Sybil's Arthur. He stayed exactly ninety seconds."[40]

Selling his prints at prices that the average Joe could afford became the secret behind De Grazia's artistic and financial success. He rarely sold an original by this time; they were all prints. In fact, De Grazia never sold the original of *Los Niños*. It remains today in the Gallery in the Sun, part of the rotating collection of paintings hung on the walls. In 1983 the value of the painting was estimated to be between $40,000 and $50,000.[41]

On one of De Grazia's trips to New York, he stayed with Ron Butler, a friend from Tucson who had moved there. Butler threw a party for De Grazia that a number of publishers and printmakers attended. In preparation De Grazia went to a nearby liquor store to buy refreshments. When the clerk asked him what he wanted, De Grazia replied, "I want one of everything." Butler remembered it as "quite a party."[42] De Grazia stayed with Butler for five days and became so bored that he sketched on cardboard and newspapers. Butler kept the sketches.[43]

Butler lined up interviews for De Grazia while he was in New York. One day the artist took off by himself, apparently in search of some free publicity. "He was a publicity machine," Butler said. "He never advertised, not once in his whole life."[44]

When he returned to Tucson, nearly two hundred well-wishers greeted De Grazia, cheering him when he stepped off the plane. In response, he said, "I don't think that many of those people were real fanciers of painting. But I'm sure that all of them must have recognized

something in my painting that touched them. I don't know or care how it touched them—it's my business to paint, not to pick motives apart."

Perhaps they recognized the humanity in his work. Not a year went by that De Grazia didn't donate at least one his paintings to a charitable organization. In 1963 the Arizona Boys Ranch used his painting *El Niño: Everybody's Boy* for fund-raising. The next year the Muscular Dystrophy Association used *Naughty Angel* on Christmas cards. In 1965 the American Cancer Society put *Navajo Madonna* on its Christmas cards.[45] In 1966, he allowed the Protestant Episcopal Church of Arizona to print *A Little Prayer* on its Christmas cards and notepaper. In 1969 Amigos de Las Americas benefited from his painting of *Flowers for Los Amigos* to raise funds for service projects in Honduras and Guatemala. In connection with that, De Grazia and folk singer Travis Edmonson wrote a song, based on the title "Flowers for Los Amigos," that they recorded and sold to raise money for the organization. In 1972 the 465 members of the Cocopah tribe were aided by De Grazia's generosity when they used limited edition prints of *Little Cocopah Indian Girl* to raise $50,000 for construction of a house of mourning and a community building. "Sometimes I help Indians simply because others won't," he said.[46] In 1973 he allowed use of the *Pima Indian Drummer Boy* for fund-raising by the Children's Arthritis Clinic.

In 1965 De Grazia traveled to the East Coast to help the American Cancer Society promote his Christmas cards. Arizona Congressman Mo Udall honored him with a showing of *Navajo Madonna* in his capitol office. De Grazia admired Udall, one of the few politicians to win his favor. The showing marked the second time Udall had played host to De Grazia; the first had come during the fiftieth anniversary celebration of Arizona's statehood in 1962.[47]

De Grazia didn't think much of politicians, lawyers, or bankers. "There are politicians and there are politicians," he said. "During the election they gum the people to death. Most have big mouths and bad breath."[48] He called them "a bunch of damn liars."[49] He likened lawyers to mule skinners, since "either one will carry something for a buck."[50] And he disliked bankers so much he claimed that he buried his money, but he didn't—unless he did so under his bed.[51]

He may have been as good at philosophizing as he was at being a painter, except that he didn't get paid for spouting his thoughts. They did bring him a great deal of attention; he could offer words of wisdom

with ease. Abe Chanin said De Grazia "was one of the quickest philosophers that I have known. If you made a sentence, he quickly triggered and started spouting off his philosophy on the world and living."[52]

De Grazia disdained politics in any form. "When I vote, I vote for the individual and not the party, but if I don't see on the ballot what I want, I don't vote, period. And so it's not too often I vote."[53]

Everything eventually came back to the Indians for De Grazia, even politics. "My politics are simple," he said. "Just side with the Indians, and justice will finally be done . . . really."[54]

In a letter to Udall dated May 18, 1975, De Grazia gave the first hint that he might be secreting paintings in the Superstition Mountains to keep them from the Internal Revenue Service. Apparently he had asked Udall to check into tax laws he felt were unfair to artists. "The IRS will have to find [them] before they can charge me for them," he wrote. "By then I will be dead."

In that same letter, addressed to "Dear Presidente"—Udall was seeking the Democratic nomination for president—De Grazia said he would donate a painting to be used for fund-raising in Udall's campaign. He even offered to say "anything . . . appropriate" on talk shows in the Southwest. He concluded the letter by telling Udall he would like to see him elected.[55]

When De Grazia moved to his new home in the Catalina Foothills, he still rented out his Campbell Avenue property to a variety of businesses, including La Piñata, a shop operated by Delia Figueroa. When Figueroa sold a dress or blouse, De Grazia would paint little figures on top of the gift box and then sign it "La Piñata" and "De Grazia." He painted about fifty of the boxes. Almost thirty-five years later, Figueroa received a telephone call from a man who said he had found a framed top of one of the boxes in an estate sale and wondered if it was an original. Yes, she told him, it probably had a value of about $800.[56]

Later, Figueroa designed little cloth dolls that De Grazia signed. She sold 144 dozen in the first year. De Grazia then decided he'd done enough signing. "You sign them," he told her. She did, copying his distinctive signature.[57]

His increasing popularity by 1966 had Hollywood beckoning. Lee Garmes, a cinematographer on *Gone with the Wind* and many other Hollywood classics, produced and directed filming in Mexico City

of an hour-long documentary about De Grazia. It included his experiences with Rivera and Orozco. Ensconced in a posh hotel there, Garmes asked De Grazia where he had stayed in 1942. De Grazia pointed to a park across the street and replied, "Right over there on that park bench with the rest of the Indians."[58]

De Grazia told a *Tucson Daily Citizen* reporter, "My life is not my own since I met these filmmakers. I have to work all the time. . . . It's tiring as hell." Added Jose Harrison, the movie's director, "And he loves it."[59]

While filming in Mexico, De Grazia came across Oscar-winning actor Broderick Crawford, also starring in a film being made there. Crawford was fifty-five; De Grazia, fifty-seven. They hit it off immediately. "The bum walks in with his beard, and it's love at first sight," Crawford said. "He walks in, and we suddenly struck it up . . . *simpatico*." Said De Grazia, "We're the same kind of mesquite."[60]

Once while they were drinking in a saloon, a woman fell all over De Grazia, seeking his autograph. She failed even to notice Crawford, who had starred in the six-year run of TV's *Highway Patrol*.

De Grazia told reporter Maggie Wilson that Crawford was like a long-lost brother, "and I just found him. Crawford and I are going steady." The actor replied, "This nut said that on television the other day. Thank God it wasn't network television. Imagine what a line like that could to do to my he-man image. But he's right. . . . What a guy this De Grazia is."[61]

Crawford and De Grazia formed a solid relationship and became longtime drinking pals. "I like to drink," De Grazia said. "Maybe we weren't good for each other."[62] Once when they were in Apache Junction, Arizona, to work on a film about the Lost Dutchman Mine in the Superstition Mountains, they talked the owners of the Lucky Nugget saloon into opening the doors early. "Imagine a good western town like Apache Junction not having a bar open at nine in the morning," Crawford bellowed.[63]

Crawford bought a house outside Tucson on what he described as "five acres of cactus." He kept the location of his residence secret from everyone, even De Grazia, to protect his privacy. Crawford spent a lot of time at the gallery along with another Oscar winner who lived in Tucson, Lee Marvin. The three friends often belted back a few on the gallery's patio.[64]

Figure 29. Actor Broderick Crawford and De Grazia were great drinking buddies.

Once Crawford traveled with De Grazia to Palm Desert, California, for a print signing for adoring fans at Ginger Renner's gallery. While there, De Grazia found himself called constantly to answer the phone or to step into another room to meet someone. Even though Crawford's TV show made him popular in those days, some attendees apparently failed to recognize him. After De Grazia left the room, fans would approach Crawford and ask him to sign their prints. Without hesitation, Crawford accommodated them, copying De Grazia's familiar signature while sitting with a whiskey bottle in a brown bag between his legs, taking periodic sips for authenticity.[65]

Renner recalled another visit from De Grazia when he brought along artist Ross Santee. After the signing the trio went out to dinner and then to a bar, which they closed. Renner drove De Grazia and Santee to their hotel and went home. The next day she ached from head to toe. It dawned on her that she had laughed for seven hours straight the night before. "Ted brought me not only artwork, he brought me lots of fun," she said.[66]

14

Building the Gallery

An artist is an architect who works in two dimensions.
An architect is an artist who works in three dimensions.

—*De Grazia*[1]

DE GRAZIA'S MOST EXTRAVAGANT building, the one he considered his best work, was yet to come—the more than 16,000-square-foot Gallery in the Sun, a "40-room complex . . . comprised of three buildings . . . connected by a wall enclosing a large vegetated courtyard," which he built in six stages beginning in 1960.[2] His love of Arizona inspired its design; he said he wanted "to get the feeling of the Southwest. I wanted to build it so that my paintings would feel good inside of it."[3]

He designed the whole complex with rudimentary sketches that he adapted as he went along, but at one point he also made a clay model that he placed on a fifteen-by-fifteen-inch piece of wood. One time a county building inspector came out to check on construction. It turned out De Grazia had gone to the university with the inspector. He showed the inspector the clay model and a couple of sketches. They had a couple of drinks. Then they had a couple more drinks. Before long the inspector signed the necessary papers. Then he had a couple more drinks and headed back to town.[4]

Visitors enter the gallery through a door framed, like a mine shaft, by three railroad ties. "The door [itself] is a copy of the door at the Yuma Prison. I like jails, but I like them better when the doors are

left open."[5] He had a metalsmith make the gate look old by burying it in a pit with water, mud, and salt to age it over time. Colored glass marbles inset in the irregular door embellish it.[6]

He built the foyer like a mine tunnel, saying he liked tunnels, a reminder of his days in Morenci. In the foyer are exposed wooden beams called "vigas" and very small windows filled with colored glass. Straight ahead is a tiled lobby with a sitting area, a beehive fireplace, and built-in adobe benches. Filtered skylights diffuse light, and three narrow vertical windows face north into a courtyard. To the right is a gift shop. Behind the shop is another minelike door heading into offices and storage space. Marion vividly described her impressions:

> *Walk through the tunnel. At first the prison gate and the tunnel with its darkness has blinded your eyes. And then at once there is a comfortable feeling, a friendly feeling. The gentle light from the skylights becomes a part of you. The many impressions of visitors become a kaleidoscope of many impressions. Many, many pleasant impressions. Creativity prevails. The building itself is a work of art.[7]*

To the left of the main entrance are three galleries. Niches and alcoves hold pottery and sculptures. Walls are painted in desert colors or left natural with a plastering of mud and straw. "A wall out of mud is beautiful and satisfying," De Grazia said, "but a wall of mud and straw is a union of materials that are in complete harmony and produce an aesthetic feeling, long to be remembered. To me this is the great Southwest. The mud wall is masculine—physically strong and durable. The straw is feminine—delicate as a thread. Its color is sun and gold."[8] In Marion's words:

> *No money. Put up your walls from the earth. Tamp it. Form it. It is a shelter. From a shelter to a gallery is a long way, a long, long, long way. A lonely way.[9]*

On some walls De Grazia used plaster with rough gravel, heavy on the cement and not much lime, to produce a severe texture. Then, as he had done with the houses and other structures he had built, with the plaster still wet, he painted with at least three colors, sometimes

six, to soften the walls. "The result," he said, "is that they come alive. They sing and exude beauty."[10]

The floors are made of a variety of materials—concrete and red lime, burnt adobe, flagstone, and slices of cholla branches. "On some of the gallery floors, I use mud, on others, jumping cholla cactus. The cholla, cut about four inches long, is sanded and sealed with wax. The tops of some of the cholla I dye in color. Then I bed them in cement. The finished floor produces a feeling of walking in a strange magic place. You see it; you feel it in your feet—texture on your toes, so to speak, a magic rug."[11] De Grazia told workers not to level the uneven floor because he liked the way it looked. When they objected, De Grazia pointed out, "Well, life isn't even."[12]

He liked the building techniques passed down to the Papagos and Yaquis from generation to generation and said he gave his Indian workers "lots of freedom. If they do not work, I do not pay them. I never fire anyone. So they work for me when they feel like it. We work together, drink together, and become friends. We stay together, we have many laughs, and now we are growing old together."[13]

Papago builder Tom Franco, one of as many as twenty or thirty Indians who worked on the gallery, said with a chuckle that De Grazia "works us like ah, like what you say, slave?"[14] Marion observed:

> His Indian helpers took their time and put a lot of love into their work.
> Slide rules are deadening. Bulldozers are devils who destroy the land.
> No devils were allowed, only angels to guide the realization of a dream.[15]

The gallery ceiling is exposed wood. De Grazia applied light coats of pastel colors to it. "It produces a delicately colored atmosphere that's there, you know it only by feeling it."[16] He then hung sacks of Bull Durham tobacco from the rafters "to remind me how I started," when he had to roll his own cigarettes.[17] They still hang in the gallery today.

In 1966 he wrote an article entitled "Texture" for the magazine *Mountain States Architecture* in which he described his philosophy of construction. "When a man is creating a building or a painting it must be—first and last—a thing of beauty with good proportions and

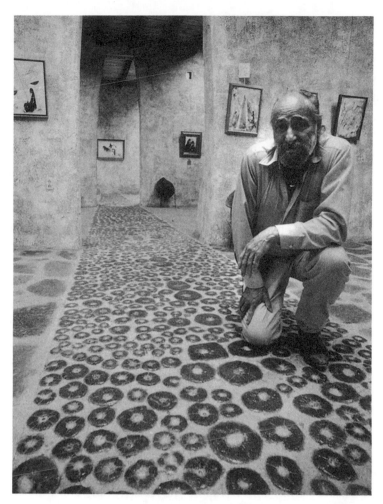

Figure 30. De Grazia looks over his floor, made from slices of cholla cactus, in the Gallery in the Sun.

harmony. These qualifications are things of the spirit, of the soul, and of the mind." He said he tried to capture reverence for the land from which he came. "What I find around me is what I use."[18]

In accord with that philosophy, De Grazia wasted nothing. The ongoing construction of the gallery provided him with ample material for his artistic experimentations. He used leftover scraps of wood to do quick, small paintings. When the knots fell out of knotty pine green wood used in the construction, he painted on them, too. He

never rested. When his stepson, Hal Grieve, cleared out the gallery after De Grazia died, he found paintings on all kinds of materials, including plywood, Masonite, and canvas. There were a couple of shoe boxes full of the painted pine knots. "I even found a painting that he'd done on the backside of a furnace panel," Grieve said.[19]

Once a man rudely interrupted De Grazia while he ate lunch at a restaurant, saying he had heard that he would paint on anything. "Well, I paint on a whole lot of things," De Grazia said. He grabbed a tortilla and sketched a horse on it with a black marker, then tossed it at the man. Then he took his marker and scribbled on the man's shirt, saying, "Now I've painted on everything." The man swore at De Grazia and stomped off. The tortilla is still in the possession of the DeGrazia Foundation.[20]

De Grazia's mission, gallery, and other buildings began attracting the attention of magazines, including *Desert*, *Western Ways*, and *Arizona Highways*. As ever more visitors came, this eventual National Historic Site didn't sit well with many of De Grazia's wealthy neighbors, particularly those living in the exclusive Skyline Country Club just north of the property. One time club officials called De Grazia and told him they wanted him to take down clothes he had hanging out to dry. De Grazia refused, saying he had moved there first.[21] On another occasion club officials told him his buildings were a disgrace and that he should move. De Grazia rarely lost his temper in public—in private, yes—but this time he did. "I build my homes and galleries from dirt; someday they will turn back into dirt, just like you and I will. So you build what looks like a dead ship on those lovely hills, and I shall hide here in my dirt buildings. History will say who respected nature."[22]

After De Grazia's death, developers wanted to buy the acreage and demolish the buildings. Marion De Grazia said they offered as much as a million dollars. She turned the offer down.

> In their mind they saw only the dollar sign. Their offer of dollars went unheeded. They could not demolish the gallery. They could not do it.
> The angels stood in their way. As long as the angels are the gallery will be.
> May the [money] crunchers never frighten them away.[23]

De Grazia rued the day he declined an offer by the owner of the property where the country club now sits to sell it to him. "That's one of the big mistakes I made, not buying the whole mountain, but nobody wanted it," he said years later. "It was out there in the wilderness, no roads, no nothing."[24] Not anymore. Today the gallery is surrounded by apartment complexes, office buildings, expensive homes, the country club, and even a convenience store.

He became so peeved with the country club's wealthy snobs looking down their noses at him and his gallery that he bought a $70,000 Mercedes-Benz so that on garbage day he could put his garbage can on the back of his Mercedes, drive down to the gallery's entrance on North Swan, and unload it beside the road for pickup.[25]

After completing the gallery in 1965, he began to make additions in 1966. On its east side, he built bigger living quarters, 1,653 square feet, in keeping with the gallery's architecture and connected to it by a door. The addition consisted of a living room, kitchen, bedroom, and storage space. About that time he also added eight rooms to the gallery to exhibit his paintings—the Papago, Spider, Retrospective, Project, Atrium, Yaqui, Bullfight, and Gold Rooms. In 1980 he added the Kino, Cabeza de Vaca, and Enchanted Rooms.

The four-room, 910-square-foot Nun's House, built in 1968 adjacent to De Grazia's residence, is one of the more interesting buildings on the grounds. Visiting Benedictine nuns stayed there for free, using the building as a retreat. "It's a form of tithe for him," a gallery employee said.[26] De Grazia told Abe Chanin, who was Jewish, that he built the house so nuns could visit and relax. He looked at Chanin and said, "Oh, yeah, and Jewish nuns, too."[27] (Besides, De Grazia said, "I like nuns better than priests. Many priests are like cops. Give them a badge, and they become dehumanized.")[28] Some of the nuns wrote their names on a mural and door in the living room. The house also has a bathroom and a beehive fireplace.

The gallery courtyard is graced with a seven-foot-tall bronze sculpture of a Yaqui deer dancer that De Grazia made in 1964. It has remained in the same place since its delivery from Noggle Bronze Works in Prescott, Arizona, which cast it. Bernardino modeled for the statue. De Grazia also made a limited edition of forty-five ten-inch replicas of the deer dancer, which he quickly sold.

In the 1970s, demands on De Grazia's time and the fact that he had become wealthy led him to contract out some additions to the gallery property, including the 1,318-square-foot Garden House, which served as a guesthouse. All additions were done by A. C. Caballero, a local contractor who worked for many years building custom homes. Caballero died at the age of ninety-six in 2011. Lance Laber, executive director of the DeGrazia Foundation, who worked with Caballero on De Grazia projects, said Caballero "was still making mud [adobe] and slopping it well into his 90s."[29]

> *One man eleven galleries. Three score and ten years*
> *Of a lifetime of bounding energy produced vast amounts of work.*
> *The eleven galleries represent only a small part of it. The question*
> *repeated.*
> *"How could one man do so much?" "How could he do it?"*
> *The question repeated and repeated by visitors who stroll along*
> *wending their way.*
> *"The ability to constantly surprise is seen as a vital component of*
> *genius."*
> *This quote from an unknown is something to savor.*[30]

Years later, *Tucson Weekly* columnist Jeff Smith called De Grazia "the most over-rated artist and under-appreciated architect in the recent history of the American Southwest."[31]

De Grazia made several strict rules when he opened the gallery. Among them were that all the women working in the gift shop had to wear long skirts, not shorts or pants; that the nine or ten gift-shop clerks were not to push customers to buy his work; and that the gallery had to open promptly at 10 a.m. and close just as promptly at 4 p.m. Only good friends were allowed to remain later.

Once, vendor Jim La Fond brought De Grazia a big check from the sale of his decorative plates just after the gallery closed. "You know I have my rules," De Grazia told La Fond. "I don't see anyone after four o'clock, and I don't care if you're bringing me a million dollars." He told La Fond to come back the next day.[32]

Even with his hard-driving construction schedules, De Grazia never neglected his artwork. In 1961, he created a series of more than

twenty paintings about Father Eusebio Kino, the Italian-born seventeenth-century Jesuit explorer and founder of missions in what was then New Spain. (In addition to Kino, De Grazia painted only a handful of Anglos, all of whom bear a resemblance to the artist.) The first showing of the Kino paintings, on October 21, 1961, at the Arizona Pioneer Historical Society, opened to acclaim. Then he took twenty of the paintings on the road to the Southwest Museum in Highland Park, California, where it brought out "the biggest crowd in fifty years." Museum director Carl Dentzel said, "There were so many people I couldn't get down the hall to my office." More than two hundred visitors were turned away at the exhibit's opening. Dentzel called it the "most exciting event in the half-century of the museum's history."[33]

Raymond Carlson, editor of *Arizona Highways*, put De Grazia's painting of Kino on horseback on the magazine's March 1961 cover. Carlson predicted that within a short time the Kino paintings would become rare collector's items. "De Grazia has reached an epic milestone in a life of artistic endeavor," Carlson wrote. Letters praising the magazine for "presenting such dramatic and outstanding art" poured in from around the world.[34] In 1962, De Grazia combined prints of the Kino paintings and text describing Kino's treks into a book published by the Southwest Museum. De Grazia titled it *Padre Kino: Memorable Events in the Life and Times of the Immortal Priest-Colonizer of the Southwest, Depicted in Drawings by De Grazia*. Contributing commentary to the book were buddies Carlson, Ross Santee, and artist Thomas Hart Benton.

De Grazia had probably met Benton in the late 1950s when he traveled to Kansas City, Missouri, to visit the Hallmark headquarters about producing Christmas cards. Benton, who was born in Neosho in southwest Missouri, took De Grazia to the Harry S Truman library, where he showed him a mural he had painted on a library wall.[35]

De Grazia and Benton had a lot in common. Although Benton was twenty years older, they were about the same height and were not averse to having a few drinks. (Benton taught art to the famed Jackson Pollack, but he disclaimed any influence on him. "The only thing I taught him was how to drink a fifth a day," he said.)[36] Benton has been described as a flamboyant and opinionated character who was rude to people but had devoted friends.[37]

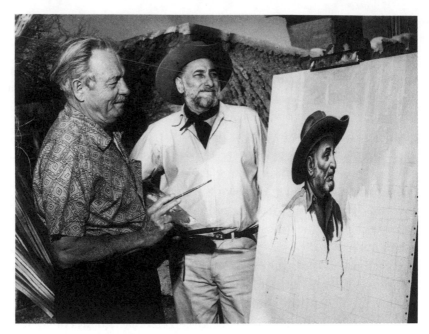

Figure 31. Acclaimed artist Thomas Hart Benton and De Grazia look over Benton's portrait of De Grazia.

But more than that, De Grazia and Benton were influenced by the same artists and artistic styles. Both learned from Diego Rivera, Benton while he and the Mexican artist lived in Paris. Both claimed José Celemente Orozco as a friend. Both were influenced by Synchromism. Moreover, both were pilloried by critics, who called Benton's work "Okie baroque" because he had a following among ordinary people. Benton forged a public image of himself as a hard-drinking hillbilly, much like De Grazia's prospector façade.[38]

Benton called De Grazia a "master of fantasy" in his art. "His pictures tell a story partly because there is a story in what inspires them, but mostly because he knows how to find a story—and because he has the right kind of intuitions," Benton wrote. "His stories are very real though the means of telling them are fanciful rather than realistic. His painted world is an intangible one of iridescent floating colors but it calls up poignantly, that real world of the desert which he loves and close to which he lives. . . . [His art] is full of a delicate and very human poetry which everybody feels and everybody can understand."[39]

15

Honors for the Artist

I don't like the word *famous*. It carries too
much responsibility. I prefer *notorious*.
—*De Grazia*[1]

IN 1961, A *TUCSON DAILY CITIZEN* reporter asked De Grazia how
he felt about his long road to success. The artist, typically contemp-
tuous, responded, "How I feel about it is more important than the
johnny-come-lately opinions of academic specialists and art dilet-
tantes." The reporter, Gene Brooks, wrote, "People in his home
town hadn't yet warmed to De Grazia's talents or simple ways. . . .
Many Tucsonians [*sic*] still wonder, often in suspicious tones, 'What's
with this guy? Is he a real artist?' Others comment simply, 'He's a
character,' and let it go at that."[2]

At least one critic seemed to capture De Grazia's essence in his
review of a one-man show of paintings and sculptures in November
1963 at the Tucson Art Center. "In general De Grazia's work is not
particularly impressive from a purely artistic point of view, however,
the works represented . . . do convey a feeling. They are, therefore,
successful in expressing the artist's theme. The pictures are colorful
and sensitive, and certainly indicate sincerity—something which is
often not in evidence in some academically more perfect works."[3]

De Grazia's most ambitious series of paintings up to this point
in his career was *The Way of the Cross*, which he painted in 1964.
The Reverend Robert L. Graff commissioned the paintings for the

Saint Thomas More Catholic Newman Center near the University of Arizona. De Grazia expressed reluctance to do the paintings because he thought someone "who goes to church every Sunday" should do them.[4] But the more he thought about it, the better he felt. He had, after all, been raised a Catholic.

De Grazia called the paintings *The Way of the Cross* instead of *The Stations of the Cross*, which number fourteen, because he added a fifteenth painting depicting Christ's resurrection, saying the death of Jesus had no value unless he was resurrected.[5] He painted Christ in the series variously as a white man, an African American, a Native American, and an Asian. Saguaro cacti and Indians appear in the backgrounds, giving the paintings a southwestern look. De Grazia used bold colors and a technique that conveyed a strong sense of emotion and symbolism. The smallest painting is sixteen inches by ten inches; the largest, thirty-six inches by twenty-seven inches.

De Grazia concentrated so intensely on the project that he slept little and didn't smoke or drink until the entire series had been completed. He called it a "deep religious experience. It was simple, yet exciting—a work on the sensual unity of mankind."[6]

The paintings hung on loan in the Newman Center for a year before De Grazia removed them. According to De Grazia's friend Louise DeWald, the Catholic church "got on a holier than thou decree and said that he was no longer a good Catholic because of his lifestyle." When the church threatened to excommunicate him, DeWald said, a "furious" De Grazia gathered up his paintings and brought them back to the Gallery in the Sun,[7] where they go on display every year during Lent.

In 1964 De Grazia also finished his eight-by-twelve-foot mosaic mural *Desert Medicine Man*. The mural, made of glass and tile and weighing three and a half tons, was to be displayed at the Sherwood Medical Terrace at 8230 East Broadway. "We desired not only a decorative piece, but also one rendered in materials that would preserve the distinctive work of this artist for several generations," said the building's developer, Ted Tietz.

De Grazia worked on the mural with Charles Clement, also a Tucson painter and sculptor, who laid the tile and glass following De Grazia's two-by-three-foot painting of the mural design. When a huge crane lifted the ninety-six-square-foot mural into place on a hot

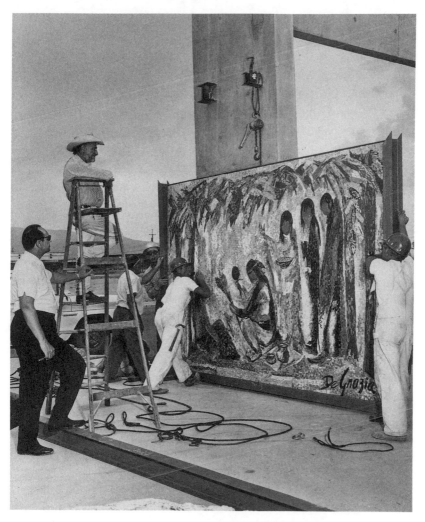

Figure 32. Workers get ready to unload De Grazia's mural *Medicine Man* at the Sherwood Medical Center on Broadway in Tucson.

day in July, it sank into the soft ground and melting asphalt. They had to wait until that night to put it into place.[8] Climate and exposure eventually damaged the mural, so it was moved to De Grazia's gallery for restoration in 1991. The mural sits west of the De Grazias' original house, helping to block the view of North Swan Road. A print of it hangs inside the entrance to the University of Arizona's medical school.

In 1964 De Grazia also painted his favorite work, *Alone*, of a Native American on horseback leading a second horse. He commented about it, "You're born alone, you go through life alone, and you die alone."[9] Marion probably gave the painting its title, as she often did for his works. *Alone* may have been De Grazia's favorite, but he said it wasn't his best, "because that one hasn't been done yet."[10]

That same year De Grazia took off again to New York for a reception in his honor put on by UNICEF for his contribution of *Los Niños*, which by virtue of international sales exceeding five million boxes helped raise thousands of dollars for children around the world.[11] But a security guard denied him entrance to the United Nations building because he couldn't believe that De Grazia, dressed as always, could be the honored guest. De Grazia had turned around to head back to his hotel when a United Nations official vouched for him. "What's wrong with my clothes?" De Grazia said later. "They let all those African and Asian people in when they wear those fancy sheets."[12]

While in New York he heard that pickpockets were a problem, so he dropped into Tiffany's and bought three solid gold safety pins to fasten his cash in a pocket. Later he admitted that the safety pins cost more than the amount of money he was carrying. At times he also traveled with a cardboard box wrapped in rope, which he used as a suitcase.[13] "Few men have the talent of a De Grazia, but perhaps a few more should have the courage to be half so eccentric," wrote syndicated columnist Bill Thomas.[14]

De Grazia found himself turned away in New York City at least one other time because of the way he dressed, when a doorman refused him entrance to a hotel for an interview. Ties were required, and De Grazia not only didn't have one, he refused to wear one. He just turned around and walked back to his hotel.

By this time, the trips to New York had taught him one thing, he said: "The art market is a different breed completely. They don't know what they are selling, but they sure as hell know how to sell it."[15]

De Grazia didn't wear the label of "famous" very well. "I'm not impressed with the fact that I'm supposed to be famous," he said. "All

that really means—once you start to believe it—is that people have some kind of an unnatural 'hold' on your life. I don't want anybody, or any situation, to dictate how I live my life."

He cited as an example his insurance agent calling him to suggest that he carry the same insurance "as one of our more famous loud mouth politicos from Arizona."

"Why?" De Grazia asked.

"Well," the agent said, "you're a famous person. You have more in assets now. At least you should let us insure your hands."

"I'll tell you what," De Grazia replied. "I'll save you a lot of worry. You just cancel everything. Cancel all my insurance. You guys have me at the point now that I'm afraid to live and afraid to die."

"You're joking," the agent said.

"Like hell I am. I figure I've paid enough taxes to cover the cost of my burial. If I can't afford to pay for my own funeral, then let the county do it."[16]

In 1977, in another run-in with an insurance agent, the agent presented De Grazia with a bill for unpaid insurance over a number of years. De Grazia and an aide searched through five years of canceled checks and discovered that the agent was right, so he paid the bill and fired the agent, telling him that if he was no better at collecting his money than that, then maybe he wasn't so good for him.[17]

In 1966 De Grazia illustrated *Journeys with Saint Francis of Assisi*, written by Alvin Gordon and published by Best-West Publications. He also illustrated two other Gordon books: *Inherit the Earth* and *Brooms of Mexico*. When the Desert Southwest Art Gallery in Palm Desert, California, honored the artist and the author at a reception and autograph party, gallery owner Ginger Renner commented about De Grazia that "few artists have run the gamut of success that De Grazia has known and still retained their deep humility, unsullied imagination and child-like sincerity. His attachment to the land of his birth and to the *Indios* and *Mexicanos* has never wavered."[18]

De Grazia also illustrated an award-winning book, *They Sang for Horses*, written by La Verne Harrell Clark, head of the University of Arizona Poetry Center. The University of Arizona Press published the book, which is about the importance of the horse in Navajo and

Apache folklore. It proved to be so successful that the university published three more editions. In 2001 the University of Colorado reissued it.

The university press had asked De Grazia to illustrate Clark's book. During a visit with De Grazia, he asked her, "How do you want me to illustrate this?" Clark replied, "Well, I wrote it, and nobody told me how to write it. I want you to read it and—" And he interrupted to say, "Good. If you'd have said it any other way, I wouldn't have done it."[19]

De Grazia began to get some recognition in his own backyard in 1966. Morenci honored its favorite son that year, greeting him as he arrived in town with a huge banner hanging from an ore trestle that said, "Welcome De Grazia."[20] During a dinner attended by 235 people that night, he presented the high school with a painting, said to be worth several thousand dollars, of an angel playing a bass viola.[21]

In the early 1960s De Grazia offered the University of Arizona his entire collection of paintings if the school would build a wing to house it as a permanent collection. UA President Richard A. Harvill asked the head of the school's art department, James Scott Powell, whether the collection should be accepted. Powell opposed it vigorously. Powell never passed up a chance to criticize De Grazia's work. When asked about De Grazia, Powell would give the listener a "vitriolic earful." A bitter De Grazia thought the university treated him "very unkindly, very improperly."[22]

The university finally relented and recognized De Grazia's work on May 31, 1967, when Harvill presented De Grazia with its distinguished Alumni Achievement Award at the school's graduation ceremony. Harvill told the 3,044 new graduates and their guests that De Grazia's "work as an artist has captured the spirit and the life of the Southwest and has provided inspiration for people throughout the world."[23] It must have been a bittersweet moment for De Grazia, shown in photos smiling through his beard while wearing a cap and gown. Five years later, he told a reporter the honor "meant that I had to dress up in one of those monkey suits and go to the ceremony. I told them, why don't they just give me a bottle of whisky?"[24] Under that gown De Grazia still wore his flannel shirt, jeans, and cowboy

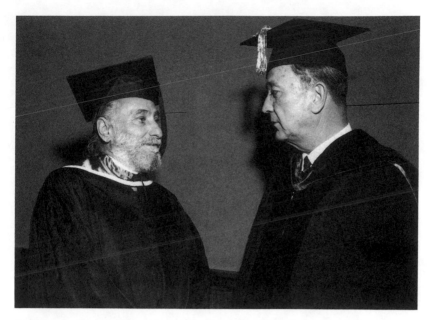

Figure 33. University of Arizona President Richard Harvill congratulates De Grazia after the artist received the Alumni Achievement Award in 1967.

boots. A graduation cap that replaced his cowboy hat was the only variation from his usual getup.

Marion accompanied De Grazia to the affair and the dinner that followed, along with Ron Butler and Buck and Leo Saunders. No liquor was served because they were on campus. Butler remembered with a laugh that "we were dying."[25]

16

On Bullfighting and Ballet

I must admit that while painting bullfights I feel many of the
same emotions that I experienced when I have participated
in a bullfight either as a spectator or torero.
—*De Grazia*[1]

THE RELENTLESS MALIGNING of his work as "cutesy commercial-
ism" continued to dog De Grazia, though he had long ago stopped
worrying about what critics thought, preferring to be labeled an
"artist of the people." Douglas Hale, a historian at Northern Ari-
zona University, wrote that no one would argue De Grazia was "the
darling of the public, not a painter's painter."[2]

Writing in the *Arizona Republic*, columnist Joan Bucklew defended
a statement she had made that De Grazia's work tended to be deco-
rative. "What's wrong with that?" she asked. "It is because his work
has been gay and pleasing to the eye and non-taxing to the gloomier
emotions that he has pleased so many people and had such a wide
appeal." Bucklew concluded her column by remarking, "I still con-
sider De Grazia's greatest work of art the man himself."[3]

Someone once approached De Grazia's brother Greg and said,
"You know, De Grazia is improving." Greg responded, "He paints
just as bad as he ever did; you are the one who has improved in taste."[4]

In 1966 De Grazia completed a series of paintings on bullfighting,
his favorite of all the exhibits in the Gallery in the Sun. "When I
painted the matador in this collection I was the matador—dancing,

skipping, swaying in front of the bull. When I painted the bull I was the bull—panting, sweating and feeling the pain in the muscles of my neck."[5] In 1967 Northland Press of Flagstaff, Arizona, published De Grazia's *Ah Ha Toro*, a fifty-three-page book that included commentary about bullfighting.

The series of twenty-six oils and sketches for the book gave De Grazia a means of defending himself against critics who considered him too commercial, especially those who claimed he could do little more than paint cute children and angels. Books were more intellectual, more academic. Critics loved them. For example, "Seldom has a more vibrant, exciting, dramatic and non-commercial De Grazia been seen by this writer," wrote Hal Moore of *The Arizonan*.[6]

Dick Frontain, an expert on bullfighting, posed as a torero for the oil paintings and worked on the book's text. "How strange it was to stand in the bedroom at 4 a.m., swinging a book like a muleta, and describing the positions to Ted who was sketching in his office." De Grazia told Frontain that if he were to put his face on the toreros he would become famous, but he preferred for readers to imagine their own faces there and feel brave.[7]

Arizona Republic columnist Bucklew noted that De Grazia's bullfighting pictures portrayed more sympathy with the bull than with the matador.[8] De Grazia remarked about the paintings that "all of the action has been retained—swosh! As an artist, this is the way a bullfight looks to me . . . as beautiful as a ballet . . . a tragic drama . . . a riot of color . . . charged with emotion . . . an atmosphere of music . . . I notice these things . . . the bullfight has color, lines, and power . . . lines are beautiful . . . power too, for when a bull charges, she shows positive power."[9]

When asked at a book signing at Buck and Leo Saunders's art gallery in Scottsdale about what seemed to be a new freedom of line and color in *Toro*, De Grazia replied, "Yes, there is much more freedom. I have a lot more freedom in my painting now—and a lot less freedom in my personal life. Once I thought that to have a lot of money would mean more freedom. But it means less. I am on the money merry-go-round. And I am not sure I want to get off." De Grazia then revealed that he was selling less of his art at this point, preferring to put it in books to sell. "I keep the paintings myself. I like my work, and I like to keep it."[10]

The books kept coming. In 1968, Best-West published *The Rose and the Robe: The Travels of Fray Junípero Serra in California.* As usual, De Grazia researched his subject extensively before putting palette knife to canvas. He spent almost a year studying the padre's life, beginning with his birth in 1713 on the Spanish island of Majorca, eventually retracing Serra's route from the Atlantic to Mexico City to San Blas and Lower California until he reached Velicatá, 270 miles south of San Diego.[11] "I followed in Father Serra's footsteps, trudging the path he took from Velicatá, Baja California, to San Francisco. I stopped, ate the native foods and seeds he had eaten. I dogged him until finally he turned around and faced me. Then I was ready to draw and write about him."[12]

De Grazia said he was the kind of painter "who must become involved with my subject . . . to know it, feel it and to understand it before I can truthfully sketch or paint it." Before he painted he did dozens of sketches. "I sketched and sketched and sketched," he wrote. "I was not myself anymore—I was living the life of Serra."[13]

Dolly Maw, a writer for *San Diego Magazine*, said about the book, "It is really soul painting, finely distilled essence. It comes as a shock to realize that there are no features drawn, yet the man is vividly there." Said De Grazia, "All the trips I made to California to trace the Padre's steps were in my mind as I faced each canvas, each bare canvas. What went through my mind were the thoughts I remembered on the way Fray Sierra must have felt."[14]

De Grazia also kept up a long relationship with the University of Arizona Press, writing or illustrating several books for the academic publisher. His editor there, Elizabeth Shaw, said De Grazia's writing needed a great deal of editing. They finally persuaded him to talk into a tape recorder so that editors could assemble the text from the recording. "We realized he was never going to do it as well as when he was sitting there, talking to us."[15] Karen Thure, the editor on several of his books, said De Grazia took editing well. "He never felt like somebody changing the copy or making a new transition was insulting to his stature," she said. Thure later went to work as a freelance editor for De Grazia.[16]

At one point De Grazia became disenchanted with the small royalties the UA Press offered him. "I could publish these things myself. The major outlet is the gallery. That's where they're making their money from. Why should I be subsidizing the university?"

Becoming his own publisher meant that De Grazia not only had to write and illustrate books, he had to learn about the publishing side as well. "You learn business because, well, you like being used but you hate like hell being abused. After you see the way people abuse you, you get smart."

He once explained his publishing experiences to a *Scottsdale Progress* reporter by showing him a book attributed to Dr. U. R. A. Boozer entitled *How to Live Longer and Be Happier*. A flask of Chivas Regal and two tin shot glasses rested inside the hollow "book." De Grazia poured a shot for himself and another for the reporter and remarked, "I never allow interviews without something to relax us." They polished off half the flask.[17]

Despite his building projects, his late hours of painting, and his numerous public appearances to sell his work, De Grazia still managed to remain prolific in other endeavors, including the adaptation of *Brooms of Mexico*, the book he illustrated for Alvin Gordon, into a night of music, dancing, and recitation at the Tucson Symphony's second annual International Music Festival in March 1970. The Tucson Civic Ballet based its performance on De Grazia's illustrations for the 1965 book of the same name, for which Alvin J. Gordon wrote the text. Robert McBride, a music professor at the University of Arizona, composed the music. De Grazia and McBride had played together in the UA band in 1932.[18] Richard Holden handled choreography for the show; folksinger Travis Edmonson sang "Malagueña Salerosa" and narrated Gordon's text.

The team came together not only out of friendship but also because each of them had encountered some aspect of the Mexican culture in their lives. De Grazia was born in Morenci, McBride in Tucson; Edmonson grew up in Nogales, Arizona, and Gordon had traveled extensively in Mexico. De Grazia involved himself in every step of the production. He even approved all costumes and sets, but he refused to touch any of them. Cecilia Hammarstrom, a costume maker for the ballet, said that De Grazia told them, "If he put one brush or hand on anything, then we'd have to burn it after we were through . . . because it was valuable if he had touched it." He attended rehearsals, often showing up sipping wine from a wineskin.[19] De Grazia, McBride, and Gordon went to the opening night

performance, which played to a packed theater. After the ballet the three of them joined Edmonson on stage to cheering and a standing ovation. Holden, however, was ignored. In his online autobiography, Holden never said why he wasn't called up with the others. He later said he didn't mind, "as it was a terrible ballet, anyway."[20] The music was eventually recorded as a phonograph album.

Tucson Daily Citizen drama critic Micheline Keating described the performance as portraying "the hardworking poor, the swish of whose brooms set the tempo for their day, the atmosphere . . . permeated with a kind of sun-drenched laziness."[21]

Edmonson and De Grazia teamed up again when Edmonson created a musical score to accompany De Grazia's art. They performed together before audiences in Tucson and Santa Barbara, California. "Ted painted music, and I played paintings," Edmonson said.[22]

At least once a year reporters from what were then called the "women's pages" of daily newspapers such as the *Arizona Daily Star*, the *Tucson Daily Citizen*, the *Tucson American*, and the *Arizona Republic*, interviewed the De Grazias about the idyllic life they led as a loving couple who rarely left each other's side—a stretch at best.

Self-absorbed De Grazia wasn't much of a husband. More and more, he left Marion at home to mind the store while he traipsed around Mexico and the Indian country of New Mexico and Arizona looking for subjects to paint, prospecting for gold, drinking with his buddies, and perhaps enjoying a fling every now and then. He knew Marion would take care of the gallery. She loved the gallery as much as De Grazia did.[23]

> *Oddly, sadly*
> *the one cherished the most*
> *is never there*
> *. . . and yet the neglected one*
> *is the one*
> *who cares*
> *and cherishes*
> *your creations*
> *and will protect them.*[24]

Figure 34. Marion and Ted De Grazia in happier days.

When Ted was home, the De Grazias lived a pretty simple life. On a typical day he would arise at three, four, or five o'clock in the morning to paint. He considered sleep a waste of time and often just took fifteen-minute catnaps to refresh himself.[25] He would wake up and do what he called quick midnight sketches in pen and ink. "You see, sketches are the very soul of an artist. They are fresh, they are meaningful and often more beautiful than the painting."[26] He put the date on many of the sketches and even included times, such as 1 a.m. or 3 a.m.

He liked quiet when he was painting, remembering hearing his mother say, "Be still and know that I am God." De Grazia believed that people with a fast-paced life had little time to be quiet. "You lose who you are if you can't find solitude and silence. That's why I paint at night, early in the morning, when the rest of the world is sleeping. I need silence to create."[27]

"The picture knows what it's supposed to be already," he said. "All I have to do is just listen and pay attention and I will see it, and then

I know what it's supposed to be." He said he entered another realm, a kind of slowed-down consciousness, as he painted.[28] Today, this state is known as "flow," a term popularized by psychologist Mihaly Csikszentmihalyi and described as a state in which people typically experience deep enjoyment, heightened focus and creativity, and a total immersion in what they are doing.[29] After De Grazia began working, no one was allowed to enter the studio, not even Marion, because "any straightening up would distract me and the continuity would be lost."[30] Said Marion, "I [don't] even knock on the door."[31]

De Grazia had to get in the mood before he put paint to canvas. "I do a lot of brooding before I begin work. You have to know what you're going to do when you walk up to the canvas, because once it's done, you can't go back and touch it up again." De Grazia sometimes painted to music about Pancho Villa and the Mexican Revolution, listening to folk songs like "La Adelita," "La Cucaracha," "La Toma de Zacatecas," "La Valentina," and "Las Mañanitas de Benjamin Argumedo." With lighting provided by a 150-watt bulb, a warm bottle of Chivas Regal, and a pack of cigarettes nearby, De Grazia would be ready to go. He would pick up his palette knife, and it would fly through the air, dipping and diving as he put paint on the canvas. If he got into a groove, he painted for hours without stopping, even though during the day temperatures in his studio could become almost unbearable.[32]

Reporter Maggie Wilson once stayed overnight at the De Grazias' home and then wrote an article for the *Arizona Republic* about how they spent their day. She arose early, before De Grazia got up, to find Marion working in the kitchen. "This is it," Marion said, "the very best time of the day. Sunrise. The play of light and shadow on the Catalina Mountains. And silence. The kind of silence that treats the ear. And beauty. The kind that makes you want to cry."

Not long after that, De Grazia strolled into the kitchen and demanded with a laugh, "Where the hell's my breakfast, woman?" Marion turned to the reporter and remarked, "And people say they envy me—being married to a great artist who creates beauty with every little flick of his finger. Ha! To that man, beauty is food on the table."[33]

After breakfast, he returned to his studio until 10 a.m., when the gallery opened for business. He would say, "Well, I've got to put on my other face because I have to go out in public." He called it "going

to work" because he considered operating the gallery to be work. Painting was not.[34] He would greet visitors in his usual prospector's garb and charm them with his expressive blue-green eyes that twinkled with happiness at the attention he received.

He always found time for visitors, chatting them up, kidding with them, acting like the rough-hewn prospector that he pretended to be, and signing prints and greeting cards as they watched him with awe and admiration. "Listen, these are my people," he would say. "Without them, where would I be? How can I not love them and accommodate them?"[35] But Marion knew how much he actually kept inside:

> *All of the visitors leaving with a smile will never know the depth of the artist's mind.*
>
> *That is private for he is a private person. Only that which is revealed through his work will they ever know.*[36]

"We are from New York," one visitor told De Grazia. He replied, "Yes, isn't everyone." Another time a woman told him that her husband was in the stock market. De Grazia answered, "Yes, I bought a carload of cattle myself this morning."[37] He could put a visitor in his or her place, too, if he were offended. Once a visitor told De Grazia that his kid could paint as well as he did. The artist replied, "That's fine. You should put him to work. By the way, has he sold any lately?" Another time a woman said, "Why, I can get prints like that for a dime a dozen." De Grazia pulled a dime out of his pocket and shot back, "That's wonderful. Bring me a dozen."[38]

He couldn't stand arrogance. One time a visitor told De Grazia he could afford to buy all of his paintings, but he wouldn't because he didn't like them. De Grazia retorted, "Nobody says you have to buy [them]," then turned his back and stalked away.[39] Another time a man made a derogatory remark about a $300 picture his wife wanted to buy. De Grazia decided right then and there to add a zero to the price. Of course, the woman didn't buy the painting. "None of my work should have to put up with people like that woman's husband," he said.[40]

Once a woman came up to De Grazia holding something in her hand behind her back. She said, "Mr. De Grazia, I'd like to show you a copy I made of one of your paintings." He replied, "Oh, yeah?

Okay." He pushed back his hat, looked at it, and said, "Damned good. Here." Then he got out his paintbrush and signed his name to it. When he handed it back to her, he said, "Now you have an original."[41]

At ten minutes to four a bell would ring in the gallery, telling visitors—and employees—it was time to leave. As 4 p.m. approached, Bernardino or Two Guns would go into De Grazia's office, where he would pour them a glass of Chivas Regal, "and they'd be on their way," said Dave Fisher. Two Guns was a colorful character who wore a wide sombrero, a serape, and a gun on each hip; De Grazia liked having him hang around.[42]

De Grazia wasn't often fussy about dinner. He would reply when Marion asked whether he liked a certain dish, "I ate it, didn't I?" On one occasion he grumbled when she put ham in his enchiladas, "Don't monkey around with them." They spent evenings reading, except when Marion watched *Jeopardy* on television, a show she loved. De Grazia would plan for the next day of painting or read or watch a western on TV. At times he retired early, sometimes getting up again about 10 p.m. to paint.[43]

Marion felt it was a woman's job to "stick by her husband while he is attempting to reach his goal." She did that by taking care of the mundane side of their life so that he could paint and travel. De Grazia acknowledged that he owed a great deal of his success to Marion. During the interview with Wilson for the *Arizona Republic*, De Gratz, as Marion called him, came into the room from his studio and said, "Forget everything the old lady told you. She gets mad when I say it, but she did all this," waving his arm around the expanse of the room. "Without her, none of this would have happened. I would be the biggest bearded bum in Arizona. I've done it because of her. That's all there is to say."

Marion told Wilson, "Sure, I'm a woman to be envied. To watch a man create things of beauty has to be one of the most exciting, exhilarating experiences there is. And I watch it happen constantly. . . . And I happen to be crazy about him. So, of course, I'm envied."[44]

They had a certain respect for each other, although their relationship lacked any shows of affection. Hal Grieve described his mother as a "cold fish."[45] She and De Grazia lived together but apart. When not traveling, he spent most of his time in his studio, painting, painting, painting. He liked being alone; she felt lonely.

De Grazia liked nothing better than belting back a few and having a good laugh with his buddies. Edmonson said that De Grazia "was not what you'd call a sweet man. He was a man's man any way you look at it, and tougher than nails."[46]

De Grazia once gave a telephone to a friend who couldn't afford one. When he asked her why she drank so much, she replied, "Because I don't have a family." De Grazia responded, "I drink so much because I have a family."[47]

Marion, on the other hand, drank when she was alone—and that was often. When she drank around his friends, she often embarrassed him. At times she would wander off into the desert at night and not return until the next day.

Alone
By myself
When
You came home
I was alone
And you
Went away
With yourself
By yourself
Alone
Miserere [Latin for have mercy][48]

The De Grazias enjoyed the wildlife, ranging from desert tortoises to rattlesnakes and from quail to javelina, that shared their foothills property. They once took pity on a three-legged female coyote they saw prowling down in the wash outside their dining area. The coyote apparently had chewed its leg off to escape a trap. Knowing it would be difficult for the animal, which they named Martha, to run down prey, the De Grazias set out to help her.

They had built near the mission what they called "our air-conditioned bedroom," a twelve-by-twelve-foot platform holding a king-sized bed atop four telephone poles to protect them from animals while they slept. They climbed a ladder each night to the top, which was enclosed by a railing to keep them from rolling off to the ground eight feet below.

To help Martha, De Grazia hooked a wire cable on one corner of the railing and dropped it down to the dry wash the coyote inhabited. The wire served as a pulley. Every night before the De Grazias retired, they put table scraps in a pan and eased the pan down into the wash. The pan had a bell attached so that it jingled when the coyote ate. Martha, of course, gobbled up everything. A small bronze sculpture that De Grazia made of the coyote resides today in the Gallery in the Sun.[49]

Once he invited friends to stay overnight and sleep on the platform. It was "the most miserable night we ever spent," said Varda Pritchard. "Because [of] the animals howling, we didn't sleep a wink. And it was a real hard bed."[50]

De Grazia prohibited killing spiders and termites found on the property. Teachers Norma and Dave Fisher, who worked summers in the gallery, recalled that spiderwebs infested the Nun's House. De Grazia told the Fishers to leave them alone. They also pointed to termite tunnels that were visible on a beam in the house. "Well, they have to eat, too. Don't worry about it," he said. Norma Fisher remembered cleaning the Nun's House. "I would leave the wolf spiders alone, because they're big and spectacular and harmless," she said, but she did kill black widows and didn't tell De Grazia.[51]

Marion captured something of their special relationship with the desert wildlife:

Alone by myself
as I waited and waited.
Suddenly you burst in the door.
At my feet
you laid a desert turtle.
You were silent.
The turtle was silent.
Silence is beautiful
Silence is full of mystery.[52]

While drinking was part of De Grazia's macho image, he would embellish it by going as far as watering down his whiskey or putting tea in a whiskey bottle so it looked like he was imbibing more than he actually was. He made luminarias out of empty Jim Beam bottles

and often carried a pint in his hip pocket. In De Grazia's early days in Tucson, he would carry around a bottle of liquor that he placed on a table at lunchtime to share with his friends. An interviewer once asked Abe Chanin, the former *Arizona Daily Star* newsman, if De Grazia was a happy man. "Well," Chanin said, "I think he had to be very happy, since he always kept a case of scotch in his truck."[53]

"He never painted drunk—never," Travis Edmonson said. But photographer Sheaffer disagreed. "He could paint just as well if not better" when drinking. He said he once watched an "under the influence" De Grazia paint, in about ten or twelve minutes, a picture of an Indian boy that he then gave Sheaffer. Sheaffer said he was later offered $1,000 for the painting.[54]

De Grazia was known to smoke, drink, or eat anything that he could put in his mouth: cigarettes—in lean times he'd roll his own; chewing tobacco—"I take Copenhagen just to feel I belong to the world"; cigars—"I don't take the band off so people will know what kind of cigars I'm smoking (Garcia y Vega); pipes; peyote; marijuana; pulque and *bacanora*—alcoholic beverages made from the juice of the maguey or agave plant; and other liquors, preferably Chivas Regal scotch. De Grazia drank cheap whiskey when he was poor but switched to Chivas Regal when he became successful. The story goes that he sat next to a millionaire on an airplane; when the millionaire ordered a Chivas Regal, De Grazia figured that was what "us millionaires" drank.[55]

Workers cleaning up the property after De Grazia's death discovered a cache of peyote, a hallucinogenic drug prepared from a cactus, in one of the storage rooms. They also found drug paraphernalia, presumably for smoking pot.[56]

Once when Chanin was interviewing De Grazia on the gallery patio, the artist's secretary came out to tell him that a policeman wanted to see him. Chanin noticed perspiration break out on De Grazia's forehead. He turned to Chanin and said, "You know, I think they finally got me." Chanin replied, "Ted, what do you mean 'they got you?'" He told Chanin he had been smoking marijuana in Casa Grande, Arizona, with friends, "and I think they must have found out about it." The plainclothes policeman walked up to De Grazia and said, "I'm sorry to interrupt you, but Mr. De Grazia . . . I've always wanted to meet you, because I've always wanted to shake hands with you." De Grazia was so relieved that he almost fell off his chair.[57]

Years later in a TV interview, Rita Davenport, who was host of *Open House* on KPHO in Phoenix, asked De Grazia how he got in the mood to paint. He responded with a twinkle in his eye, "Marijuana," and then he quickly followed up by saying he didn't need any stimulus to paint. He said he was "in the mood all the time."[58]

De Grazia liked nothing better than to get his buddies together, belt a few, swap stories, and eat. To prepare for these shindigs he would dig a hole about three feet deep and two feet wide outside the original adobe house and line the hole with fire bricks. Then he piled paper, kindling, and firewood in the hole, topped off by river rocks. He let a fire burn for about three hours before the hot rocks dropped to the bottom. Then he took a pound of round steak for each person, smothered each steak in salt, and wrapped it in gauze. After dropping the meat into the hole, he covered it with a tarp, followed by dirt to keep in the heat. Dinner took about four to eight hours to cook, depending on the amount of meat. He called it "Apache meat." Friends would arrive, and the booze and talk flowed freely while the group sat around a mesquite fire waiting to eat.[59]

As De Grazia's fame grew, it became difficult to coax him away from his property except to do exhibits and signings. He rarely agreed to go to someone's house for dinner, although friends would drop by for a barbecue now and then. One night the De Grazias were invited to Rae and Fred Landeen's house for dinner, along with Ross Santee and Olaf Wieghorst. The Landeens served a dinner of hasenpfeffer, a traditional German stew made from rabbit. De Grazia and Marion got into an argument about what the dish was. That brought laughter from Santee. Ted got angry, bolted out the door, and said he would not return. He apparently went someplace where he "got his nose in a jug pretty good," as Landeen put it. Sometime later De Grazia returned to the Landeens' house. He didn't explain his absence. "No, he just came in and sat down, entered right into the conversation as though he'd been there every moment of the time," Landeen said. "I'll never forget that one."[60]

In the mid-1970s De Grazia entered into an agreement with a Scottsdale stained-glass studio to do reproductions of his work. Owner Ken Toney made glass pieces that ranged in price from $18 for little De Grazia angels, Indians, and children to use as holiday ornaments or to hang in windows all the way up to $1,900 for entire

Figure 35. Fellow artists Pete Martinez, Ross Santee, and Oleg Wieghorst look on as De Grazia cooks "Apache meat" in a pit.

windows or wall-hung light boxes. "De Grazia and I were leery at first," he said, "but he had done stained-glass work himself and was happy with our quality so we struck a deal. I now see a lot more in his artwork than I've seen before. When you have to reduce his paintings to pieces of colored glass, you realize that his simplicity of form is really masterful skill." Toney said he expected his gross revenues to jump from $150,000 to $450,000 because of sales of

De Grazia glass.[61] Just before De Grazia died, Toney was selling little stained-glass items in more than 600 outlets.[62]

While the bulldozers De Grazia hated were closing in on his foothills property, they also were demolishing an important structure from his past. In March 1969, the Plaza Theater in downtown Tucson, which De Grazia had managed for three years in the late 1930s and again in 1943, was closed, scheduled to be torn down as part of an urban renewal project. De Grazia, unhappy with what he called "bourbon renewal, with all its bungling and demolition," raged that "the whole idea burns me up." He reminisced about drinking with customers at the theater, "and if necessary [I'd] fight with them. I'd throw them out if they got too boisterous, but all in all I had a ball."[63]

The DeGrazia Foundation archives contain a scrapbook full of articles written in 1969 by Carl Payne Toby for which De Grazia drew astrological signs. The articles, "This Week in Astrology," were syndicated to at least twenty-five newspapers by the Newspaper Enterprise Association. One clipping predicted that the Kennedy family would be in more trouble. A few weeks later, on July 19, 1969, Mary Jo Kopechne drowned in Ted Kennedy's submerged car.

De Grazia decided to go out on his own with a self-published volume, *De Grazia Paints the Signs of the Zodiac*, a forty-nine-page book he called "the hottest thing I've done. . . . It's really an art book. I don't claim to be an astrologer or a writer." The paintings had a definite Mexican flavor, with a few alterations to the typical symbols. For example, his Aquarius is three women carrying water jugs on their heads. His own birth sign, Gemini, depicts Pancho Villa's army, with two marching, gun-laden soldiers. He started a promotional tour for the book in Yuma, Arizona, and then headed to Los Angeles, La Jolla, and San Diego.[64] One hundred special-edition copies, which included original watercolors, sold out in six weeks at $250 each. The paperback book sold for $12.

Autograph parties for the zodiac book, like most others, were hectic, demanding, and tiring, but De Grazia never let up. "Sure I get tired. After a week of traveling, meeting thousands of people and signing hundreds of books, cards, and prints, anyone would be tired, but that's part of the price you have to pay. They are my public. . . . They put me on top. I love them and they love me. Still,

the more you are exposed, the less time you have to call your own. That's what I mean when I say I'm fighting over-exposure. I need time alone—brooding time."[65] He would skip dinner on these trips and retire to his hotel room with a bottle of Chivas Regal at 4 p.m.[66]

The zodiac book offered De Grazia a chance to explain his religious beliefs. In the opening section, entitled "The Artist Wonders," De Grazia wrote: "I like to believe that when God created our world He went around the universe far away and created many other worlds like ours—maybe a little different—with more suns, more stars, and even more moons. Worlds with mountains to climb, water and skys [*sic*]. Some worlds more advanced than ours and some more primitive—still in the Stone Age. I believe that people on the other worlds are people like us and that someplace somewhere there is a heaven, a place for dreams. And, too, I believe that God created men everywhere in his own image, but he is a small man with feet of clay."

In 1971 Marion De Grazia gained some attention in her own right, even though she preferred to remain out of the limelight.[67] The Gallery in the Sun published *M Collection*, a book devoted to her sculptural works in bronze, wood, clay, Nambé metal, wax, and papier-mâché. Ted did the layout and contributed a series of ink drawings and watercolors that complemented her artwork.[68] "She sculpts and plays with clay and does very well," he said.[69]

De Grazia often sketched or painted before an audience, taking as little as ninety seconds to complete the work and then donating it to the organization to use for fund-raising.[70] In August 1971 he traveled to Altus, Oklahoma, a town of 22,000, to be honored by a women's group, the Erolethian Club. *Erolethian* means "searchers of truth." About eight hundred people turned out to watch him sketch a picture that he donated to Altus Junior College. He also signed autographs. The club gave him a new cowboy hat.[71]

A year later, he was honored by Duke University in Durham, North Carolina, with an exhibition of one hundred of his paintings. The private university hailed De Grazia as "unlike any other artist. He is not to be categorized."[72]

17

Finally, a Retrospective

Oh, I miss those old days when I could
walk into a bar and raise hell.
—*De Grazia*[1]

IN THE FALL OF 1971, Frontier Heritage Press published a 191-page biography of De Grazia entitled *De Grazia: The Irreverent Angel* by William Reed. Reed had won the 1970 Best Western Art Book of the Year award for his biography of cowboy artist Olaf Wieghorst. He followed De Grazia throughout the Southwest and Mexico off and on for several years, carrying with him a tape recorder, pen, and pad.[2]

While the book is quite readable, it offers little insight into De Grazia's private life, which was exactly the way the artist wanted it. It's really a coffee-table book, beautifully illustrated with one hundred color reproductions of De Grazia's work. It was written with his cooperation, but De Grazia said, "It's not my life because I didn't tell them everything."[3] That is understandable from De Grazia's perspective: He zealously guarded his privacy and he would let no one get an intimate look at his life, even if it helped sell more books. Reed did come up with one good insight, though: De Grazia's "psychological makeup," he wrote, "is a complex mingling of unbounded self confidence and a defensive façade of bizarre action and statement. This is a weapon which he wields with abandon when he feels challenged; it is used more subtly during his frequent moods of mischief. Those who know him well can tell the difference by the intensity of the gleam in his eye."[4]

In November 1971, De Grazia, Reed, and Shorty Thorn donned their cowboy hats and hit the road, heading to the Yuma Fine Arts Association, where, fortified with pitchers of margaritas provided by the hosts, De Grazia and Reed autographed the book. De Grazia brought along his own books and prints as well as a phonograph album of his pithy philosophy to sell. A reporter asked Reed what it was like to put De Grazia's life and art into words. "I had trouble keeping up with him," Reed said. "It was about the most frustrating and productive thing in my life. Ted's a challenge; there was a game he played called, 'Guess what I'm thinking.' . . . Some of Ted's fans are mad about the 'irreverent' part. They say he's just an angel, but he really isn't."[5]

Even as De Grazia attended these promotional events, so necessary to his success, he always yearned to get back to Indian country. During an exhibition in Phoenix, he told a reporter, "You ever been to a chicken scratching? That's what I'm really up here to see. I just came in from it, and I'm going back. Indians up there playing polkas and dances. They do it in their own style. I can't tell you where they do it. Somewhere up there off the road," he said, pointing north. "I gotta get back soon, I told 'em."[6]

De Grazia's paintings began to skyrocket in value in the 1970s as his art became more popular. Oils went for $10,000. Lithographs in limited editions of 25 cost $600 apiece. A limited edition of 125 serigraphs sold for $260 each. And an etching limited to 30 prints went for $300 each print.

Being rich and famous created contradictions for De Grazia. He adored the attention but often wanted to run away from it. He was making a lot of money, which he said he didn't need, but he kept working to make more. "Fame has too much responsibility," he said. "People forget you are human."[7]

In 1972 the University of Arizona approached him about staging a retrospective exhibition of one hundred of his paintings. De Grazia, recalling how the university had shunned him in 1943 when he sought an exhibition, replied with some bitterness, "I needed you in 1943. Where were you then? Now, I don't need you anymore." He eventually relented, but only after setting some conditions.

He wrote to director William Steadman that the retrospective show was important to him "because it is almost fifty years of painting

and that is a hell of a long time. Any dummy who paints for that long is bound to be good." De Grazia demanded that an exhibit of his work "must be the best show you've ever had." He rejected a proposed catalog of his paintings, insisting on a book instead. Steadman agreed to the book and had it produced in time. In the introduction Steadman called De Grazia "a genius who records memorably and for eternity the way we Arizonans look, think, and act."

Steadman turned down De Grazia's request that the show run for six months to a year; it ran for nine weeks, from November 3, 1973, to January 6, 1974.

De Grazia also gave Steadman advice on how to put on the exhibition. "The impact of the show must have sparks like when a hammer hits an anvil, so the publicity must really be good. . . . After all, my work is sold internationally, and I am the most reproduced artist in America, having more work of mine in prints than any other living artist." Then he got in a little dig. "You know Bill, I don't get along with Museum Directors anyway. They are not my kind of wood with the exception of a few. The rest or ninety-eight percent should be wearing tu-tus."[8]

As the retrospective's opening day approached, the *Arizona Daily Star* wanted to do an article about De Grazia. Features editor Virginia Lee Hodge wrote to De Grazia that the *Star* had hired a new art columnist, Adina Wingate, who was twenty-four years old and "a really bright kid." In an October 5, 1973, reply to Hodge, De Grazia said he cared not a hoot about publicity at the age of sixty-four and that he wasn't fazed to be interviewed by "a snot nose with a degree in art history." After a few paragraphs of raving and ranting about Wingate's youth and probable lack of experience, De Grazia closed his letter with the hope that "she is well versed and has done her homework before she talks to me."[9]

Wingate met De Grazia at Rosita's Mexican restaurant. She said she felt like she was walking into a lion's den. De Grazia sat surrounded by friends and began posturing for them about the interview. "I don't have any need for what you do," he barked, hinting that he was irritated by being interviewed. Wingate, who wanted a "connected conversation," not one in front of a group of people, felt a bit intimidated, not so much by De Grazia but by those surrounding him. She refused to grovel in front of the famed artist, however, so she decided to leave even though she knew this was an important interview. As she got up, De Grazia calmed down. She had called

his bluff. "He could see it in my face that I meant it. I didn't have to say anything." De Grazia then invited her up to the Gallery in the Sun, where they spent the next three or four hours discussing his art.

Wingate came away from the interview with a better understanding about how De Grazia's work had been influenced by the great Mexican artists. She knew full well that De Grazia had become more "commercial" because of his need to survive as an artist. The article appeared November 4, 1973, in the *Star*. De Grazia never commented to Wingate about her column, nor did their paths cross again.[10]

Not surprisingly, at a reception in his honor the night the retrospective opened, practically a black-tie affair, De Grazia showed up in his usual attire—boots, jeans, flannel shirt, and cowboy hat. The show came off without a hitch. The exhibit included 109 paintings that Buck Saunders had appraised at $560,200. In a review, Wingate called the show "a thorough and excellent assemblage of this Tucsonan's contribution to the field of art."[11] An editorial in the *Star* noted how the university had failed to recognize De Grazia's talent in his early years but had rectified that by staging "a remarkable show."[12]

Tucson Daily Citizen art critic Robert Quinn wrote, "Here, in presenting a model which so effectively counteracts any effete academic insistence upon craftsmanship and intellectuality, there has been filled . . . a long needed and totally admirable gap."[13]

After the exhibit De Grazia wanted to donate the paintings to hang on permanent display in the university's art museum, but he was turned down because the school lacked space. A UA spokesman said the school only had room to put up a third of the paintings it already had on hand. De Grazia feared his paintings would wind up "crated, gathering dust in some basement, so I said I would give them the [paintings] provided they would hang [them]."[14]

He told the *Arizona Daily Wildcat*, the university's student newspaper, "When I was younger, I felt that each painting I did was mine. As I got older, something changed, and I began to feel that if the public likes to see my paintings, then the paintings belong to them. Hell, I can't eat my paintings. . . . If my alma mater can't [give my paintings a home] then I'll give the collection to someone who can."[15]

UA president John Schaefer made an unpublicized offer on April 19, 1975, to De Grazia to auction off some paintings in order to raise enough money to build a museum to house his work. De Grazia turned that down as well. He wrote back to Schaefer, "I want the

people to want my work; and I feel that if the community wants my work they will provide a building for it."

New Mexico governor Jerry Apodoca, the San Diego Historical Society, and Arizona State University also wanted De Grazia's collection, but he rejected them as well.[16] Tucson mayor Lew Murphy tried to get De Grazia to donate his paintings to the city. De Grazia replied, "The hell with you, unless you have a museum." Murphy left empty-handed.[17]

The squabble over a building on campus to house his paintings intensified De Grazia's cynicism, hatched all the way back in his student days, about the UA. "He just hated [the university], and he could not be swayed," said Karen Thure. "He could not forgive. . . . He just loved to rail against them, how much he hated them, in a very blind and ignorant way."[18]

De Grazia often clashed with people who sold his artwork, and he usually won. Rick Brown, who operated Sandstone Creations, sold hundreds of De Grazia prints in the 1970s. He would go round and round with the artist about what to print. De Grazia wanted Brown to do bullfighters, religious scenes, and even a pink mouse eating a watermelon. Brown, incredulous over the mouse, told him, "Ted, that's not going to sell for me." De Grazia replied, "Just watch."

One of the questions most often asked of De Grazia was, "What is your favorite painting?" After the discussion with Brown, De Grazia replied, "This pink mouse eating a watermelon." Twenty people snapped up the print. De Grazia turned to Brown and said, "See?"[19]

Another time Brown complained to De Grazia that they had a batch of calendars nobody would buy because they were outdated. De Grazia told Brown not to worry. Double the price, he said, and limit the purchases to two per customer. The calendars sold out in no time.[20]

In October 1972, Jim La Fond, a newly hired Goldwater's department store vice president in Phoenix, showed up for his first day of work. Arriving an hour before opening, he saw about five hundred people lined up outside the store. Must be a sale, he thought. It turned out that Goldwater's had brought in De Grazia for an appearance. Before the day ended, three thousand fans had met De Grazia, bought some memorabilia, or snagged his autograph.[21]

La Fond soon persuaded Goldwater's to order five thousand collector's plates with *Los Niños* on them. The first five hundred plates, numbered and signed by De Grazia, sold for $100 each. They moved

so fast the price on the next five hundred rose to $500, and the rest went at $1,000 each. "We could have sold twenty thousand of those plates," La Fond said. Before this plate, the best-selling ever had been a Hummel by Goebel in 1971.[22]

La Fond recalled a plate convention that he and De Grazia attended in Century City, California, where two thousand people lined up to see him. "When he arrived, they all started cheering, hollering, patting him on the back," La Fond said. "There were actually three movie stars in that line waiting to meet him who were signing autographs for other people in the line. The whole thing just gave me a chill—it took him almost half an hour to get to the head of the line so he could start meeting people officially."[23]

De Grazia now could afford to reject offers to show his work around the United States and Europe. "If they want to see my art, they can come to Arizona," he said. Asked why his work wasn't in museums, he grumbled, "Museums are for dead people, and I'm very much alive."[24]

Sometimes his fame became confusing, even humbling. Once after a personal appearance at Goldwater's, he, Shorty Thorn, and Jim La Fond went to Trader Vic's for an early dinner. When he walked in, the restaurant was nearly empty except for a table occupied by four elderly women. Their eyes followed De Grazia as he passed their table. He typically tensed up at such times, when people obviously recognized him. After his party had been seated and had ordered drinks, the women came over. De Grazia stiffened. One of the women asked if she and her friends could get his autograph and put a napkin in front of him. As he was signing, the woman chirped to her friends, "Can you imagine how excited all the girls back home will be when they've found out we met and talked with Gabby Hayes?"[25] (Hayes was a character cowboy actor who had died several years earlier.)

Being besieged with autograph requests from fans may not have been unusual, but some of the things he signed were. Over the years these memorable items included a taco shell and the side of a travel trailer.[26]

A consummate self-promoter, De Grazia once complained to Jack Sheaffer that he couldn't get write-ups in the paper. But he got his wish for a story—just not the kind he wanted—after surviving a wreck at 7 p.m. on July 25, 1973, following a drinking bout with a doctor friend. De Grazia ran a red light and collided with another car at West Twenty-Second Street and Interstate 10. His Jeep overturned twice. He was taken to Saint Mary's Hospital, where he was treated

for a head cut and bruises. The other driver sustained a cut lip. After
a story about the accident appeared in the *Tucson Daily Citizen*,[27]
De Grazia complained to Sheaffer, "Damn it, you almost have to kill
yourself to get publicity."[28]

De Grazia had to be kidding; no artist in Arizona received as
much publicity as he did. In newspaper terms, "good copy" described
De Grazia because he could be counted on to provide reporters with
a colorful story at any time.

That same year *De Grazia Paints Cabeza de Vaca* came out, a
self-published book that *Arizona Highways* called his most serious
work yet and one of his most important because of its documentation
of southwestern history. The magazine praised it as a "smashing
contrast of simple text and powerful illustrations. It is a striking book.
. . . This is not a book of angel forms and adorable children. This is a
book as real as the fascinating . . . heroism it portrays."[29] The Spanish
explorer Álvar Núñez Cabeza de Vaca wrote the first European book
devoted completely to North America, describing his perilous jour-
ney from what the Spaniards called La Florida through present-day
Arizona and Mexico between 1528 and 1537. De Grazia's book is the
author's interpretation of Cabeza de Vaca's journey. *Arizona High-
ways* called the journey "the most important movement of civilized
man. [It] started with . . . four men . . . who . . . by venturing into
inland North America, north of Mexico and west of the Mississippi,
became the precursors of the Great American West."[30]

After the book about Cabeza de Vaca, De Grazia came up with
another idea for a ballet, this one based on a book he was working on
called *De Grazia and His Mountain, the Superstition*. Diane Fisher,
a high school art teacher whom De Grazia befriended during the
Brooms of Mexico ballet, visited the gallery one day when De Grazia
brought up the proposal. She presented the idea to the Tucson Civic
Ballet's board of directors, which after some contemplation agreed
to stage it. Because De Grazia's historical book had no real plot,
ballet officials had to make up a love story between Jacob Waltz, the
apocryphal Lost Dutchman miner, and an Apache maiden.

Fisher worked with De Grazia to get the sets as close to his paint-
ings as possible. "He really sanctioned everything," she said.[31] She
put together sets of the mountains that ranged from ten to eighteen
feet high. "I tried to get the feel of Ted into the ballet through colors

more than anything else," Fisher said.[32] Even so, De Grazia wanted folks working on the ballet to visit the Superstitions to get a better feel for them. "He was so excited, so insistent that this was the way," Fisher said. "I couldn't do anything until I saw the real thing. I couldn't just take his idea. I had to get the idea myself." He paid for the entire trip, putting the group up in a hotel overnight in Apache Junction and then having a trail driver take them, with food, into the mountains. Fisher drew some sketches, which she said did help her capture the aura of the mountains.[33]

The folk ballet, *Legend of Superstition Mountain*, ran from April 27 to 29, 1973, filling the 2,300-seat Tucson Community Center on opening night to two-thirds of capacity. De Grazia brought members of his family to the performance, although records fail to identify who they were.[34] The written program described the ballet as "a story of the fabled Arizona mountain and its gold, and of how they affected the lives of the people—Indians, miners, settlers—who successively came to the area. It is a tragically beautiful tale of human emotions: greed, anger and violence, celebrative joy, tender love."[35] Branson Smith, who wrote the music, said he wanted to write "a masculine ballet" and so incorporated into it a sixteen-man chorus.[36]

After the performance, the ballet's artistic director introduced De Grazia, who ran up on the stage and hugged and kissed choreographer Richard France on the cheek.[37]

In a review the day after the ballet's opening, Robert Moore, the *Arizona Daily Star*'s music critic, called the production "an interesting historic tableaux to music, a brilliant and sexy ballet on how the Dutchman found and lost his Apache maiden and his gold mine, and a colorful but stark reprise of the whole story."[38] The *Citizen*'s Micheline Keating called it "a lively, fun ballet as well as meticulously staged and expertly danced."[39]

De Grazia certainly failed to quiet the critics who called his work commercial when he allowed the United Bank of Arizona to produce checks featuring reproductions of five of his paintings: *Roadrunner*, *Navajo Family*, *Girl with Piggy Bank*, *Navajo Groom*, and *Navajo Bride*.[40]

Furthermore, De Grazia gave permission—in exchange for a cut of the proceeds, of course—to an artists' guild to "capture and

interpret" his works in their own media—china painting, dolls, candles, jewelry, and others. De Grazia had to OK the artists' work if they were to have his name associated with it. After the guild members reproduced De Grazia's images on their goods, De Grazia would sign them on the right side, the guild members on the left.

The guild members included Jodi Kirk, who put De Grazia's images on numbered and limited plates; Carol Locust, who transfered his work onto enamel pendants and plaques; Adele Smith, onto handbags; Jan Norriss, who translated his images into needlepoint patterns; Yvette Clement, into porcelain figurines; Delia Figueroa, onto appliquéd pillows; Shirley Van Cleef, onto candles; Barry Seidel and Michel Marzano, into silver jewelry; and Ginny Moss, into dolls.

Moss had heard of De Grazia long before she joined the guild. The twenty-year-old wanted to be a guild member but for two weeks couldn't get up the courage to approach him and seek his approval. When she did, she was terrified. She walked into the gallery where De Grazia was signing prints for visitors and noticed, "There was a magical aura around him, no kidding. He was so in his element and enjoying his fans." De Grazia looked up at her, "and his eyes sparkled." A buyer at Levy's department store had told her that her dolls would sell, so De Grazia took them on. They were priced at thirty dollars in limited editions and fifteen dollars for others. Buyers knew that the dolls hadn't been made by De Grazia, that he only signed them, as did Moss, yet she sold between three thousand and four thousand of them over the next four years. She paid De Grazia royalties of half her wholesale cost, often traveling with De Grazia and other guild members to Phoenix, California, and New Mexico for shows.[41]

Signed bells with De Grazia images on them also proved to be popular. He agreed to allow other painters to copy the images onto the bells, which were produced by Rick Brown's Sandstone Creations. Brown was amazed at how well his staff could copy De Grazia's work. "Yet . . . he always had to find something wrong with anything that I did, because he didn't want us to be better than he was," Brown said. "He might take and reposition the eyes, when I brought it down for his OK, or change the hair or something. He would find something every time."[42]

De Grazia also helped set up Tish Holland and Cassandra Prescott in a needlepoint business that became quite successful, at his former

studio on North Campbell Avenue. Not only did they sell De Grazia–inspired needlework that they had stitched, they also put together kits that allowed people to do their own. This strategy proved to be so popular that stores began flying Holland and Prescott in to show them how to prepare similar displays. De Grazia loved it; he wanted the two women to make him famous in other parts of the country. At one point, Prescott said, they shipped as many as 100,000 De Grazia pattern books to the Southeast.[43]

Sometimes people substituted different colors of thread for the ones that came with Prescott's and Holland's kits. One woman stitched De Grazia's *Little Drummer Boy* in so many different colors that it looked terrible, Prescott said. The woman planned to show it to De Grazia. Holland and Prescott looked at each other and thought that would be the end of their business because De Grazia wouldn't like it. They held their breath while they waited for the inevitable phone call from him.

"So sure enough, he called," Prescott said. De Grazia told them, "I know you know this woman came out today and showed me this drummer boy that she did. I know that you know it's not the best work, but you know what? She was happy, and that's what I want. I want people to be happy with my work. She was thrilled, and I just want to tell you that it's okay. That's what I'm looking for."[44]

Once while meeting with Holland and Prescott he told them he had thirty-six "illegal" children. The women were too embarrassed to reply. They had heard of his reputation as a womanizer. ("We used to call him a dirty old man . . . but I think he just enjoyed women," Prescott said.)[45] Then he said to them, "You don't know what illegal children are, do you?" They confessed they did not. He then told them he was sponsoring children to come into the United States illegally so they could go to school here. "What I do is, I sign their immigration papers when they cross the border and say I'm their father." Prescott remembered chuckling, thinking "that it was really clever the way he wanted us to think that it was something outrageous."[46]

De Grazia never managed to shake off the negative opinions of critics; but then he didn't particularly care whether he did. He did let loose a blast now and then, though, to put them in their place. "I'm being damned and condemned by other artists," he said. "They say

nobody can paint as badly as I do and get by with it. But your bank account is the measure of your success. . . . I hate museums, I hate critics. . . . I try to tell the common man what my work is. The more understanding, the more appreciation—and critics can go to hell." By that measure, with his net worth in the millions, De Grazia was an enormous success.[47]

He loved to be considered rebellious. For example, he would paint pink horses with odd proportions, and he would get "scolded. To hell with that. If I want to stretch the neck of a horse, I'll stretch it. If I want to paint a pink horse, I'll paint it. That is what it's all about—not doing it the way they want you to do it, but doing it your way."[48]

De Grazia had fans around the world, including the Reverend Theodore M. Hesburgh, president of the University of Notre Dame. On August 18, 1975, Hesburgh wrote in a letter to De Grazia that he desired to purchase an original painting so a friend could give it to his wife on their fiftieth wedding anniversary. If an original was unavailable, Father Hesburgh wrote, he would commission one.

It took De Grazia six weeks to reply because he had been in Indian country. When he did respond, he wrote a philosophical letter that said, in part, "The name of the game is to get there. Where, I don't know. I aimed and I got there. But when I got there I was tired. My beard was grey. Though I was selling quite a lot, all I was doing was accumulating money. What for, I don't know."

He then wrote to Father Hesburgh that he was through painting. "I laid my brushes down and I quit. . . . I was at the very peak of my career. I didn't want to go higher and I didn't want to accumulate money." (De Grazia did quit painting for a while but continued to work in ceramics and other crafts.) In the letter, De Grazia referred Father Hesburgh to Buck Saunders to see if the Scottsdale gallery owner might have some originals. "As for me and the system, I want out. I think perhaps I will look for gold in the Superstition Mountains." He enclosed pamphlets and Saunders's business card.[49]

De Grazia never missed an opportunity to avoid dispelling myths that he created about his life. "I have been married seven times and have twenty-three children," he told the *Orange County Register* in October 1975. Did he acknowledge all of his children? "You're darn right, I do. They are mine."[50] A year later it was twenty-four children.

The number of wives ranged from six to eight. When he was asked yet again how many wives and children he had, he said, "I never did figure out how many of the children are Indians and how many are not." Then a smiling Shorty Thorn popped up, "Everywhere you go in Nogales there's a De Grazia." De Grazia continued, "I always have a wife. You gotta have a wife. The Lord made men and he made women. That's the only law I know. But I'm quitting at seventy." Then he was asked if a woman could trust him as a Gemini, De Grazia's zodiac sign. "If she does she's a fool," he said.[51]

At one time eighteen grandchildren joined the twenty-four children in his alleged brood. "Since I became rich my children have grown in number," he said. "In the old days when I couldn't sell my paintings, nobody wanted to hang around; now, suddenly, I'm related to people I don't even know." If reporters acted skeptical, De Grazia would try to explain away their attempts to see proof by saying something like, "You don't have to have papers to get married. Even my kids don't know everything I do. My wives have been Yaqui, Apache, and Mayan women from the interior of Mexico. Down there they don't give a damn for a paper. You are married, and that is it."[52]

Bud DeWald once commented about De Grazia's whoppers, "He wanted to see if you were gullible. He wanted to tease you. He was just Ted."[53]

At age sixty-seven, De Grazia began to talk as though he planned to slow down. He may have cut down on painting, but he still went out on the autograph trail selling his books, prints, trinkets, and other wares. He said in November 1975 that he'd found a recent autograph session an ordeal. "I'm hanging up my gloves," he said. "I'm not doing that again."[54]

Reflecting on his life, he said, "I like to think that the very best things that can happen to any human have happened to me—but also the very worst. Through a lifetime a guy has a terrible lot of breaks, and I have had them."

De Grazia often wished he was thirty-five again and struggling. "Struggling to get there, that was a good time. . . . I'd like to turn the clock back to that time."[55]

18

The Superstitions

It was a game, an escape into the past, and I loved it and painted
it. But if I ever found a really rich vein, I would have told the
Indians and let them do with it what they wanted.

—*De Grazia*[1]

DE GRAZIA CARRIED ON a more than thirty-year love affair with
the Superstition Wilderness Area, making dozens of excursions into
the rugged terrain starting in the late 1940s and early '50s. Those
were what he called his "ing" years—prospecting, painting, smok-
ing, drinking.[2]

The mountains in the Superstition range rise as high as 1,800
feet above the valley floor and encompass 160,000 acres of history,
legend, and intrigue. Known as the location of countless searches
for the fabled Lost Dutchman Mine, believed to be the richest gold
mine in the world, the Superstitions are famous for the legend that
Jacob Waltz took the secret of the mine's location to his grave in 1891.

In 1962 De Grazia had the money and the time to take off on
a weeklong search for the elusive mine. But he met with no more
success than dozens of others who had sought fame and fortune in
those arid mountains. And even if he had found a mine, it would
have been unlikely to yield much gold. In 1974, a seven-year survey
by federal, state, and university geologists determined there was little
gold in the Superstitions. Copper and silver, yes, but not gold. Some
gold could be panned out of creeks, but that was it.[3]

De Grazia went into the Superstitions, forty miles east of Phoenix near Apache Junction, with a great hope of discovering the Lost Dutchman. "We thought we had a chance," he said, "but I didn't realize fully what a hard, terrible, beautiful wilderness that it was." He took along a band of searchers who could have been mistaken for Mexican banditos, dressed as they were right down to bandoliers over their shoulders. Among the searchers were Juan Xavier, a Papago; José Campoy, a Yaqui, and his son, Juan; and Marko Romero and Vincent Garza, both of Chihuahua, Mexico.

"In the mountains, so confusing were the canyons, half of my men became lost," De Grazia said. "I wasn't able to follow through on all of my plans. At night we were being watched. We heard some gunshots, and we found some of the small, mysterious footprints that have figured in so many Superstition stories. The most important thing I found there was beauty." Did he find any gold? "We found some, maybe enough to decorate a tie clasp."[4] As was often the case, Marion gleaned his deeper motivations:

> *And yet there is reverie. A quiet time in the mountains*
> *seeking gold he will say. But having found it, all is lost.*
> *Only in seeking is there mystery, without which there is*
> *nothing.*[5]

De Grazia's favorite area was Superstition Mountain, which anchors the wilderness area often referred to in the plural. "To me the Superstition Mountain is full of mystery and intrigue," De Grazia said. "She is the most beautiful mountain in the whole world. At times she looks old, very old, craggy and tired, and very sad. Yet at other times she looks young and lovely. . . . You too will fall in love with her. Then you will succumb to her and she will possess you completely."[6]

Trips to the Superstitions also gave De Grazia and his friends an excuse to sit around the campfire guzzling booze and swapping lies. He always took buddies with him, including Shorty Thorn, Bernardino Valencia, Tom Franco, Vincent Garza, Ron Butler (who was called "the city slicker"), and two guides, Slim Fogel and Jeff Beal. A trail driver, Bill Crador, whom De Grazia later went into business with in a gallery in Durango, Colorado, organized the trips. They didn't rough it too much, as dinner often consisted of steaks and

Figure 36. De Grazia and his Indian friends often rode deep into
De Grazia's favorite spot, the Superstition Mountains outside Phoenix.

strawberry shortcake. Marion went on one trip, but she hated riding
horses and never went again.[7]

 Butler recalled that when they left the Superstitions after six days,
they were dehydrated and bought a couple of cases of ice cold beer.
De Grazia got "smashed," which Butler found unusual. "He liked to
drink, but I'd never seen him falling-down drunk." As they were leav-
ing in De Grazia's Mercedes, De Grazia drove off the road, knocking
over a stop sign and denting a fender. De Grazia tried to pull on the

fender to straighten it, with little luck. They then drove to Florence, where drinking resumed at a bar frequented by cowboys. Before long a "big brawl" broke out. "I remember De Grazia being choked," Butler said. "I kept thinking, 'Hey, hey, you can't choke him.' They had him up against the wall, and they were choking him. But he loved it. . . . We just lived on that adventure for a while."[8]

De Grazia loved the Superstitions so much, he gave long thought to resettling there. He even looked into building a museum/gallery in the mountains. Rick Brown said he thought Ted felt trapped by his own success.[9] For the time being, though, De Grazia put those thoughts aside. He decided to stay in Tucson, mainly because Marion loved it and didn't want to leave.[10]

In early 1974 he did build a gallery just outside the Superstition Wilderness, on ten acres at the base of Weaver's Needle. Again he designed the gallery himself, building it to blend in with the mountains and to capture the feeling he remembered of the Morenci mines. The 200-by-100-foot building consisted of native rock and slump block. De Grazia framed the entrance with timber from old mines and salvaged railroad ties. The entrance, a 40-foot-long tunnel, resembled a mine shaft. Inside, unfinished planks covered part of the floor, and saguaro cactus ribs formed a type of wainscoting. Huge exposed beams, put into place by a crane, supported the roof. He said at the time that construction would take two or three more years, and it would never be finished, merely completed.[11] "If I don't like it, we tear it down and do it again."[12]

The gallery, situated off a dirt road four miles from the nearest paved road, immediately created controversy among wealthy neighbors concerned that too many visitors would stir up dust. The most vocal opponent of the gallery was their nearest neighbor—the "Black Widow," they called her.[13] De Grazia hired Pinal County attorney Tom McCarville to help him deal with the legal issues, including a court order blocking use of the road. De Grazia agreed to oil it to keep the dust down.

Like Tucson's Gallery in the Sun, the studio was open from 10 a.m. to 4 p.m. De Grazia didn't visit there often, perhaps once a month to collect money from a not-so-well-stocked gift shop and to bring in more merchandise to sell. The gallery took in less than $1,000 a month.[14] When he visited, De Grazia and caretaker Phil Galpin would

go into Apache Junction for dinner and drinks, then return home to crack open a bottle of Chivas Regal on the porch. De Grazia didn't talk much about his private life, Galpin said, but "he wasn't immune to telling about the Indian ladies . . . on the reservation."[15]

Norma and Dave Fisher spent one week a year for several years at the Apache Junction gallery, filling in for the vacationing caretaker. They remembered the place as primitive and full of scorpions. A tank located a quarter mile away gravity-fed water to the house through an aboveground pipe. The water would get so hot, the Fishers could only shower in the morning, before the sun heated it up. Otherwise, Dave Fisher said, "you had to use the 'hot' water from the water heater to 'cool' down the water from the aboveground pipe." Before showering, they had to clear the centipedes and scorpions from the shower stall.

Only five to ten people a day visited the gallery during the summer. Because it had proven to be a poor business venture, De Grazia wanted to give the studio to the Apaches. The 2,600-square-mile San Carlos Apache Reservation adjoined the wilderness and seemed a likely candidate to take it over. But they hemmed and hawed so much he told them to forget it.[16] Marion disliked the gallery and sold it soon after De Grazia's death. It became a private residence.

On May 12, 1976, De Grazia made a trek into the Superstitions that gained international attention, thanks to his burning of as many as one hundred of his paintings to protest federal estate taxes. "When I sell a painting and take in money, I expect to be taxed," he said. "And I am. But I don't think there should be a tax on paintings and other works of art that aren't sold. My heirs [can't] afford to inherit my works."[17]

De Grazia had spent several years considering how to protest the hypocrisy inherent in a law that said if, while he was alive, he donated pictures to a museum or university, he could write off only the cost of his materials; but if he held on to them, when he died his heirs would owe taxes on the market value of the paintings, forcing them to sell his works in order to pay their inheritance taxes.

The paintings "were my creations," he said, and rather than force his heirs to sell them, "I have a right to destroy them."[18] He rode deep into the Superstitions with an entourage of twenty people,

including Ginny Moss, Carol Locust, Shorty Thorn, Margo Itule, Bill Crador, Arlene Silver, David Jones, Bernardino Valencia, and freelance photographer Paul DeGruccio. They rode five hours on horseback to Angel Springs, in the heart of the mountains.

Once there, they built a six-foot-high pyre shaped like a teepee. De Grazia took out a match, swiped it across his trousers to light it, held the match to a wad of papers, lit his cigar, and set the paintings afire. As they burned, he added more paintings, standing back at one point to take a gulp of Chivas Regal.[19]

De Grazia said it took a lot of courage to burn the paintings. "I had to get drunk to do it." He even doused the paintings with two bottles of Chivas Regal to enhance the flames.[20]

Locust remembered one picture in particular that "just hurt him so bad he stood there and cried." It was a painting of a little girl wearing a beautiful purple skirt that he held tightly to his chest before placing it on the fire.[21]

He claimed he burned about a hundred paintings, but Locust said it was closer to twenty-five or thirty.[22] Several of De Grazia's friends said he burned virtually worthless paintings, probably unfinished works and ones he disliked, as well as sketches. "I don't know what I burned except that there were some damn good ones in the batch," De Grazia said. "I just gathered 'em up willy-nilly."

Newspaper accounts set the value of the destroyed paintings as high as $1.5 million, but Buck Saunders estimated that they were worth about $1 million. If so, that meant each painting would have sold for between $10,000 and $15,000. "I don't know how you'd evaluate them because I don't even know what I burned," De Grazia said. He called the burning "my own silly protest. Who cares? Regrets? Oh yes, sure. Some. A thing like this is a part of you and when you do it, you put the torch to part of yourself."[23]

In addition to the burning, De Grazia said he sealed some of his paintings in tubes and hid them in caves, and whoever found them could have them. None has ever been found. Many have speculated that De Grazia wanted to elevate himself to the legendary stature of Jacob Waltz and the Lost Dutchman Mine by creating a new fable.

Locust remembered De Grazia getting up in the middle of the night, "carrying something [in a bag]. And when he came back the bag was empty. But what woke me up, the reason I saw him, is

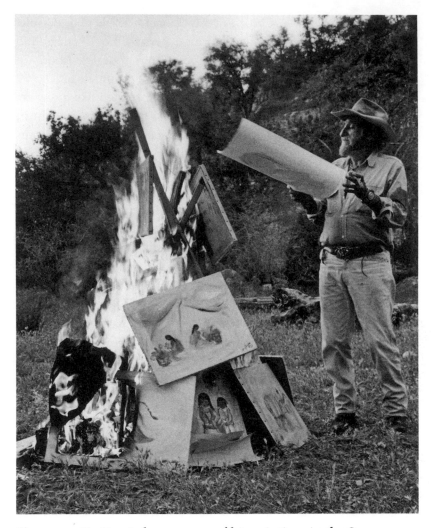

Figure 37. De Grazia burns some of his paintings in the Superstition Mountains in a fiery protest of Internal Revenue Service inheritance regulations.

because I could hear the birds. But it wasn't birds because I understood what was going on because I knew the Apaches [and] I knew that that was somebody talking to Ted." Apparently the Apaches made bird noises to signal De Grazia. De Grazia told her, "Yeah, you can carry a lot of things in [the bag], sculptures and things like that. [It] gets pretty heavy." That's all De Grazia ever told her. He

said no more than two words the entire trip when they drove back to Tucson.[24]

De Grazia offered up a different story about the unburned paintings to a couple of magazine writers, claiming that three Apaches snuck into the camp, went through his belongings, and took some paintings. "I guess it was the price we had to pay for trespassing on their lands—and they slipped away into the night."[25]

Twenty years later Ron Feldman, the owner of riding stables in Apache Junction, said he believed that De Grazia did indeed hide paintings somewhere in the Superstitions. "I don't want to create a legend for a legend's sake," he said. But Feldman believed a trusted employee of his who told him that he saw De Grazia take the tubes into the mountains. He said he was 75 percent sure De Grazia hid the paintings. But Tom Kollenborn, a Superstitions historian, author, and schoolteacher, only half-believed the tale. "My guess is that he probably hid something," Kollenborn said. "If he burned them, why wouldn't he hide some, too?" Kollenborn said De Grazia told him that to tell the truth either way would ruin the sense of mystery.[26]

Abe Chanin asked De Grazia up front to tell him the truth about the annihilated artwork. "Well, they were my worst paintings," De Grazia said, "and I knew if I burned them and got publicity, I would sell a hell of a lot more paintings at a better price." His ploy apparently worked. "I just wanted to raise the value of my paintings, and that was a great publicity scheme, best I ever invented."[27] Articles appeared in such diverse publications as the *Wall Street Journal* and *People* magazine. Fred Landeen was in Paris when he picked up a copy of the *International Herald Tribune* to find an article and a picture of the blaze covering the entire back page.[28]

Two days after the burning, De Grazia was back at his gallery signing prints. In one seventy-minute period he signed more than one hundred prints for customers whom the publicity had attracted.[29] Four days later he started threatening to burn a thousand more. "It's very painful," he said. "It's part of you. *Es muy triste*" (It is very sad). He told reporters he planned to make two more trips to the Superstitions to burn paintings, but he never followed through on the threat.

Meanwhile, behind his public façade De Grazia apparently grew so despondent over the burning that he stopped painting for almost three years. He worked with the crafts guild and did some sketches

Figure 38. Carol Locust in an undated photograph taken in the Superstition Mountains. Photo courtesy of Dave Fisher.

and watercolors, but he created nothing new of any value. "He just couldn't bear to paint anything [in oil] that was new," Locust said.[30]

But if he wasn't going to paint, he wasn't going to sit around in a rocking chair, either. In April 1977, he took tourists on one of two five-day trips into the Superstitions at $235 a head. While they rode, he told stories about the mountains and his many trips there, including the time he burned his paintings.[31]

Rita Davenport said De Grazia told her he felt "spooked" after the burning, afraid that God might prevent him from painting in the future because he had committed a blasphemy, damaging something God had given him the talent to do.[32] Davenport told him it was ridiculous to think he could not paint again. "I encouraged him, [told him] what he did was okay, that he would do a lot of good for a lot of people, and he did." He could let his guard down with her, she said, because she "could see through his *shtik*." De Grazia admitted to her, "I didn't burn that much." Davenport replied, "Well, you can still paint. Get back at it."[33]

De Grazia received four hundred to five hundred letters from around the world after he burned his works. Most of the writers

requested that, rather than burning his pictures, he give them away because they could use the financial help. Others said that if given the paintings, they would keep them forever.[34] Most said something like, "Send a painting to me," or "Keep the matches away from that nut," or "His work belongs to the public and he has no right to destroy it."[35] A few even sent along books of matches, ostensibly to suggest that De Grazia burn all of his paintings because they weren't good enough to save. Curiously, these batches of letters seem to have disappeared from the gallery's archives.[36]

An NBC *Today* crew traveled to Tucson after the burning for two days of filming to create a fifty-five-minute show about De Grazia's "stashing" of the paintings in the Superstitions. At one point he took the crew to Rosita's to eat. The cook joined them as he plopped down a bottle of Chivas Regal on the table, and they all got drunk. De Grazia didn't remember what he said, and the NBC crew didn't much care because they couldn't remember either.[37]

But he had one more project to finish, one that began with a request in 1974. One of De Grazia's drinking buddies was prominent Tucson physician and author Dermont Wilson Melick, who would drop by the gallery on occasion. In 1974, De Grazia told Melick that he would love to paint on a burro's skull. Melick, who grew up in Williams, Arizona, said he had a friend in northern Arizona who could get the skulls from wild burros that had died. Melick told him he would get two so De Grazia could paint one for him, too.

Melick brought the two burro heads home and boiled them in pots in the kitchen, much to the disgust of his wife, who complained about the smell. After the skulls were sufficiently dried, he gave them to De Grazia. The artist only finished one, which he gave to Melick. The skull was twelve inches high, eighteen inches long, and six inches wide. De Grazia adorned it with pictures of a prospector searching for gold in the Superstitions. "I think the Lost Dutchman would like that," he said. It had several small blue stones embedded in the skull and featured on the forehead an Apache crown dancer and on other places on the skull a miner, Mexican revolutionaries on horseback, and Apaches on horseback. He painted one depiction of the prospector deep inside an eye socket. Twenty-four-carat gold filigree covered the burro's incisors. De Grazia signed the skull with the date July 1976, just two months after he had burned his paintings in the

Superstitions. The decorated skull was passed down to Melick's son, Dick, who donated it to the Gallery in the Sun in June 2012. The unpainted skull is now kept in the unused fireplace in the Papago Legends Room at the gallery.[38]

When he finally returned to painting after the three-year drought, De Grazia seemed uncertain. "I'm feeling my way," he said, "just warming up. It's like a tennis player who hasn't played in three years coming back on the court and hitting the ball."

He began work on painting Indians, Mexicans, horses, and children, the same subjects as in his early paintings but done, he said, in a manner "more evasive, more abstract. My thought is to get more of the essence of what it is. My new work will be more delicate, realistic but not photographic. There will be more of a breadth of colors."[39]

The destruction of his work aroused new interest in finding a place to hang De Grazia's remaining paintings before he could burn any more. A week after the burning, UA President John Schaefer called De Grazia to say the university would like to hang the paintings in the library. De Grazia, lukewarm about the idea, responded, "A library is not a place you go to see paintings. You go there to study. If my work is any good, then it should be on permanent display in a museum."[40]

A month later De Grazia began negotiating with the Maricopa County Community College District in metropolitan Phoenix to put his work on permanent display at one of its campuses. He planned to donate one hundred retrospective paintings, including twenty from the Father Kino series, and numerous ceramics, bronzes, etchings, lithographs, serigraphs, and encaustics—paintings in which pigment is mixed with beeswax and applied to a canvas.

A. W. Flowers, executive vice president of the community college district, said the district's board of governors was in general agreement that the district would meet De Grazia's requirements for suitable housing and display. That might be on one or more district campuses, he said. "We think it is important that we meet his stipulations to preserve his works permanently," Flowers said. "We don't have many people like this who are willing to donate their work in Arizona." To which De Grazia replied, "I won't do anything until I see what their plans are."[41]

He apparently wanted a gallery with low ceilings to be built on ten acres. "I always work on ten acres," he told the district's president,

John Prince. Prince told him it would take time to work out the arrangements and asked if there was any hurry. "The hell there's no hurry," De Grazia said. "I'm sixty-seven, and I want to get started."[42]

When De Grazia and Flowers signed a preliminary agreement on July 18, 1976, it included a provision that a cowboy hat, boots, a bottle of Chivas Regal, and a sack of Bull Durham also be displayed.

The agreement immediately sparked rancor because the district hadn't estimated a cost for the museum, nor had anyone consulted members of the art faculty about the offer. Taxpayers also chimed in. One letter writer wrote that De Grazia's "works of art do not represent 'quality' in the academic art world" and urged the district board to reject De Grazia's donation.[43]

The *Scottsdale Progress* editorialized that the district had not "justified the proposal on artistic merits. . . . Even if some of De Grazia's work deserves to be in a museum, which is debatable, is he so great that he deserves a gallery of his own at public expense?" The *Progress* said a gallery devoted "solely to the work of one rather commercial artist would be absurd."[44] Ultimately, the district backed away from the proposal.

A year after the burning De Grazia was still raging about the injustice of the inheritance tax laws. "Income taxes, I hate like hell, like everybody else, but I pay them. It's the inheritance tax that makes no sense at all, especially for the artist."

De Grazia said he didn't have any lawyers or accountants or estate planners advising him. "I don't like them, and I don't need them. For better or worse, this performance [the burning] was my own idea. And I guess I'll just have to keep on thinning out my collection this way so the estate tax won't bankrupt my heirs or until somebody does something about this unfair tax."[45]

He said he had been storing hundreds of his paintings in caves "as part of the game I am playing" with the IRS. He promised to strip his studio of his paintings and put all of them in caves to keep them from the "revenuers." "I'm dynamiting the entrances to the caves," he said. "God only knows if the stuff will ever be found. My final opus happens after I die."[46]

Not long after De Grazia burned the paintings, his friend and fellow artist Thomas Hart Benton told him he had a better way of preserving his paintings without his relatives being left to pay taxes

on their inheritances. He suggested De Grazia set up a foundation. "Benton was really influential," De Grazia's friend Cassandra Prescott said, "because that's why the gallery exists today."[47]

Despite his public dismissals of accountants, lawyers, and estate planners, in March 1977 De Grazia sought advice from the accounting firm of Coopers and Lybrand about minimizing the impact of income, gift, and estate taxes on his heirs. The firm checked into De Grazia's income tax returns from 1975, noting that he paid $60,200 in taxes on $158,700 in income. It also found that the estimated value of $6 million in artwork alone would require almost $1.55 million in state and federal estate taxes. In the end the firm agreed with Benton that De Grazia could set up a private foundation for the purpose of preserving and protecting his art in perpetuity in the Gallery in the Sun.[48]

De Grazia was approaching seventy years of age, a time for reflecting on life. "Do what you like to do and the hell with society. Be yourself. You make your own environment. Remember, you are born alone, you live alone, and you sure as hell will die alone. I have never been considered the darling of society."[49] De Grazia drafted a new will that left his half of the community property to the De Grazia Art and Cultural Foundation while Marion retained the other half. He requested that all taxes, funeral costs, and medical expenses, as well as the cost of administration of his estate, be paid not from the sale of his artwork, but presumably from cash on hand.

De Grazia made little provision in his will for his three children. Marion was appointed executrix, with daughter Kathy Bushroe as alternative if Marion were unwilling or unable to serve. He knew Marion loved the gallery and the property as much as he did and would protect them, but he feared that if he left them to his children, Bushroe and her brother, Nick, would sell off the property and its holdings, and Lucia lacked the business skills to run the foundation.

Despite any marital troubles the De Grazias might have had, Ted still recognized that he would not have succeeded without Marion's help. His plan to protect his legacy by setting up the foundation has worked, as the Gallery in the Sun continues to operate today.[50] The tax laws have never changed.

19

The Love of His Life

Even an "irreverent angel" needs a good companion.
—*De Grazia*[1]

EVEN AS BIOGRAPHER William Reed profiled Marion and Ted enjoying their happy home life in the 1970s, their marriage was in poor shape. De Grazia told Reed, for example, that three or four years before the interview, he had been living in a world of his own. "I was impossible to live with. Now, for the first time in my life, I find myself going home to Mama." Reed said De Grazia then pulled out his ever-present red handkerchief and blew his nose.[2]

In reality, there were many nights when De Grazia didn't go home to Mama.[3] Marion adored Ted, but the feeling was far less than mutual. They fought often, after which Ted would go on trips and leave her home.

In 1971, at age sixty-two, Ted began a relationship with a beautiful thirty-four-year-old Cherokee woman, Carol Locust, that compounded the marital difficulties. His attorney, Tom McCarville, called Locust "the true love of De Grazia's life."[4] Their relationship lasted until his death.

De Grazia also carried on an affair—or, perhaps more accurately, a fling—in the early '70s with country singer Sammi Smith. Locust knew about the relationship with Smith but rejected any notion that De Grazia had an affair with her. She said the friendship developed because Smith's father had just died, and she needed someone to talk to. "Ted and I met with her several times, comforted her the

Figure 39. De Grazia carried on an eleven-year love affair
with Carol Locust, until he died in 1982. Photo courtesy of
Dave Fisher.

best we could. She said her father had a beard and old farm hat, and
Ted reminded her of him."[5]

The issue of whether Marion knew about the affairs or just looked
the other way in denial remains open to speculation. Locust said
Marion thought she was just someone who worked at Ted's studio.
But Marion apparently knew that De Grazia was carrying on with a
"half breed."[6] That slur, however, could apply equally to Locust or
to Smith, who was part Apache.

Figure 40. De Grazia and country singer Sammi Smith at the Gallery in the Sun.

When you came home
That evening
And told me
That an Indian girl
Had taken your bracelet
Away from you
I thought nothing of it
But
As I know more
It was more
Than a bracelet[7]

De Grazia was twice the age of Smith, who was in her mid-thirties. Smith was best known for her 1971 hit "Help Me Make It Through the Night," written by Kris Kristofferson. One of few women in the outlaw country music scene during the 1970s, Smith, whose real first name was Jewel, often traveled to the Apache reservations to make pottery and jewelry. She owned a home in Globe, Arizona.[8]

An oral history interview conducted by Abe Chanin with photographer Jack Sheaffer hinted at De Grazia's relationship with Smith.

Sheaffer said De Grazia told him not to take a picture of him with Smith. "He didn't want it up at his gallery," where Marion would see it.[9]

In 1976 Smith gave a copy of her album *As Long as There's a Sunday* to De Grazia. On the cover she wrote: "To De Grazia. Meeting you and talking with you is my greatest honor. Thank you for sharing part of your life. Love, Sammi Smith." In 1977 she released another album, *Mixed Emotions,* which had ten tracks, one of which was "De Grazia's Song." The lyrics in part are quite telling:

> *You give me a rainbow every day,*
> *And fill my heart and eyes with a sunshine bouquet.*
> *So I offer you this melody to drive your cares away,*
> *In thanks for the rainbow you give me every day.*

De Grazia wrote a blurb for the album cover that said, "Sammi Smith is a very good friend of mine. We are both artists. As a painter, I use the full spectrum of colors to paint one beautiful rainbow. Sammi uses the full spectrum of human emotions with a velvet voice. Once you hear that voice you will never forget it. . . . Sammi sings to the whole world. Yet, when you hear her, she sings to you and you alone."[10]

When Sammi moved from Dallas to Globe in 1975 to live on the San Carlos Apache Reservation, she adopted three Apache children to complement her own four offspring. A direct descendant of the famed Chief Cochise, Sammi crusaded for many years for increased rights and better living conditions for the Apaches.[11]

De Grazia directed and appeared in a movie in 1978 with Sammi, who played a singer to whom he gave a map showing where he allegedly buried paintings in the Superstitions. "Some bad guys will follow her and take her hostage to get the map," De Grazia said. "Naturally I come along and kill the bad guys." The twenty-eight-minute film was called *End of the Rainbow,* a story "of intrigue and greed for treasure."[12] De Grazia said he did the movie just " for the heck of it."[13] He'd loved movie making since his days in Bisbee.

Dick Frontain knew of the artist's affair with Locust. "He had [eleven] happy years," Frontain said. "They [were] some of the best years of his life. . . . He was excited, kind of like a boy talking about

[her]." Despite the joy, De Grazia asked Frontain not to take pictures of them together or write about them. He never told Frontain why.[14]

As De Grazia's life broadened, Marion's world "shrank to a few friends, and she became a horrible alcoholic and falling downhill," Frontain said. He was at the gallery with his children one day when Marion entered and promptly started to fall. Frontain grabbed her. Once, while Frontain was visiting De Grazia, she asked him, "What are you doing here?" When he explained, Marion said, "Don't ever come up here again. Don't get near my house again. I don't want you here."

On a later occasion, when Frontain visited the house at De Grazia's invitation, she threatened to hit him with a broom and then broke out singing opera. "I'm going to get louder and louder until you get out of here. Hurry up. I can't tolerate you in the house. I don't want you in the gallery. I don't want you on the land." Over the years, Marion's jealousy of De Grazia's friends, whom she perceived as taking him away from her, led her to act rudely toward them.[15]

Frontain said she drove off Shorty Thorne, J. J. Clemente, and others as her drinking escalated. "It was just terrible," Frontain said. "That's when Ted started getting very lonely, I think, very lonely. He had some Mexican girlfriends with him a lot, but Carol became the greatest love of his life."[16]

Locust, whose husband had died of a heart attack, had moved to Tucson to put one of her children, a disabled son named Kee, in a special school. She managed to secure a scholarship for herself at the University of Arizona to pursue a doctorate in education. One day when she was feeling homesick, one of her professors invited her "to a place that'll make you feel better."[17] The professor urged Locust to bring along a picture she had painted of a Navajo woman.

They headed over to the Campbell Avenue studio, where De Grazia was working. Once the Gallery in the Sun had been built, Marion spent little time in the Campbell studio, preferring to remain in the gallery, which she called "her gallery." Ted chose to work in the studio and often stayed overnight.

Locust and the professor went into Rosita's restaurant. When De Grazia walked in, the professor introduced him to Locust. After some chitchat, Locust reluctantly showed him her painting. He was impressed.[18]

It didn't take him long to tell Locust he needed help in his studio. He wrote his telephone number on a napkin.[19] Locust figured out later that De Grazia didn't need help; it was Locust who needed it—financial help. "He was somebody to help people, but he would never help them in a way that would belittle them," she said. "That was one of the finest attributes, I think, to have."[20] A few weeks later, she found herself financially strapped, so she agreed to take the job.

Not long after she started working for De Grazia, she got his permission to take work home with her so she could be with her children when they were out of school. Then De Grazia began to visit, sometimes during the day and sometimes at night, as their relationship became more than that of employer-employee. One night on a walk in the desert he kissed her for the first time and told her that he needed her. "I promise I will bring only good things into your life," he said. "I will never hurt you or your family. And I will watch over you, protect you, see that you are well and happy. Those are my promises."[21]

Locust sensed that something intense had happened to De Grazia that day, something that stimulated anger. "Yes, there was anger flowing out around his body like a brilliant burst of volcanic fire. . . . Beneath the terrible anger there had been great sorrow." He never told Locust what it was about. "Perhaps he did not completely trust me, did not know me well enough to bare his heart and spirit to me."[22]

The next day, when Locust went to De Grazia's studio, he acted as if nothing had happened. But while they didn't speak about the night before, Locust sensed a "distinct difference in him when he was near me." Over the course of the ensuing weeks she noticed that De Grazia seemed revitalized, and when no one else was in the studio he would hold her close to him.

De Grazia began to spend more and more time with Locust, often visiting for dinner at her home. After dinner he would play with Locust's children and tell them stories about growing up in Morenci. He would talk about his brothers and sisters and his three children. He never mentioned a wife. "My family became his family, my home his home, my children his children," Locust wrote in her memoir years later.[23] She and the children began calling him "Papa." He called her *Mi Indita*, "My Little Indian."[24] She also noted that even though she knew he liked to drink Chivas Regal now and then, he never drank around the children, and she never saw him drunk.[25]

Gradually his visits to Locust's home became more frequent. "He found sanctuary at my home, a place to rest, smile, laugh, play with the children, and walk in the desert."[26] Then Locust became his constant companion on trips to art shows, to meet with exhibitors, and to promote his guild of artists.

On a trip to Scottsdale they stopped to visit Buck and Leo Saunders at their gallery. De Grazia introduced Carol as one of the guild members. Buck asked how his children and Marion were, as well as a number of common acquaintances. Carol recognized several of the names but not Marion's. However, she didn't ask him who Marion was.[27]

In the spring of 1973, while traveling to visit business contacts in the White Mountains, De Grazia began talking about his children. Carol asked, "What about your daughter Marion? Is she in Tucson, too?" De Grazia responded, "Marion? She isn't my daughter, she's my wife." Seeing the look of shock on her face, he asked, "You didn't know that I am married?" Locust told him she thought his wife had died, apparently referring to Alexandra, although she was still very much alive, and that he had been alone since then. Falling into a "deep abyss of misery and shame," Locust moved to the other side of the car, as far away from him as she could get.

They traveled several miles in silence. Then Locust told De Grazia to find someone else to work with him. The Jeep jerked to a stop. De Grazia looked at her and said, "I thought you knew about Marion." He added, "I have tried so many times to get away." Whenever he tried to leave Marion, he said, she destroyed some of his artwork. "She told me she would destroy everything I had ever done, all of it. Then burn the buildings if I ever left her." He told her Marion's heavy drinking was "street knowledge," that the threats began after she became an alcoholic.[28] Describing his wife as a "mean drunk" who often hit him, De Grazia showed Locust bruises that Marion had caused.[29]

No one
Will ever know
Why
I am a lonely lady
I won't tell them
And you
Never will.[30]

Unquestionably, living with Marion had become difficult. Locust's tranquil nature must have felt like a godsend to De Grazia. He heard no ill words, no raving or ranting, no drunken outbursts from her. In turn, De Grazia had become the light of Locust's life, and it dawned on her that she loved him. A week after the trip to the White Mountains, she went back to the studio.

"I was afraid I had lost you," De Grazia told her.

"I made a promise to you," Locust said. "And I love you. That cannot be changed."

They resumed their relationship almost as if nothing had happened.[31]

The following summer De Grazia asked Locust if she would have a child with him. "I want a son. My son, your son," he said. Soon after, De Grazia spent the night with Locust at her house. "That night was the first of many," she wrote in her memoir. "Ted was a man passionate in life, passionate in love."[32] In July Locust learned that she was pregnant.

She kept the pregnancy a secret, often wearing Apache camp dresses and other loose outfits to hide her expanding midsection. When time came for the baby to be born, De Grazia drove her to the Indian Health Services medical facility in Phoenix. They barely made it. He parked the Jeep and hurried back to the emergency room, but Locust was gone. He went back to the Jeep and returned to Tucson. Apparently he did not want the birth of their son, Domingo, to be "marred by trashy gossip." Two days later De Grazia's brother Frenck and his sister-in-law Lisa picked up Locust and took her to their home in Florence, Arizona, where De Grazia was waiting.[33]

In the summer of 1974, a fierce storm severely damaged the twelve-by-sixty-foot mobile home that Locust lived in near the San Xavier Mission in southwest Tucson. Locust chose to live there because it was close to the Indian Health Services offices where she could get help for her disabled son. De Grazia rebuilt the mobile home over a three-week period and later added a fifteen-by-thirty-foot adobe structure, using the same techniques he'd employed for the Gallery in the Sun. He painted rafter beams before putting them in place. Domingo walked on the fresh paint on the rafters, and his footprints remain visible on them today.[34]

About the time of Domingo's birth, De Grazia began looking for a retreat that would allow him, Locust, and their newborn to escape the city and, one could assume, Marion. They looked in New Mexico, considering at one point buying a home in Taos once owned by author D. H. Lawrence.[35] Instead they purchased a plot of land for $8,000 in a subdivision called White Mountain Lakes, off Highway 77, about five miles from Show Low on the road to Snowflake, Arizona.[36] They never did build a house on the land, and the parcel remains in Locust's name today.

20

On Death

The circus is over, and the tent is coming down.
—*De Grazia*[1]

IN 1970, AT AGE SIXTY-ONE, De Grazia started pondering his mortality. He later recorded some of his reflections in a phonograph album called *His Thoughts and His Philosophy*:

> I respect a good doctor—and for the young, a good doctor should be the very best—for life is precious. He should be a biblical type, a healer, an extender of life. But a man my age should have a medicine man, a *curandero* [folk healer or shaman], a mechanic who looks under the hood, and if it can be fixed with bailing wire, okay—if not, let it go to hell. This machine is old, and all you can hope for is a few extra miles. I consider myself old with a lot of miles. I am ready to go—nobody, nothing—lives forever. But I want to die in peace. No prolonging of natural life. I want to die in peace, and when I die I want a plain redwood coffin—a monk's coffin. No people do I want around, no ritual, no talks. Maybe just a prayer. Let it be known I've died after I'm buried, but only if they ask.[2]

Despite these rather melancholy contemplations, De Grazia still had a lot of life in him. He was raking in money, painting pictures, writing books, and making movies. But he'd begun to slow down,

with age creeping up on him. Chores he had previously done with ease had become harder. He didn't care for it. "I'd give anything if I could go back twenty-five years," he said when he tried to saw a branch off a tree and after ten strokes couldn't do it anymore. "I hate that. I just cracked off the son of a bitch."[3]

He knew he couldn't live forever, but he wasn't ready for the "ugly, rickety rocking chair" of retirement, either. "Peace of mind, love and contentment," he said about retirement. "It ain't there."[4]

One of the last books he illustrated was the second edition of an earlier one he had collaborated on with Rita Davenport, hostess of the TV show *Open House* in Phoenix. The book almost didn't get done because of De Grazia's fears about painting after the burning, during his three-year sabbatical from oils. Davenport said that after she called his concerns "hogwash," he phoned her in the middle of the night to tell her, "We're going to do the cookbook. Get the recipes ready, and I'm going to do the art."[5] The eighty-six-page book, *De Grazia and Mexican Cookery*, was published in 1981 by Northland Press in Flagstaff, Arizona.

Also in 1981 a second biography came out, *The World of De Grazia* by Harry Redl. Redl, a photographer whose work had appeared in *Time, Life, Look, Newsweek*, and the *Saturday Evening Post*, photographed and wrote the 200-page book containing 199 full-color plates of De Grazia's artwork. It sold for $49.50, or about $125 in 2011 dollars. Redl had to charge that much because it reportedly cost $250,000 to publish.[6]

Redl said he was skeptical when he first began shooting photographs of De Grazia because "I had the feeling that he was a phony in a cowboy hat." But after watching for De Grazia to make a wrong move, he eventually decided, "It was no pose."[7] Redl said he wrote the book because "when you look at him, you see sagebrush, cactus, and broncos. . . . He appears a naïve ruffian, but then he has the most complex, sophisticated thoughts. The amazing thing was, when I first met him, he had this interesting dignity underneath the hat and the cowboy boots. He is an American original."[8]

Redl said he also came to see De Grazia in a different light as he photographed his paintings, laid out the images, and saw them printed. "You get a feeling of a very serious painter. I like the man. I think we ought to look at him before he dies and pay tribute to him."[9]

In the late 1970s De Grazia visited Carol Locust at her home, complaining about his back, hands, shoulders, and feet hurting. He often worked on wax figures that he later cast in pewter, but at this point he couldn't do even the simplest artwork.[10] He asked Locust if she had any tribal remedies for pain in his leg and knee. She applied an ointment and tried several herbs, but the pain remained.[11]

At one point De Grazia was in such agony that Locust suggested he retire from painting. "Retire? Me?" he replied. "You know what happens when people retire, they die. What would I do if I didn't paint?"[12] He continued painting with Locust's help. She would put her hand under his elbow to help steady him. "I need your hands to hold the tool," he said. "I will guide your fingers the same as I would guide my own."[13] After a while, though, even that didn't help.

De Grazia always contended that he stayed away from physicians, that he only needed a medicine man to cure his ills. Using a remedy he said he had received from the Seri, he took the shell of a gourd that still had a seed in the bottom and poured liquor into it until the seed, or medicine, was absorbed into the liquor. Drinking this helped relieve the pain.

Locust told him he had to find out what was causing the pain. "I know what the problem is," he said. "I'm old."[14] De Grazia felt that doctors were not healers but "extenders of life, and that's bad. Just as there is a time to be born, there is a time to die. I'm over seventy, looking toward the west into the sunset."[15]

At one point he decided to see a Navajo medicine man for the pain. The two men grabbed a bottle of Chivas Regal and went down to a creek bed, where they polished it off. De Grazia felt pain no more and congratulated the medicine man. The next day the pain came back.[16]

Davenport, who thought of De Grazia as a father figure, became certain he was ill after he drew the second set of illustrations for the cookbook. The illustrations for the first book had been more precise, less primitive, she noticed. "I could look at his work and tell he was in pain."[17]

Finally a doctor diagnosed him with prostate cancer. It had spread through his spinal column to virtually all areas of his body. Davenport visited De Grazia in the gallery when he could no longer travel. She told him she knew he had cancer. "Marion doesn't even know I have cancer," he said. "How do you know?" Davenport replied, "I

just know," and offered to connect him with a doctor renowned for natural healing techniques. But the doctor's remedies didn't work; the cancer was too far advanced.[18]

De Grazia knew time was short. His calendar from June through December 1981 chronicled his battle with his illness. On various days he would write one- or two-word reminders about appointments with his doctor and radiation treatments for his cancer. He repeatedly noted times when he suffered pain. At one point he crossed out the words "Window Rock," indicating that he had canceled a planned trip to the Navajo Nation's headquarters because of his illness.[19]

Chemotherapy and radiation plus medications made his beard and hair thin, gray, and scraggly. "Like an old mare's tail," he grumbled.[20]

De Grazia spent a lot of time at Locust's home. She had tracked down an assortment of herbal medicines that she thought might help him, mostly teas. They even took trips to see medicine men on the San Carlos Apache Reservation and another in the South Tucson Yaqui barrio. At times De Grazia could not eat, was nauseated, and became depressed. Spending time with Domingo cheered him up, and the herbs seemed to ease his pain, Locust said. "He would talk about his going to the next world and how he had really lived four or five lifetimes in his one time on this earth," Locust said.[21]

Sometime during the last year of his life De Grazia requested that Rita Davenport interview him on camera. He looked gaunt, with long, stringy hair hanging from his cowboy hat. He was in a pensive mood during the one-hour session. Davenport asked him how he wanted to be remembered. "I think they should think what they want to think. I don't want to influence them," he replied. "I don't want to be someone who is precious. I want to be known as a human being." He also described himself as "a man who has made a lot of mistakes and was capable and human." He remarked at the end, "One thing for sure, I don't have as long as I think." Then the footage cut to a shot of De Grazia walking off into the sunset.[22]

Eventually he lacked the strength to travel to Locust's house. "Tell the Young Eagle [Domingo] I can't come out. I want you to come see me." She and Domingo, who was eight, visited at night when it was quiet.

De Grazia didn't want Domingo to see him so sick. "He wanted him to remember him as a papa whom he'd always known," Locust

said. De Grazia would wear his hat while in bed because he had lost so much hair. Once when Domingo visited, he said, "Papa, you're still in bed." De Grazia replied, "Oh, yeah. Well, I worked real hard today."

Domingo and his father had a good relationship. They prospected for gold, "hunted for monsters," and did many other things together. De Grazia was concerned that, as Locust put it, "some things have been said that haven't been very good" about De Grazia having a child with his lover. "I'll protect the Young Eagle," he told Locust. One thing they did—since they didn't want people to know where Mingo, as he was known, and his mother lived—was to put a sign on her gate that said "Gomez" to protect their privacy.[23]

De Grazia spent some time in the University of Arizona Medical Center, not far from his gallery on North Campbell Avenue, before being sent home to die. While he was in the hospital, his first wife, Alexandra, who had rarely spoken with Ted since their divorce, visited him at their daughter Lucia's request. "Ted, you old scamp, how are you?" she asked, holding back tears. Ted smiled. Alexandra described their conversation as tranquil but brief.[24]

Apparently in the last week or two of his life, he was moved into hospice in the Nun's House behind the Gallery in the Sun. Dick Frontain visited De Grazia a week before he died. Greg and Frenck, De Grazia's brothers, sneaked in at night, too. They had to visit at night because Marion didn't want people to bother him in the daytime. But "at night, of course, she's falling down drunk so she would never know," Frenck told Frontain.

Frontain noted during a visit that the artist had lost seventy-five pounds, but his eyes were clear, his voice was strong, and he had a firm handshake. He even tried to get out of bed to sign some plates, although of course he could not.[25]

De Grazia's hospital bed in the Nun's House faced the southern window, looking out over tall bamboo trees and adobe walls. He could see light from the morning sun through the window and could watch as it got dark at the end of the day. "That seemed to please him," Frontain said.

Two days before De Grazia died, Frenck called Frontain and asked if he wanted to see the artist one last time. "He's slipping away from us," Frenck said. When Frontain came into the room, De Grazia said, "I'd know that voice anyplace." Then he asked Frontain, an

accomplished photographer, where his camera was. Frontain replied, "Well, where's your palette?" They chatted about thirty minutes, and he left. It was the last time Frontain saw his friend.[26]

De Grazia was well aware the end was near, telling Locust, "I'll be going soon." His parting words to her were about their son: "Never let the Young Eagle forget that his Papa loves him." And then he told her, "Don't you forget that I love you, love your family. We had so few years together, but they have been wonderful years."[27] Locust and Domingo, with tears in their eyes, left for the night. The next day, September 17, 1982, De Grazia died.[28]

Several months before he died, De Grazia had said one of his greatest disappointments was that Greenlee County, where Morenci is situated, had not put up a billboard proclaiming it as his hometown the way Willcox, Arizona, had done for cowboy singer Rex Allen. But on the morning of September 17, Morenci officials did put up a black banner to tell the world that De Grazia was gone.[29]

In her musings written after De Grazia's death, Marion wrote, "She was beautiful. She was wringing her hands. He was bedraggled. The baby was crying." These sentences have given rise to speculation that she may have been referring to Locust, De Grazia, and Domingo.[30]

Curiously, no oral history and no interviewees mentioned seeing Marion in the Nun's House by De Grazia's side during his final days. Brian Domino, then eighteen, whom Marion did allow to visit during the daytime, said he was so focused on De Grazia that he paid little attention to who else was in the room.

But perhaps Marion did spend some time alone with De Grazia before he died. Afterward, she wrote:

> *I remember that evening*
> *When you said "good-bye"*
> *You said it very quietly*
> *Now I remember*
> *How often you said*
> *"We are born alone*
> *And we die alone."*[31]

Domino recalled that on the day De Grazia died, he was waiting for his mother to come home so he could go to the gallery to visit

him. "When she walked in the door she was crying, and I knew he had passed. She had heard it on the news while driving home." Marion's son, Hal Grieve, and Domino were the only ones allowed in the gallery after it closed to honor De Grazia's passing.[32]

The day after De Grazia's death, a sign appeared on the Gallery in the Sun door that read simply: "Closed due to the death of Ted De Grazia."

Six hundred people attended his funeral, including his son, Nick, who had once vowed that he would not. Nick had become somewhat remorseful over his loathing of his father. "I felt very sad that he was in pain at the end. I realized that, once, he was my Dad. I wished I could have dealt more with him."[33] Yaquis led the procession and danced before the ceremony. A Catholic priest, Father Robert Brauer of Saint Augustine Cathedral, gave the liturgy. When he finished, he placed De Grazia's cowboy hat on the simple pine coffin. Marion sat quietly watching the ceremony, with Domino sitting next to her, at her request.[34]

> *Once upon a time*
> *In the middle of my mind*
> *I said—I hope*
> *That I go before you do*
> *To be free-free-free.*
> *But alas*
> *You are the one*
> *Who is free*
> *Here I am*
> *Living with the memory of you as I must*
> *I am the one to carry on.*[35]

Mourners placed flowers on the casket. Most of those who paid their respects were the poor. Two Guns, wearing a wide sombrero and a green serape, still packed a gun on each hip. Bernardino played haunting music on his flute. After the casket was lowered into the grave near the front of the Gallery in the Sun, several people took turns throwing shovels of dirt on the coffin, including Domingo.

Figure 41. Hundreds of people attended De Grazia's funeral at the Gallery in the Sun, where he was buried. Photo courtesy of Dave Fisher.

The service ended as the sun set behind the Catalina Mountains, casting a mournful aura over the site. Later, a private rosary was said for De Grazia at a nearby Catholic church. Marion remembered:

> *Then he gave me*
> *Your hat and a crucifix*
> *Cry, no, no, no tears*
> *They were lost in a lonely desert*
> *The pascolas* [Indian historians] *danced*
> *In consecration of the weather*
> *Bernardino played his flute*
> *As he beat his drum*
> *He was crying.*[36]

Epilogue

Como tu, no hay dos, or, "There is no one else like you."
—*Tribute to De Grazia by Dick Frontain*[1]

AFTER DE GRAZIA'S DEATH, letters of condolence poured into the Gallery in the Sun by the hundreds. Now, years later, those letters are nowhere to found. Lance Laber, the DeGrazia Foundation's executive director, can't explain why they are missing but doubts that Marion had anything to do with their disappearance.

The *Arizona Daily Star* printed several letters to the editor about De Grazia's death that seemed to reflect the sentiments of his following. Helen L. Goff wrote, "I will always remember him as a beautiful artist and a man who was humble, friendly and destined to be great. His art will live on." William T. Zivic Sr., also an artist of the Southwest, called it a sad day when De Grazia died. "His vast influence in the art community was a blessing to every person who makes a living by selling art." Dolan Ellis, Arizona's official state balladeer, called De Grazia "truly one of Arizona's greatest treasures. Without people like Ted De Grazia, the world would become a very bland place."[2]

Toward his last days, Carol Locust asked De Grazia what he wanted for the gallery's future. "I want the gallery to be full of visitors," he said. "I want children dancing, music, drums, singing, celebrations there. I want the gallery to be a living museum, not a damn dead building, a tomb like the mines, but a place alive with color, people, events. I want to reach out to the world, hold all nations inside the circle of *Los Niños*. I want history told about my paintings, about art, about me."[3]

Today, some thirty years after De Grazia's death, his wishes are being fulfilled. The gallery sponsors events throughout the year, including rotating exhibitions of his original art, the annual fall opening of the Little Gallery to showcase visiting artists, and La Fiesta

de Guadalupe every December. The fiesta includes outdoor perfor-
mances by mariachis and *folclorico* dancers; traditional Yaqui deer
dances; ethnic foods; and a La Posada procession. In addition, chil-
dren swing sticks at piñatas; there are arts and crafts; and Domingo
De Grazia plays his guitar. The hundredth anniversary of De Grazia's
birth drew one thousand visitors in 2009. School children visit the
gallery in droves. Visitors from around the world go out of their way
to pay homage to De Grazia at the gallery. As Hal Grieve put it, "It
has a heartbeat of its own."[4]

For Marion, the impact of his death was incalculable.

When I walked
In the gallery
That morning
The silence was deaf[en]ing
With memories
Of you
The crepe on the door
Sounded
A horrifying finality
That is the way
It was
That morning
Now the memories
Of you
Are alive. . . . [5]

Nine months after De Grazia died, his widow wrote him a letter
addressed to "Dear Papa." She told him that the gallery was doing
fine. "And we hope to keep it that way, a place where visitors can find
peace and quietness. Alright Papa? Love, Marion." She noted in the
letter that De Grazia had wanted to be sure he had enough artwork
to last a long time. "Well you do, 1,600 oils, 3,500 watercolors,
2,500 original prints, 500 ceramics, 250 enamels, bronzes, jewelry, it
is astonishing—a genius you are—I can't think of another artist who
worked so hard and accomplished so much."[6]

Buck Saunders appraised 5,297 of De Grazia's works at a "realis-
tic" wholesale value of almost $9 million on June 9, 1983. Saunders

noted that the artwork had a limited market. "It would be difficult to sell even a small portion of his many works on the open market," Saunders said. "The retail value [double the wholesale value] of his paintings could only be attained if they could be sold . . . on a single-piece basis or in small quantities."

Saunders said the value of De Grazia's paintings had doubled since his death nine months earlier. "What has happened . . . is that the prices for many of the things have gone way up. Some of the limited edition lithographs have doubled in value, and some will triple in value because of their scarcity," he said.[7]

In late 1982 the foundation's board authorized construction of a vault to house the collection and preserve it from damage or theft. Hal Grieve then devoted twelve years to cataloguing all the artwork. De Grazia had left the gallery in shambles, with leaking roofs, peeling stucco, and artwork stacked carelessly about. Workers spent weeks clearing out stuff piled in storage sheds and scattered all over the property.[8]

> *I have worked*
> *and I will work*
> *to perpetuate your creations*
> *which you began*
> *so long ago.*[9]

Marion De Grazia vowed to keep Ted's legacy alive, but she had to struggle to do it. She could be a difficult woman at best, and she hit the bottle pretty hard over the year following De Grazia's death. After a series of clashes with the foundation's board of directors, she began calling them "Dopey and the Seven Dwarfs." The board wanted to mount traveling exhibits of De Grazia's work; she didn't want his paintings to leave the gallery. The board wanted cocktail receptions at the gallery; she considered them a waste of time. The directors tried to force her out, considering her a troublesome meddler; she prevailed.[10]

> *It is not easy papa*
> *I will try to keep your enchantment*
> *And not let a museum keeper*
> *Destroy your magic. . . .*

I will keep the enchantment
I will not let
Dollars destroy it.[11]

Marion quit drinking the second year after Ted's death and thus became better able to handle the turmoil over the gallery's direction. In the end, she won. Most of the directors were replaced. De Grazia, Marion, brother Frenck, accountant Ira Feldman, and attorney Tom McCarville had made up the original board, with DeGrazia, Marion, and Frenck members for life. Hal Grieve joined the board in 1983. Today, Grieve is the only remaining member of that old board.

Over the years the foundation has had nine executive directors and three interim directors. Lance Laber, who served as interim director on two occasions, was named permanent director in August 2005.[12]

My dear board of directors of the Gallery in the Sun
. . . As you persue [sic] the laws and regulations
With all of the legalities as you must
I will be calm and pretend to understand
Altho I do not
because they are over and beyond
my comprehension
For the enchantment of the gallery is my only dedication
To ensure that it must be beautiful
That it must forever be an honor to De Grazia
A shrine, a sanctuary
And may the angels ·
Come hovering
Lovingly
To help.[13]

In August 1992, De Grazia's career came full circle when the Diego Rivera Studio Museum in Mexico City held a show of forty of De Grazia's paintings—eight of them from the 1942 Bellas Artes exhibition. The following January, the Gallery in the Sun played host to an exhibition of the paintings of Rivera's wife, Frida Kahlo. That show was not without controversy. Marion De Grazia hated it. At no other time had anyone's pictures but De Grazia's hung in the

gallery. "The Kahlo show is nothing but blood and penises," Marion said. She kept her vow never to set foot in the gallery as long as the Kahlo exhibit was there. Nonetheless, the exhibit drew big crowds.[14]

By 1996, fourteen years after De Grazia's death, the gallery was flourishing. Gift shop sales, most ranging from $5 to $20 per customer, reached $700,000 annually. One year the gift shop sold about $30,000 worth of magnets at $1.50 each.[15] As many as 135,000 visitors a year from around the world flocked to it in the early years, all with free admission, as Ted had wished. For example, a Mesa couple, Len and Marian Garnick, brought New York friends to the gallery in 1996. It was the Garnicks' fourth visit. "It's like a religious pilgrimage for us," Len Garnick said. "It's soothing here—there's a spiritual tone to it."[16]

More recently, the 9/11 tragedy and the country's economic hard times have hurt attendance. The number of visitors also has declined because the generations who knew De Grazia's work have decreased. Today, gift shop and Internet sales total slightly less than $500,000 a year.[17]

As of June 30, 2011, the DeGrazia Foundation ranked sixth among the largest private foundations in Pima County,[18] with total assets of $22,868,631, a drop of almost $4.5 million from 2008.[19] In 2012, the foundation's total assets were $24,043,093, and it declared $786,972 in revenue coming from dividends, trades, and gross receipts.[20]

The next fifteen or twenty years will determine whether De Grazia's legacy will live on. Board member Ira Feldman noted in 1996 that "the history of most artists is that some time after their death . . . people don't know who they are. If after the year 2025 people still flock to his place in Tucson, he will be remembered."[21]

While De Grazia's gallery has thrived since his death, the family he left behind has gone through a number of squabbles over the estate.

For example, even though De Grazia's family and close friends knew about Domingo, Marion apparently only found out when she saw her late husband's will containing an addendum, written about six months before he died, declaring that Domingo was his son. The addendum specified that his brother Frenck was to oversee a trust to provide for Domingo's "basic comfort such as food, shelter, clothing and education, including college."

A dispute over that trust later found its way into the courts.[22] In 1990, when he was in high school, Domingo requested trust money to learn to fly an airplane, but Uncle Frenck refused to release it. He told Locust that Domingo was just "a kid, a half breed." After Ted died, she said, Frenck became hostile toward Domingo and didn't want the trust to provide for him. Locust was unsure why Frenck had become "discriminatory, almost racist, and difficult to work with." He turned down several of Locust's request for funds, including one for braces for Domingo's teeth. "Indians don't need braces," he said. Locust took out a loan to pay for the flying lessons, and in 1991 Domingo received his pilot's license.[23] Four years later, six months before Frenck died, Domingo De Grazia, then twenty-one, filed suit to recoup the cost of the lessons and other expenses that had been denied. The court awarded him $27,468 plus attorney's fees a year later.[24]

De Grazia's will, filed with the Pima County Superior Court clerk's office, acknowledged that Marion was entitled to half of the estate as community property. The other half became property of the foundation. Pima County probate officials estimated the value of his estate at $6,266,766, with the gallery property accounting for $870,000 of that total.[25] De Grazia's son, Nick, and his two daughters, Kathy De Grazia Bushroe and Lucia De Grazia Bustamante, received the Campbell Avenue studio as beneficiaries of a trust their father had set up for them in 1974. Under terms of the trust, Marion became executrix after her husband's death.

Marion didn't see the studio complex as part of De Grazia's legacy and wanted to get rid of it. "The studio is run down, and looks terrible. And it's not a credit to De Grazia's name."[26] She and her son, Hal, wanted to sell the property. Eventually, the fate of the studio wound up in court after Marion and Hal sued, claiming that Bushroe had blocked the property's sale by signing long-term leases with shopkeepers. Marion wanted the leases terminated and Bushroe removed as trustee of the studio estate. Most of the shopkeepers wanted to remain in business at the studio; they cherished its status as a historic complex. "To me, this is a memorial to him when he was a struggling artist—when he had nothing," Tish Holland said. "I would hate to see it torn down. It's a memorial to the man."[27]

Bushroe responded to the suit by saying that it violated the intention of the trust and that it went against De Grazia's wish that the

property not be sold. Nonetheless, Marion won. Within three years the property sold for $265,000 for commercial purposes.[28] "It's a heartbreaker, having to watch something that was part of my father and a part of Tucson history being wiped out," Bushroe said. "To me, it's part of my dad. It's very hard. Death is very hard. But then to lose the land he loved so much—it's very hard."[29] Today a Chevron gas station is doing business on the site.

Marion took care of the Gallery in the Sun for twenty years after De Grazia's death. She died of heart disease on December 9, 2002, at the age of ninety-seven. No memorial was held, at her request. She was cremated and her ashes placed at the base of a tree near the grave of her "beloved husband" on the gallery property.[30]

Locust waited until after Marion De Grazia's death to write a 238-page memoir of her eleven years with De Grazia, entitled *De Grazia: The Rest of the Story*. She still lives in her home near the San Xavier Mission and is a docent at the Gallery in the Sun.

A Renaissance man like his father, Domingo has a clear drive to succeed as well. He also seems to have inherited his father's artistry and penchant for diverse interests. After earning college degrees in aerospace and aeronautical science, he went to law school. He is now a practicing attorney and an accomplished Spanish guitarist with his own band. In addition to holding a pilot's license, he is a skydiver, a scuba diver, a former X Games bicycle stunt rider, and a former motorcycle road racer.[31]

Four of De Grazia's children survive him: Lucia De Grazia, Kathy Bushroe, Domingo De Grazia, and stepson Hal Grieve. His two daughters and son live in Tucson, while Grieve splits his time between Pennsylvania and Tucson.

Postscript

The question remains: What is De Grazia's legacy? Surely he will always be known as the self-proclaimed "world's most reproduced artist." By the time of his death in 1982, more than 100 million reproductions of his images, including prints, bank checks, postcards, posters, lithographs, magnets, candles, figurines, collector plates, and

greeting cards, have been executed and are scattered around the world, in the hands of art collectors as well as of common people who were attracted to his paintings.[32] Much of his work may be passed down from generation to generation.

De Grazia's art is forever linked with his gallery. One enhances the other and will not survive without the other. De Grazia's paintings would not have much chance of remaining before the public without the gallery. In fact, his artwork looks better within the gallery's confines. Take them away, and they often lose some luster. One saving grace for De Grazia's legacy is that the gallery is on the National Register of Historic Places, which ensures that every effort will be made to preserve the gallery—and a place to hang De Grazia's work. It seems unlikely that any museum or gallery could display his work the way it is in his gallery. It also seems unlikely that De Grazia recognized this when he built the Gallery in the Sun. After all, he was just trying to find a place to sell his work. But the gallery had the long-term effect of achieving what he so much craved—perpetuating his legacy.

To art historian Sherrye L. Cohn, it is likely that De Grazia's legacy will be deeply rooted in the Southwest but not extend much beyond. The combination of the aesthetics of the gallery and of his paintings should assure that, she said.[33]

The DeGrazia Foundation is charged with keeping his legacy before the public, but as each year passes that becomes harder, as this colorful man fades from memory. His work may survive, but will his persona? That has been the purpose of this work—to tell future generations about the man behind the paintings.

When we look at legacy, isn't there more than just the physical work an artist leaves behind? What about his characteristics, his personality, his ambition, his principles? Too often De Grazia is remembered for the cutesy paintings or his burning of his works. He spent his entire life taking heat from the established art community because it didn't approve of his "commercialism" (or his success). He stood up to them just as he did to the government. "What artist would burn his creations to prove a point?" asked Laber. "It takes some chutzpah to thumb your nose at the IRS. This says to me that his principles were the most important thing he had. I think that's why so many regular folks loved him. He was honest, and the rank-and-filer could see that." In the end, Laber said, "it will be his

non-conformist, mountain man, me-against-the-world persona that he'll be remembered for."[34]

Few artists remain famous from one century to the next. It may be too early to tell whether De Grazia will live on, but it won't be for lack of trying on his part. If he does, much of it will be in the hands of the foundation as it keeps the Gallery in the Sun a vibrant place to remember him.

While his "kitsch" drawings may be dismissed over the ages, surely his depictions of Southwest history will survive the test of time. His art and text in books on Fathers Kino and Serra, the Yaqui Easter ceremony, Cabeza de Vaca, and Papago Indian legends may well prove to be invaluable for those interested in the Southwest of times past. That, in itself, confirms a legacy.

At least one critic, Frank DeHoney of the *Chicago Tribune*, predicted a lasting legacy for De Grazia. He wrote in a 1978 article: "Nothing of his is a copy of any other style known. His individualism is unique and absolute. Whether or not you like his style is unimportant. His innovative works have so influenced the art world that the impact will probably be felt for as long as our civilization survives."[35]

As Marion De Grazia wrote in her musings about the gallery:

It leaves a lasting memory
year after year
its essence is becoming
more and more
a truth.
The magic there cannot
Be explained
For only the angels know.
They are watching over the gallery,
De Grazia's dream will prevail.[36]

Acknowledgments

A BOOK USUALLY HAS ONE AUTHOR on the cover, two as in this case. But there are dozens of people who have contributed to this end product. Some of their names have been lost out of haste or lack of time, or the author forgot to ask their identities. They are all important, and I need to thank them up front. I wish I had everyone's name.

Of those names I do have, two that stand at the top of the list are Lance Laber, executive director of the DeGrazia Foundation, and my wife, Marilyn Johnson, whose name graces the cover. Laber gave me complete access to the De Grazia archives, cheerfully responded to my telephone calls and e-mails with insightful answers, and didn't even mind when I had lunch with him, devouring Mexican food, when he was on a diet.

Jim Jenkins, a DeGrazia Foundation archivist, also helped a great deal with tracking down archival material. Particularly gracious were other staff members who made my visits to the Gallery in the Sun so pleasant. I visited there so often that one time a visitor thought I was the gallery's director.

Marilyn meticulously edited my manuscript, as she has two of my other books, ridding it of my clumsy syntax, catching contradictions, and encouraging me to rewrite numerous sentences written in passive voice. It's amazing how many times I used the verb *was*. Her feminine insight also helped me show some sensitivity to the women in De Grazia's life.

The University of Arizona Press's Diana Rico polished the manuscript even more. She saved me from several embarrassing mistakes, tightened up my writing, and cleared up ambiguous statements. Her editing makes this a far better effort than what I put forth. I am extremely grateful.

Encouragement from acquiring editor Kristen Buckles of the University of Arizona Press gave me motivation and discipline to complete this work.

Thanks as well to Jack Riddle of the Bisbee Mining & Historical Museum and to librarians at the University of Arizona; the Pima County Public Library; the Arizona Historical Society; Northern Arizona University; and the Arizona State Library, Archives, and Public Records.

Friends I counted on to come to my rescue included Stan and Phyllis Newman, who live in Manhattan and made several trips to the Museum of Modern Art to gather information; University of Arizona emeritus journalism professor Donald W. Carson, who read my manuscript with great care; and *Arizona Daily Star* executive editor Bobbie Jo Buel and senior editor Debbie Kornmiller, who gave me access to the newspaper's library.

Notes

Introduction

1. Butler, "Words of the Artist," 46.
2. Davis, "De Grazia—Arizona's Impetuous Impasto."
3. Jennifer Potter, e-mail message to author, September 7, 2012.
4. *San Diego Union,* December 12, 1971.
5. De Grazia interview, *The Today Show.*
6. Locust, *The Rest of the Story,* x.
7. Butler, "Words of the Artist," 43.
8. Davenport oral history, 22.
9. Dave and Norma Fisher oral history, 25–26.
10. Locust oral history, 38.
11. Biographical files, *Tucson Citizen* library.
12. Grieve oral history, 13.
13. Prescott oral history, 28.
14. Butler, "Words of the Artist," 46.
15. Chanin oral history, 17.
16. *Arizona Daily Star,* September 26, 1982.
17. Ibid., October 17, 1971.
18. Exhibition brochure, Temple of Fine Arts Gallery, February 19, 1956.
19. *Arizona Daily Star,* September 26, 1982.
20. *Scottsdale Progress,* n.d., 1944–66 scrapbook, DeGrazia Foundation library.
21. Frontain, *De Grazia in Fotos,* n.p.
22. Reed, *The Irreverent Angel,* 61.
23. Marion De Grazia, notebook of musings, 25.
24. McCarville interview.
25. National Center for Charitable Statistics, accessed January 8, 2012, http://nccsweb.urban.org/orgs/profolder.php/860339837?popup=1.
26. Michael Lewis, "Art, Politics, & Clement Greenberg," *Commentary,* June 1998, accessed July 25, 2013, http://www.commentarymagazine.com/article/art-politics-clement-greenberg.
27. Luey and Stowe, *Arizona at 75,* 41–42.
28. *Prescott Courier,* October 1, 1982.
29. Dalton, "Kitsch and Southwest Hybridity in the Art of Ted De Grazia," 2; Laber interview.

Chapter 1

1. Redl, *The World of De Grazia*, 14.
2. Ira Feldman, e-mail message to author, January 7, 2012.
3. Laber interview.
4. Davenport oral history, 4.
5. Butler, "Words of the Artist," 44.
6. Feldman interview.
7. "Artist Hates Money, Buries It," n.d., 1944–1966 scrapbook, DeGrazia Foundation library.
8. Dalton, "Kitsch and Southwest Hybridity in the Art of Ted De Grazia," 80.
9. Maw, book proposal.
10. *New York Daily News*, November 11, 1965.
11. Redl, *The World of De Grazia*, 15.
12. Wilson, Frontain, and Stacey, "De Grazia: Three Views," 5.
13. Family history document courtesy of Lucia De Grazia.
14. "Morenci Copper Mine, Arizona, United States," accessed March 15, 2012, http://www.mining-technology.com/projects/morenci/.
15. Colquhoun, *The History of the Clifton-Morenci Mining District*, 97–99.
16. Martinelli, *Undermining Race*, 5.
17. Lucia De Grazia oral history, 38.
18. Port of New York Passenger Record for Lucia Gagliardi, August 12, 1902, American Family Immigration History Center at Ellis Island, accessed July 21, 2013, http://www.ellisisland.org/search/passRecord.asp?MID=04817161 870881562528&FNM=LUCIA&LNM=GAGLIARDI&PLNM=GAGLIARDI &CGD=F&first_kind=1&last_kind=0&TOWN=null&SHIP=null&RF=8& pID=105349040029.
19. Certificate of Marriage, Domenico De Grazia to Lucia Gagliardi, November 12, 1903, De Grazia vertical file, Arizona State Library, History and Archives Division, Phoenix.
20. Kluger, *The Clifton-Morenci Strike*, 20.
21. "Greenlee County History, Morenci," accessed March 15, 2012, http://www.co.greenlee.az.us/historymorenci.aspx.
22. Lucia De Grazia oral history, 6.
23. Martinelli, *Undermining Race*, 149.
24. Ibid.
25. Faulk, *Arizona: A Short History*, 220.
26. Martinelli, *Undermining Race*, 161.
27. Ibid., 1.
28. *New York Times*, November 2, 1915.
29. Faulk, *Arizona: A Short History*, 221.
30. Martinelli, *Undermining Race*, 161.
31. Lawrenzi and Molina, "They were my creations . . . ," 52.
32. De Grazia, *Borderlands Sketches*, 13.

33. Martinelli, *Undermining Race*, 148.

34. *Morenci Leader*, July 8, 1905.

35. Chanin, *This Land, These Voices*, 241.

36. Ford, "The Art and Craft of Ted De Grazia," 8.

37. Maw, book proposal.

38. De Grazia, *His Thoughts and His Philosophy*.

39. Locust, *The Rest of the Story*, 73.

40. Ibid., 49.

41. De Grazia, narrative statement, National Register of Historic Places, 2005, sect. 8, p. 22. Copy in DeGrazia Foundation archives.

42. De Grazia, handwritten autobiography.

43. Ibid.

44. Dalton, "Kitsch and Southwest Hybridity in the Art of Ted De Grazia," 11.

45. Pulice, "My Childhood Days with Ted De Grazia."

46. De Grazia, *Ah Ha Toro*, n.p.

47. Pulice, "My Childhood Days with Ted De Grazia."

48. Olson, "The Unpredictable De Grazia."

49. Marion De Grazia, *A Biographical Sketch*, n.p.

50. Olson, "The Unpredictable De Grazia."

51. Marion De Grazia, *Son of Lightning*, n.p.

52. Maw, book proposal.

53. Pulice, "My Childhood Days with Ted De Grazia."

Chapter 2

1. Davis, "De Grazia—Arizona's Impetuous Impasto."

2. Lucia De Grazia oral history, 31.

3. Butler, "With De Grazia among the Seris," 38.

4. De Grazia, *De Grazia Moods*, 36.

5. Family history document courtesy of Lucia De Grazia.

6. "Amantea Photos," accessed November 30, 2010, http://en.comuni-italiani.it/078/010/foto/index.html.

7. Carlson, "De Grazia," 1941, 30.

8. Reed, *The Irreverent Angel*, 14.

9. De Grazia, narrative statement, National Register of Historic Places, sect. 8, p. 22.

10. Marion De Grazia, *Son of Lightning*, n.p.

11. De Grazia, *Borderlands Sketches*, 12.

12. McCarville interview.

13. Redl, *The World of De Grazia*, 75–76.

14. Lucia De Grazia oral history, 35.

15. *Chicago Tribune*, November 23, 1978.

16. Wilson, "De Grazia: The Man, the Artist, the Spirit," 90.

17. De Grazia, handwritten autobiography.

18. Olson, "The Unpredictable De Grazia."

19. Davis, "De Grazia—Arizona's Impetuous Impasto."
20. De Grazia, *His Thoughts and His Philosophy*.
21. Renner oral history, 1.
22. De Grazia, narrative statement, National Register of Historic Places, sect. 8, p. 22.
23. "Greenlee County History, Morenci Mining District," accessed April 5, 2012, http://www.co.greenlee.az.us/morencimining.aspx.
24. De Grazia, handwritten autobiography.
25. Marion De Grazia, *Son of Lightning*, n.p.
26. De Grazia, handwritten autobiography.
27. Olson, "The Unpredictable De Grazia."
28. Locust, *The Rest of the Story*, xiv.
29. Maw, book proposal.

Chapter 3

1. Butler, "Words of the Artist," 29.
2. Maw, book proposal.
3. *WPA Guide to 1930s Arizona*, 252–54.
4. Reed, *The Irreverent Angel*, 15.
5. De Grazia, narrative statement, National Register of Historic Places, sect. 8, pp. 23–24.
6. Peterson oral history, 1996, 5.
7. Ibid., 5, 13.
8. Maw, book proposal.
9. Pintek oral history, 1.
10. Chanin, *This Land, These Voices*, 241.
11. Kerson, *Remembrance of Tucson's Past*, 95.
12. Redl, *The World of De Grazia*, 15.
13. Marion De Grazia, *Son of Lightning*, n.p.
14. Butler, "Words of the Artist," 29.
15. Chanin, *This Land, These Voices*, 239.
16. Olson, "The Unpredictable De Grazia."
17. Chanin, *This Land, These Voices*, 241.
18. Pintek oral history, 7.
19. Ibid., 11.
20. Chanin, *This Land, These Voices*, 241.
21. Maw, book proposal.
22. De Grazia, handwritten autobiography.
23. Chanin, *This Land, These Voices*, 241.
24. Kerson, *Remembrance of Tucson's Past*, 94.
25. Ibid., 122.
26. Ibid., 28.
27. Ibid., 94–95.
28. Ibid., 96.

29. *Tucson Daily Citizen*, September 5, 1935.

30. Ibid., June 29, 1936.

Chapter 4

1. Butler, "Words of the Artist," 46.

2. "Bisbee History," accessed October 3, 2011, http://www.discoverbisbee.com/about_hist.htm.

3. *WPA Guide to 1930s Arizona*, 173.

4. Ibid., 172.

5. Kerson, *Remembrance of Tucson's Past*, 98.

6. Lenon, *It Seems Like Only Yesterday*, 42.

7. Alexander oral history, 20.

8. Kerson, *Remembrance of Tucson's Past*, 98.

9. Dalton, "Kitsch and Southwest Hybridity in the Art of Ted De Grazia," 34–35.

10. Feeney oral history, 5.

11. Ibid., 2.

12. Alexander oral history, 11.

13. "Cochise County Courthouse Art, Bisbee, AZ," accessed July 22, 2013, http://livingnewdeal.berkeley.edu/projects/cochise-county-courthouse-art-bisbee-az/.

14. Pintek oral history, 6.

15. Carlson, "De Grazia," 1949, 35.

16. Alexander oral history, 17.

17. Chanin, *This Land, These Voices*, 244.

18. "Musical Compositions of Ted DeGrazia," exhibit narrative, De Grazia Gallery in the Sun, January 21, 2011, to January 16, 2012.

19. Kerson, *Remembrance of Tucson's Past*, 98–99.

20. Ibid., 99.

21. Ibid., 100.

22. Feeney oral history, 3–4.

23. Kerson, *Remembrance of Tucson's Past*, 103–4.

24. Ibid., 100–101.

25. Ibid., 105.

26. Lawrenzi and Molina, "They were my creations . . . ," 51.

27. De Grazia, handwritten autobiography.

28. Carlson, "De Grazia," 1941, 30.

29. De Grazia, handwritten autobiography.

30. Kerson, *Remembrance of Tucson's Past*, 106.

Chapter 5

1. Marion De Grazia, *Son of Lightning*, n.p.

2. Carlson, "De Grazia," 1941, 30–33.

3. Ibid., 30.

4. Alexander oral history, 20.

5. *San Pedro Valley News*, August 22, 1941.

6. Carlson, "De Grazia," 1941, 35.

7. Reed, *The Irreverent Angel*, 18.

8. *Bisbee Daily Observer*, February 23, 1941.

9. *Brewery Gulch Gazette*, May 5, 1941.

10. *Home Movies Diamos Family*, DeGrazia Foundation archives.

11. Butler, "Words of the Artist," 20.

12. Kerson, *Remembrance of Tucson's Past*, 116.

13. Ibid.

14. Lucia De Grazia oral history, 23–25.

15. Hirale interview.

16. *Bisbee Shopping News*, January 15, 1942.

17. Kerson, *Remembrance of Tucson's Past*, 106.

18. Delayed Certificate of Birth, April 14, 1942, Arizona State Department of Health, De Grazia vertical file, Arizona State Library.

19. Marion De Grazia, *A Diamond in the Rough*, 11; Kerson, *Remembrance of Tucson's Past*, 107.

20. Kerson, *Remembrance of Tucson's Past*, 107–8.

21. Ibid., 108–9.

22. Ibid., 109–10.

23. Ibid., 110–11.

24. Ibid., 112.

25. Registrar's Report, October 16, 1940; Registration Card, serial no. 1966; Classification Record; National Personnel Records Center, Saint Louis, MO.

26. Diego Rivera to U.S. Embassy, Mexico City, September 2, 1942, DeGrazia Foundation archives, series 1, box 2, folder 20.

27. Chanin oral history, 11.

28. Alexander oral history, 12.

29. Olson, "The Unpredictable De Grazia."

30. Marion De Grazia, *A Diamond in the Rough*, 23.

31. Butler, "Words of the Artist," 38.

32. Redl, *The World of De Grazia*, 18.

33. Chanin, *This Land, These Voices*, 244.

34. De Grazia, *Ah Ha Toro*, n.p.

35. Redl, *The World of De Grazia*, 18, 20.

36. Chanin, *This Land, These Voices*, 242.

37. Shaw, "Ted De Grazia," 38.

38. Kerson, *Remembrance of Tucson's Past*, 107–15.

39. "Ettore 'Ted' De Grazia," accessed July 19, 2012, http://degrazia.org/about-degrazia/bio/.

40. Letters of reference from Diego Rivera (November 17, 1942) and José Clemente Orozco (November 9, 1942), DeGrazia Foundation archives, series 1, box 2, folder 20.

41. *Tucson's Early Moderns*, exhibition catalog, 1988, Tucson Museum of Art.
42. *Christian Science Monitor*, December 8, 2011.
43. Kerson, *Remembrance of Tucson's Past*, 117.
44. Locust oral history, 15–16; Redl, *The World of De Grazia*, 20, 23.
45. Chanin oral history, 8.
46. Shaw oral history, 11.
47. *De Grazia*, University of Arizona Museum of Art, n.p.

Chapter 6

1. Butler, "Words of the Artist," 21.
2. Kerson, *Remembrance of Tucson's Past*, 115.
3. Redl, *The World of De Grazia*, 23.
4. *Los Angeles Times*, June 1, 1977.
5. Locust oral history, 36.
6. Olson, "The Unpredictable De Grazia."
7. Bell oral history, 9.
8. Ibid., 3, 8.
9. De Grazia, *Borderlands Sketches*, 14.
10. *Phoenix New Times*, March 22, 1989.
11. Ibid., April 18, 2002.
12. De Grazia interview, *The Today Show*.
13. Jesus Lopez Jr., "De Grazia's 'Power of the Press' Mural Lives on in Hearts of Many Alums," accessed March 21, 2011, http://wc.arizona.edu/papers/93/100years/story.13.html.
14. "Orozco at Dartmouth," accessed August 12, 2011, http://hoodmuseum.dartmouth.edu/docs/orozcobrochure.pdf.
15. Lopez, "De Grazia's 'Power of the Press' Mural."
16. Marion De Grazia, *A Biographical Sketch*, n.p.
17. Reed, *The Irreverent Angel*, 27.
18. Marion De Grazia, *Son of Lightning*, n.p.
19. *Arizona Daily Star*, September, 26, 1982.
20. De Grazia, handwritten autobiography.
21. Reed, *The Irreverent Angel*, 29.
22. Butler, "Words of the Artist," 1.
23. Redl, *The World of De Grazia*, 23.
24. De Grazia, narrative statement, National Register of Historic Places, sect. 8, p. 28.
25. Frontain, *De Grazia in Fotos*, n.p.
26. Butler, "Words of the Artist," 26.
27. *Tucson Citizen*, February 28, 1987.
28. Pintek oral history, 8.
29. De Grazia, handwritten autobiography.
30. Edmonson oral history, 6.
31. *Arizona Daily Star*, September 17, 1982.

32. Wilson oral history, 10.
33. Pichetto oral history, 1–2, 4.
34. Horky oral history, 2.
35. De Grazia, handwritten autobiography.
36. Locust oral history, 6.
37. Reed, *The Irreverent Angel*, 30.
38. Shaw, "Ted De Grazia," 40.
39. De Grazia, handwritten autobiography.
40. Carlson, "De Grazia," 1949, 31.
41. "Unforgettable: Danko Gurovich & the Copper Hills," accessed March 15, 2011, http://www.gmtnewsnviews.com/2010/10/08/unforgettable-danko-gurovich-the-copper-hills/.
42. "Raymond Carlson: "He Took Arizona to the Whole World," *Arizona Highways* news release, February 2, 1983, DeGrazia Foundation archives, series 3, box 5, folder 30.
43. Pichetto oral history, 21.
44. Chanin oral history, 2.

Chapter 7

1. Reed, *The Irreverent Angel*, 32.
2. Ibid., 19–21, 23.
3. "Thomas Hart Benton," accessed September 17, 2012, http://www.theartstory.org/artist-benton-thomas-hart.htm.
4. Charles and Lucile Herbert, "De Grazia: Painting Sound," Western Ways Features Manuscript and Photograph Collection, ca. 1930–1970, folder MS 1255, Arizona Historical Society.
5. Redl, *The World of De Grazia*, 23.
6. "Painting Music in Color: Untaught Artist Seeks the Relation between Art and Music," 12–13.
7. De Grazia, "Art and Its Relation to Music in Music Education," 55.
8. Ibid., 43.
9. Ibid., 59.
10. Roberta Sinnock, interview by Ed Kupperstein, *Arts Upbeat*, KUAT-FM, October 22, 1996.
11. De Grazia, "Art and Its Relation to Music in Music Education," 2.
12. Renner oral history, 10.
13. Dalton, "Kitsch and Southwest Hybridity in the Art of Ted De Grazia," 16.
14. Chanin, *This Land, These Voices*, 244.
15. Laber interview.
16. Cohn interview.
17. Quoted in Cohn, *Why We Look at Art, What Happens When We Do*, 1.
18. Alexander oral history, 29.
19. Kerson, *Remembrance of Tucson's Past*, 116.
20. Ibid., 116–17.

21. Locust, *The Rest of the Story*, 108.

22. Complaint for Divorce, Stipulation, Judgment, and Decree, case no. 27364, filed July 31, 1946, Clerk's Office, Pima County Superior Court, Tucson, AZ.

23. Lucia De Grazia interview.

24. Bill of sale signed by Alexandra De Grazia, July 31, 1946, DeGrazia Foundation archives, series 1, box 2, folder 22.

25. Lucia De Grazia interview.

26. Ibid.

27. Lawrenzi and Molina, "They were my creations . . . ," 52.

28. Locust interview.

29. Diamos interview.

30. Redl, *The World of De Grazia*, 23.

31. *Tucson Citizen*, July 5, 1985.

Chapter 8

1. Lawrenzi and Molina, "They were my creations . . . ," 51.

2. Lucia De Grazia oral history, 4.

3. Ibid., 3–4.

4. Lucia De Grazia interview.

5. *Arizona Republic*, August 9, 1987.

6. *Tucson Citizen*, March 4, 1980.

7. DeWald oral history, 8.

8. Frontain oral history, 1.

9. Marion De Grazia oral history, 4.

10. Grieve oral history, 5.

11. Grieve interview.

12. "The De Grazia 'Other Half,'" *Arizona Republic*, n.d., 1944–66 scrapbook, DeGrazia Foundation archives.

13. "M. De Grazia," *Desert Leaf,* October 1995.

14. Grieve interview.

15. Ibid.

16. Marion De Grazia oral history, 4.

17. Ibid., 7.

18. *Tucson Daily Citizen*, April 19, 1966.

19. *Arizona Republic*, December 11, 2002.

20. *Arizona Daily Star*, September 17, 1996.

21. Rosenfeld, "Ettore De Grazia."

22. Marion De Grazia, notebook of musings, 55.

23. Grieve oral history, 1.

24. Marion De Grazia oral history, 7.

25. *New York Daily News*, November 4, 1965.

26. *Tucson Daily Citizen*, July 25, 1947.

27. Marion De Grazia oral history, 9.

28. *Tucson Daily Citizen*, July 25, 1947.

29. Olson, "The Unpredictable De Grazia."

30. Butler, "Words of the Artist," 16.

31. Dalton, "Kitsch and Southwest Hybridity in the Art of Ted De Grazia," 36.

32. Marion De Grazia oral history, 10.

33. Reed, *The Irreverent Angel*, 31.

34. Aldine von Hisser and Hal Grieve, "Spotlight on a Neighbor," accessed March 17, 2012, http://catalinapueblo.com/sitebuildercontent/sitebuilderfiles/2009marchcompletel.pdf.

35. Lucia De Grazia interview.

36. Lucia De Grazia oral history, 14.

37. Reed, *The Irreverent Angel*, 32.

38. Brown oral history, 12.

Chapter 9

1. Wilson, Frontain, and Stacey, "De Grazia: Three Views," 2.

2. Carlson, "An Artist in Navajoland," 27.

3. Ibid.

4. Cutts, "De Grazia," 20.

5. Butler, "Words of the Artist," 11.

6. Ibid., 12.

7. Shaw, "Painter's Pilgrimage," 25.

8. Butler, "Words of the Artist," 24.

9. *Arizona Daily Star*, November 4, 1973.

10. Locust oral history, 33.

11. Locust, *The Rest of the Story*, 1–9.

12. "About Taos Pueblo," accessed March 17, 2012, http://www.taospueblo.com/about.

13. Locust oral history, 32.

14. Butler, "Words of the Artist," 1.

15. Locust, *The Rest of the Story*, x.

16. *Arizona Daily Star*, December 15, 1973.

17. Marion De Grazia, notebook of musings, 24.

18. Butler, "Words of the Artist," 10.

19. Brown oral history, 17.

20. Landeen oral history, 13.

21. *Mesa Tribune*, August 10, 1967.

22. De Grazia interview, *Today Show*.

23. Butler, "Words of the Artist," 16.

24. Dalton, "Kitsch and Southwest Hybridity in the Art of Ted De Grazia," 32.

25. Butler, "Words of the Artist," 16.

26. *Mesa Tribune*, August 10, 1967.

27. Butler, "Words of the Artist," 12.

28. Ibid., 11.

29. Ibid., 12.
30. Ibid., 13.
31. Locust oral history, 32.
32. De Grazia, *De Grazia Paints the Yaqui Easter*, 11–12.
33. Gust, "Seri Indian Land," 1.
34. Ibid.
35. Butler, "With De Grazia among the Seris," 38.
36. Ibid., 40.
37. Frontain oral history, 18.
38. *San Diego Sentinel*, May 5, 1970.
39. De Grazia, with William Neil Smith, *The Seri Indians*, preface.
40. *Arizona Republic*, June 23, 1983.
41. *Arizona Daily Star*, July 25, 1976.
42. De Grazia, *De Grazia Paints the Apache Indians*, book jacket copy.

Chapter 10

1. Butler, "Words of the Artist," 35.
2. De Grazia, *A Biographical Sketch*, n.p.
3. Olson, "The Unpredictable De Grazia."
4. Marion De Grazia to Ted De Grazia, "Satisfaction," April 8, 1948, DeGrazia Foundation archives, series 1, box 2, folder 37.
5. Thure oral history, 16.
6. Marion De Grazia to Ted De Grazia, "Satisfaction."
7. Olson, "The Unpredictable De Grazia."
8. Complaint for Divorce, case no. 40408, filed April 30, 1953, Clerk's Office, Pima County Superior Court, Tucson, AZ.
9. Marion De Grazia, notebook of musings, 72.
10. Laber interview.
11. Ada P. McCormick to Marion De Grazia, May 1, 1953, Papers of Ada Pierce McCormick, ms. 327, box 22.
12. *New York Daily News*, November 4, 1965.
13. Landeen oral history, 20.
14. Marion De Grazia, *Son of Lightning*, n.p.
15. De Grazia, last will and testament, May 29, 1959, DeGrazia Foundation archives, series 1, box 2, folder 25.
16. *Tucson Daily Citizen*, April 19, 1966.
17. Marion De Grazia oral history, 29.
18. Ford, "The Art and Craft of Ted De Grazia," 40.
19. Marion De Grazia oral history, 86.
20. Redl, *The World of De Grazia*, 30.
21. Edmonson oral history, 1.
22. Ibid., 2.
22. Ibid., 3.
24. Dalton, "Kitsch and Southwest Hybridity in the Art of Ted De Grazia," 19.

25. *Arizona Daily Star,* December 5, 1948.

26. Reed, *The Irreverent Angel,* 33–34.

27. Butler, "Words of the Artist," 22.

28. Redl, *The World of De Grazia,* 142.

29. Ibid., 34.

30. Wilson oral history, 1.

31. *Mesa Tribune,* August 10, 1967.

32. Sheaffer oral history, 2.

33. *Arizona Daily Star,* n.d. (probably late 1940s).

34. Sheaffer oral history, 2.

35. Jacobson oral history, 2–4.

36. Miller oral history, 2–3.

37. "Christmas on the Desert," 14.

38. Saunders oral history, 3.

39. Wilson oral history, 8.

40. Saunders oral history, 5.

41. *Arttalk,* March 1987, 6.

42. Butler, "Words of the Artist," 6.

43. *Arizona Daily Star,* April 18, 1954.

Chapter 11

1. *Trumpeteer,* Spring 1952, 12.

2. Conrotto, "One Man's Southwest," 24.

3. De Grazia with Vardaman, "Make Your Own Pottery," 37, 74–75.

4. Buck Saunders interview, n.d. (ca. September 17, 1982), "Newscast, Phx, Obituaries," videotape, DeGrazia Foundation archives.

5. Alexander oral history, 20.

6. *Arizona Daily Star,* January 8, 1948.

7. Butler, "Words of the Artist," 22–23.

8. "Cochineal," accessed May 23, 2012, http://en.wikipedia.org/wiki/Cochineal.

9. *Arizona Daily Star,* November 13, 1962.

10. "Cochineal."

11. *Tucson Daily Citizen,* October 15, 1951.

12. "Plaza Gallery Reception Opens De Grazia Show," unidentified Albuquerque newspaper, 1944–66 scrapbook, DeGrazia Foundation library.

13. *Tucson Daily Citizen,* October 15, 1951.

14. "Riddle in the Sun," *Tucson Guide,* Fall 2002, 171.

15. De Grazia, *De Grazia in Graphics,* 16.

16. *Tucson Daily Citizen,* January 10, 1952.

17. Ibid.

18. "Artist Skirts Featured in Tucson Store," *Women's Wear Daily,* n.d., photography scrapbook, DeGrazia Foundation library.

19. De Grazia interview, *The Today Show.*

20. *Tucson Daily Citizen*, September, 22, 1953.

21. Ibid., December 18, 1952.

22. *Trumpeteer*, Spring 1952, 12.

23. *Tucson Daily Citizen*, February 21, 1952.

24. Butler, "Words of the Artist," 20.

25. Marion De Grazia, notebook of musings, 19.

26. *Copper Era*, June 27, 1990.

27. Wilson, Frontain, and Stacey, "De Grazia: Three Views."

28. *Arizona Daily Star*, September 26, 1982.

29. Wilson, "De Grazia: The Man, the Artist, the Spirit," 9.

30. Psychiatrist's statement, Irrevocable Trust Agreement, December 17, 1979, Raymond Carlson folder, DeGrazia Foundation archives, series 3, box 5, folder 30.

31. Figueroa oral history, 32; DeWald oral history, 28.

33. Landeen oral history, 12.

34. *Tucson Daily Citizen*, July 7, 1952.

35. Figueroa oral history, 9.

36. Locust interview.

37. Thure oral history, 22.

38. Quoted in Dalton, "Kitsch and Southwest Hybridity in the Art of Ted De Grazia," 22.

39. Olson, "The Unpredictable De Grazia."

40. DeWald oral history, 6.

41. Ibid., 7.

42. Ibid., 22.

43. Ibid., 8–9.

Chapter 12

1. De Grazia, *His Thoughts and His Philosophy*.

2. Butler, "Words of the Artist," 8.

3. Laber interview.

4. Marion De Grazia, notebook of musings, 19.

5. Frontain, *De Grazia in Fotos*, n.p.

6. Marion De Grazia oral history, 18.

7. Clark oral history, 26.

8. De Grazia, *Borderlands Sketches*, 57.

9. Ibid., 70.

10. Maw, "De Grazia."

11. "Artist Says 'Art Is Like Religion,'" *Desert Magazine*, n.d., 1970–72 scrapbook, DeGrazia Foundation library.

12. Brown oral history, 14.

13. Davenport oral history, 28.

14. De Grazia, narrative statement, National Register of Historic Places, sect. 8, p. 28.

15. "From Tucson to Tombstone," *National Geographic*, September 1953, 350.
16. Marion De Grazia, notebook of musings, 21.
17. Rosenfeld, "Ettore De Grazia."
18. Marion De Grazia oral history, 17.
19. De Grazia, narrative statement, National Register of Historic Places, sect. 7, p. 7.
20. Laber interview.
21. Reed, *The Irreverent Angel*, 7.
22. De Grazia, narrative statement, National Register of Historic Places, sect. 7, p. 8.
23. Clark oral history, 23–24.
24. Marion De Grazia oral history, 20.
25. Shaw, "Ted De Grazia," 40.
26. *Tucson Daily Citizen*, August 22, 1975.
27. "The Power of Positive Space," *Architectural Record*, 172.
28. Marion De Grazia, notebook of musings, 21.
29. De Grazia, "Texture."
30. Butler, "Words of the Artist," 38.
31. De Grazia, narrative statement, National Register of Historic Places, sect. 7, p. 11.
32. Domino interview.
33. Domino, e-mail message to author, n.d.
34. Marion De Grazia, notebook of musings, 23, 39, 63, 85.
35. Ibid., 21.
36. *Arizona Daily Star,* June 8, 1961, and October 20, 1961; *Tucson Daily Citizen*, June 8, 1961, October 13, 1961, and November 21, 1961.
37. Prescott oral history, 28.
38. *Tucson Citizen*, March 4, 1980.
39. *Arizona Daily Star,* January 29, 1965.
40. Ibid., March 9, 1980.
41. Ibid., March 3, 1980.
42. Figueroa oral history, 31.
43. *Arizona Daily Star*, March 12, 1980.
44. *Arizona Republic*, September 9, 1982.
45. *Scottsdale Progress*, April 18, 1980.
46. Marion De Grazia oral history, 18.
47. McKusick oral history, 3.

Chapter 13

1. *Arizona Republic*, March 25, 1981.
2. H. D. Quigg, "National Columnist Finds Artist De Grazia of Tucson," United Press article, *Tucson Daily Citizen*, n.d., De Grazia folder, Arizona Historical Society.
3. Butler, "Words of the Artist," 45.

4. *Albuquerque Tribune*, December 10, 1976.

5. De Grazia interview, *Today Show*.

6. Knagge oral history, 20.

7. Lucia De Grazia interview.

8. Figueroa oral history, 42.

9. Marlene McCauley, "Artist's Farewell," unpublished essay, n.d., DeGrazia Foundation archives, series 2, box 3, folder 17.

10. Grieve oral history, 12.

11. Thure oral history, 29.

12. Brown oral history, 13.

13. Frontain, *De Grazia in Fotos*, n.p.

14. Prescott oral history, 20.

15. Ron Butler, "De Grazia and the Indians," accessed December 17, 2011, http://blog.absolutearts.com/blogs/archives/00000340.html.

16. Maggie Wilson, "The World's Most Reproduced Artist Fortifies Autograph Party with Scotch," *Arizona Republic*, n.d., 1966–76 scrapbook, DeGrazia Foundation library.

17. McCauley, "Artist's Farewell."

18. *Tucson Citizen*, September 8, 1981.

19. Reed, *The Irreverent Angel*, 55, 58.

20. *Chicago Tribune*, November 23, 1978.

21. *Phoenix Gazette*, November 4, 1975.

22. *Wall Street Journal*, May 21, 1976.

23. Wilson, Frontain, and Stacey, "De Grazia: Three Views," 11.

24. *De Grazia*, University of Arizona Museum of Art, n.p.

25. Cohn, *Why We Look at Art, What Happens When We Do*, 1.

26. *Tucson Daily Citizen*, January 28, 1961.

27. Maggie Wilson, "Art Pricing: The Artist's Way of Scalping White Men," *Arizona Republic*, December 14, 1969.

28. *Albuquerque Tribune*, August 4, 1957.

29. Marion De Grazia, notebook of musings, 19.

30. *Albuquerque Tribune*, August 4, 1957.

31. Butler, "Words of the Artist," 34.

32. Catherine Slye, "Greeting Card Artist Ted DeGrazia's 'Unseen' Murals on Roosevelt Street," accessed July 28, 2011, http://blogs.phoenixnewtimes.com/jackalope/2010/04/ettore_ted_degrazia_murals.php.

33. Redl, *The World of De Grazia*, 34.

34. De Grazia oral history, 1.

35. *Tucson Daily Citizen*, April 21, 1960.

36. De Grazia, narrative statement, National Register of Historic Places, sect. 8, p. 29.

37. Marion De Grazia, notebook of musings, 25.

38. "Reached by Working Stiff Man, Painter Gives His Pictures Away," *New York World-Telegram*, n.d. (probably late October 1960), De Grazia file, Arizona Historical Society.

39. Ibid.

40. *Newark Star-Ledger*, October 29, 1965.

41. *Tucson Citizen*, February 22, 1983.

42. Butler oral history, 4.

43. Frontain oral history, 38.

44. Butler oral history, 5.

45. *Arizona Daily Star*, April 3, 1965.

46. "People-Styled Project," August 1980, 1979–86 scrapbook, DeGrazia Foundation library.

47. *Arizona Daily Star*, October 19, 1965.

48. Butler, "Words of the Artist," 8.

49. De Grazia, *His Thoughts and His Philosophy*.

50. Butler, "Words of the Artist," 10.

51. Ibid., 44.

52. Chanin oral history, 3.

53. De Grazia, *His Thoughts and His Philosophy*.

54. Wilson, Frontain, and Stacey, "De Grazia: Three Views," 6.

55. De Grazia to Congressman Morris K. Udall, May 18, 1975, DeGrazia Foundation archives, series, 1, box 2, folder 18.

56. Figueroa oral history, 7.

57. Ibid., 8.

58. Reed, *The Irreverent Angel*, 45.

59. *Tucson Daily Citizen*, August 25, 1966.

60. *Arizona Republic*, November 13, 1966.

61. Maggie Wilson, "Fair Warning, Fellows: De Grazia's Coming," *Scottsdale Progress*, n.d, 1944–66 scrapbook, DeGrazia Foundation library.

62. Lucia De Grazia interview.

63. Helen Brooks, "Ted De Grazia and Brod Crawford Hit Town," *Apache Junction Sentinel*, n.d., 1966–76 scrapbook, De Grazia Foundation library.

64. Dwight Whitney, "I Have a Jaundiced Eye but a Young Mind," *TV Guide*, March 6–12, 1971, accessed September 4, 2010, http://highwaypatroltv .com/TVGuide1971.

65. Clark oral history, 37; Renner oral history, 5.

66. Renner oral history, 5–7.

Chapter 14

1. De Grazia, narrative statement, National Register of Historic Places, sect. 8, p. 36.

2. State of Arizona Historic Property Inventory Form for the De Grazia Foundation Gallery in the Sun, Mission and Outlying Buildings for Eligibility to the National Register of Historic Places, 2005, continuation sheet no. 1, DeGrazia Foundation archives.

3. De Grazia, narrative statement, National Register of Historic Places, sect. 7, p. 14.

4. Frontain oral history, 47.

5. Butler, "Words of the Artist," 26.

6. Laturo oral history, 3.

7. Marion De Grazia, notebook of musings, 23.

8. De Grazia, narrative statement, National Register of Historic Places, sect. 7, p. 14.

9. Marion De Grazia, notebook of musings, 21.

10. De Grazia, "Texture," 11.

11. De Grazia, narrative statement, National Register of Historic Places, sect. 7, p. 15.

12. *Tucson Citizen*, August 27, 1996.

13. Frontain, *De Grazia in Fotos*, n.p.

14. Franco oral history, 2.

15. Marion De Grazia musings, 21.

16. De Grazia, "Texture," 11.

17. *Arizona Daily Star*, March 26, 1971.

18. De Grazia, Ted, "Texture," 10.

19. Grieve oral history, 17–18.

20. Locust oral history, 40.

21. Clark oral history, 26.

22. *Arizona Daily Star*, September, 26, 1982.

23. Marion De Grazia, notebook of musings, 29.

24. Alexander oral history, 23.

25. Sheaffer oral history, 17.

26. Elliot, "Arizona's 'Irreverent Angel' Lives Up to His Reputation," 28.

27. Chanin oral history, 6.

28. Butler, "Words of the Artist," 9.

29. Laber, e-mail message to author, n.d.

30. Marion De Grazia, notebook of musings, 23.

31. *Tucson Weekly*, August 12, 1987.

32. Prescott oral history, 23; Quintanilla oral history, 18.

33. *Arizona Daily Star*, October 21, 1962.

34. De Grazia exhibit brochure, Museum of Modern Art, New York City, n.d.

35. Marion De Grazia oral history, 72.

36. "Thomas Hart Benton," accessed September 16, 2012, http://www.theartstory.org/artist-benton-thomas-hart.htm; quote from Samuel Adams, *Thomas Hart Benton: An American Original*.

37. "Thomas Hart Benton," accessed September 16, 2012, http://www.theartstory.org/artist-benton-thomas-hart.htm.

38. "Benton Profile," accessed September 16, 2012, http://www.pbs.org/kenburns/benton/benton.

39. Thomas Hart Benton, "Master of Fantasy," *Arizona Highways*, October 1977, 12.

Chapter 15

1. Butler, "Words of the Artist," 33.
2. *Tucson Daily Citizen*, January 28, 1961.
3. *Arizona Daily Star*, November 27, 1963.
4. Ibid., April 7, 1984.
5. *Arizona Daily Star*, March 15, 1974.
6. Ibid.
7. DeWald oral history, 19.
8. *Arizona Daily Star*, July 31, 1964.
9. Elliott, "Arizona's 'Irreverent Angel' Lives Up to His Reputation," 28.
10. Wilson, "De Grazia: The Man, The Artist, The Spirit," 91.
11. De Grazia, narrative, National Register of Historic places, sect. 8, p. 29.
12. *New York Daily News*, November 4, 1965.
13. Figueroa oral history, 3.
14. Bill Thomas, "Desert Artist Sets His Own Standards," General Features Corporation syndicated column, July 31, 1966, DeGrazia Foundation archives, series I, box 2, folder 33.
15. Butler, "Words of the Artist," 32.
16. Reed, *The Irreverent Angel*, 49.
17. Galpin oral history, 3.
18. "De Grazia Exhibit Opens Saturday," *Palm Desert Post*, n.d., 1966–69 scrapbook, DeGrazia Foundation library.
19. Clark oral history, 14–15.
20. *Copper Cactus*, October 11, 1966.
21. "Morenci Honors Native Celebrity," *Arizona Daily Star*, n.d., 1944–66 scrapbook, DeGrazia Foundation library.
22. Landeen oral history, 8–9, 20.
23. *Arizona Daily Star*, June 1, 1967.
24. *Colorado Springs Gazette Telegraph*, November 26, 1972.
25. Butler oral history, 21.

Chapter 16

1. De Grazia, *Ah Ha Toro*, preface.
2. *Arizona Republic*, July 23, 1967.
3. Ibid., December 11, 1967.
4. Lanning, "De Grazia: Legend of the Southwest," 22.
5. *Tucson Citizen*, August 15, 1978.
6. *The Arizonan*, October 20, 1967.
7. *Arizona Daily Star*, September 26, 1982.
8. *Arizona Republic*, December 11, 1967.
9. Ibid.
10. *The Arizonan*, October 20, 1967.
11. De Grazia, *The Rose and the Robe*, introduction.

12. Maw, "Artist-Genius, Hermit-Millionaire," 91.

13. De Grazia, *The Rose and the Robe,* introduction.

14. Maw, "Artist-Genius, Hermit-Millionaire," 93.

15. Shaw oral history, 8.

16. Thure oral history, 4–6.

17. *Scottsdale Daily Progress,* December 12, 1975.

18. McBride oral history, 1.

19. Hammarstrom oral history, 1, 3.

20. "Dancing on a Greyhound Bus: Recollections of Dancer-Choreologist Richard Holden," accessed March 13, 2012, .http://richka.net.

21. *Tucson Daily Citizen,* April 15, 1970.

22. "Travis Edmonson," accessed July 23, 2012, http://www.folkera.com/Travis/index.html.

23. *Arizona Republic,* July 28, 1968; Laber interview.

24. Marion De Grazia, notebook of musings, 4.

25. Locust oral history, 42.

26. De Grazia, *His Thoughts and His Philosophy.*

27. Locust, *The Rest of the Story,* 39.

28. Locust oral history, 8–9.

29. "Mihaly Csikszentmihalyi," accessed January 18, 2013, http://en.wikipedia.org/wiki/Mihaly_Csikszentmihalyi.

30. *Arizona Daily Star,* October 4, 1964.

31. *Tucson Daily Citizen,* April 19, 1966.

32. Ron Butler, "The Colors between Earth and Sky," accessed June 1, 2012, http://www.thefreelibrary.com/The+colors+between+earth+and+sky.-a013905688.

33. *Arizona Republic,* July 28, 1968.

34. Locust oral history, 7, 35.

35. *Arizona Republic,* July 28, 1968.

36. Marion De Grazia, notebook of musings, 25.

37. McKusick oral history, 5.

38. Reed, *The Irreverent Angel,* 50.

39. Locust oral history, 6.

40. Locust, *The Rest of the Story,* xiii.

41. DeWald oral history, 10.

42. Fisher oral history, 52.

43. *Tucson Daily Citizen,* April 19, 1966; Laber interview.

44. *Arizona Republic,* July 28, 1968.

45. Grieve interview.

46. Edmonson oral history, 20.

47. Lucia De Grazia interview.

48. Marion De Grazia, notebook of musings, 51.

49. Laber interview; Wilson, Frontain, and Stacey, "De Grazia: Three Views," 11.

50. Pritchard oral history, 2.

51. Dave and Norma Fisher oral history, 28–29.
52. Marion De Grazia, notebook of musings, 27.
53. Chanin oral history, 6, 8.
54. Sheaffer oral history, 14.
55. Wilson oral history, 6.
56. Laber interview.
57. Chanin oral history, 21.
58. De Grazia, interview by Rita Davenport, *Open House*, KPHO-TV, Phoenix, n.d. (ca. March 1982), "Newscast, Phx, Obituaries," videotape, DeGrazia Foundation archives.
59. *Arizona Daily Star*, February 25, 1962.
60. Landeen oral history, 23.
61. "Art as Pure as Glass: Studio's Stained-Glass Works Take New Theme for Holidays," *Arizona Republic*, n.d.
62. Toney oral history, 7.
63. *Arizona Daily Star*, March 1, 1968.
64. *Yuma Daily Sun*, January 27, 1971.
65. Reed, *The Irreverent Angel*, 60.
66. Prescott oral history, 19.
67. *Arizona Republic*, December 11, 2002.
68. *Arizona Daily Star*, October 8, 1971.
69. *Yuma Daily Sun*, January 27, 1971.
70. Locust oral history, 7.
71. *Altus Times-Democrat*, August 22, 1971.
72. *De Grazia of Arizona*, exhibition brochure, Duke University, Spring 1972, DeGrazia Foundation archives, series 3, box 6, folder 79.

Chapter 17

1. *Chicago Tribune*, November 23, 1978.
2. *Arizona Republic*, September 26, 1971.
3. *The Santa Fe New Mexican*, July 21, 1971.
4. Reed, *The Irreverent Angel*, 10.
5. *Yuma Daily Sun*, November 10, 1971.
6. *Arizona Republic*, April 15, 1973.
7. *Chicago Tribune*, November 23, 1978.
8. Ted De Grazia to William Steadman, December 6, 1972, DeGrazia Foundation archives, series 1, box 12, folder 201.
9. Butler, "Words of the Artist," 47–48.
10. Wingate interview.
11. *Arizona Daily Star*, November 4, 1973.
12. Ibid., November 5, 1973.
13. *Tucson Daily Citizen*, October 30, 1973.
14. *Chicago Tribune*, November 23, 1978.

15. *Arizona Daily Wildcat,* July 20, 1976.
16. Proposals for museums, DeGrazia Foundation archives, series 2, box 10, folder 152.
17. Butler, "Words of the Artist," 9.
18. Thure oral history, 17, 26.
19. Brown oral history, 9–11.
20. Laber interview.
21. La Fond oral history, 1.
22. Ibid., 4–5.
23. Van Maanen, "De Grazia: A Fresh Look," 30.
24. *Chicago Tribune,* November 23, 1978.
25. La Fond oral history, 25.
26. Prescott oral history, 12.
27. *Tucson Citizen,* July 26, 1973.
28. Sheaffer oral history, 3.
29. De Grazia, "Cabeza de Vaca," *Arizona Highways,* August 1973, 35.
30. Ibid., 38.
31. Fisher oral history, 2–3.
32. *Tucson Daily Citizen,* April 19, 1973.
33. Diane Fisher oral history, 3, 12, 16.
34. Ibid., 13.
35. France oral history, 1.
36. *Tucson Daily Citizen,* April 19, 1973.
37. France oral history, 9.
38. *Arizona Daily Star,* April 28, 1973.
39. *Tucson Citizen,* April 28, 1973.
40. "De Grazia Checks to Be Offered by United Bank," October 20, 1973, 1973–79 scrapbook, DeGrazia Foundation library.
41. Moss, e-mail interview with author, November 7, 2010.
42. Brown oral history, 25.
43. Prescott oral history, 10.
44. Ibid., 13.
45. Ibid., 25.
46. Ibid., 15.
47. *Albuquerque Journal,* October, 9, 1977.
48. Chanin, *This Land, These Voices,* 244.
49. De Grazia to Theodore Hesburgh, August 18, 1975, DeGrazia Foundation archives, series 1, box 2, folder 18.
50. *Orange County Register,* October 26, 1975.
51. *Albuquerque Tribune,* December 10, 1976.
52. Lanning, "De Grazia: Legend of the Southwest," 22.
53. DeWald oral history, 4.
54. *Phoenix Gazette,* November, 4, 1975.
55. Chanin, *This Land, These Voices,* 240.

Chapter 18

1. Butler, "Words of the Artist," 1.
2. Redl, *The World of De Grazia*, 30.
3. *Apache Junction Sentinel*, January, 27, 1974.
4. *San Diego Union*, November 4, 1962.
5. Marion De Grazia, notebook of musings, 17.
6. De Grazia, *De Grazia and His Mountain*, 1.
7. Marion De Grazia oral history, 83.
8. Butler oral history, 17.
9. *Arizona Daily Star*, January 31, 1975.
10. Brown oral history, 1–2.
11. Settle, "Superstition Gallery: A Living De Grazia," 13.
12. *Apache Junction Sentinel*, February 6, 1974.
13. Marion De Grazia oral history, 73.
14. Galpin oral history, 7.
15. Ibid., 14.
16. Dave and Norma Fisher oral history, 39, 41.
17. *Arizona Daily Star*, May 15, 1976.
18. Lawrenzi and Molina, "They were my creations . . . ," 51.
19. *Superstition Mountain Burning*, May 12, 1976, videotape, B-27-10, DeGrazia Foundation archives.
20. *Arizona Daily Star*, May 15, 1976.
21. Locust oral history, 11.
22. Ibid., 13.
23. *Arizona Republic*, May 15, 1976.
24. Locust oral history, 21–22.
25. Lawrenzi and Molina, "They were my creations . . . ," 52.
26. *Tri-Valley Dispatch*, August 9–10, 1995.
27. Chanin oral history, 5, 17.
28. Landeen oral history, 17.
29. *Arizona Republic*, June 15, 1976.
30. Locust oral history, 22.
31. *Arizona Daily Star*, June 12, 1977.
32. Davenport oral history, 9.
33. Ibid., 14–15.
34. Dave and Norma Fisher oral history, 33.
35. *Washington Post*, June 12, 1976.
36. Laber interview.
37. *Arizona Daily Star*, n.d. (about 1977), DeGrazia Foundation archives, series 5, box 16, folder 5.
38. Laber interview; De Grazia, *De Grazia Moods in Gold*, 30.
39. *Phoenix Gazette*, May 16, 1979.
40. *Arizona Daily Star*, May 20, 1976.
41. *Tucson Daily Citizen*, June 15, 1976.

42. DeWald oral history, 18.

43. *Scottsdale Progress*, June 23, 1976.

44. Ibid., August 4, 1976.

45. *Wall Street Journal*, May 21, 1976.

46. *Los Angeles Times*, June 1, 1977.

47. Prescott oral history, 17–18.

48. Coopers & Lybrand to De Grazia, n.d., DeGrazia Foundation archives, series 2, box 5, folder 69.

49. *Today Sun*, June 7, 1978.

50. De Grazia, last will and testament, 1978, DeGrazia Foundation archives, series 1, box 2, folder 26; Laber interview.

Chapter 19

1. Reed, *The Irreverent Angel*, 64.

2. Ibid.

3. Andy McCarville, "A Small Town Lawyer," accessed July 24, 2013, http://www.myazbar.org/AZAttorney/PDF_Articles/AZAT0903McCarvPG28–32.pdf.

4. Ibid.

5. Locust, e-mail message to author, n.d.

6. Locust interview.

7. Marion De Grazia, notebook of musings, 6.

8. Associated Press, "Sammi Smith, 61, Grammy Winner, Is Dead," *New York Times*, February 20, 2005, accessed July 23, 2005, http://www.nytimes.com/2005/02/20/obituaries/20smith.html?_r=0.

9. Sheaffer oral history, 18.

10. Sammi Smith Albums file, De Grazia Foundation archives.

11. "Dave's Diary—17 February, 2005—Sammi Smith RIP," accessed March 14, 2012, http://www.nucountry.com.au/articles/diary/february2005/170205_sammismith_obit.htm#top.

12. DVD jacket copy, *End of the Rainbow*, directed by Ted De Grazia, DeGrazia Foundation archives.

13. *Phoenix Gazette*, May 10, 1978.

14. Frontain oral history, 26–27.

15. Laber interview.

16. Frontain oral history, 30–31.

17. Locust oral history, 3.

18. Locust, *The Rest of the Story*, 23–30.

19. Ibid.

20. Locust oral history, 4.

21. Locust, *The Rest of the Story*, 70.

22. Ibid., 71.

23. Ibid., 72–76.

24. Ibid., 57.

25. Ibid., 76.

26. Ibid., 84.

27. Ibid., 82.

28. Ibid., 104–7.

29. Locust interview.

30. Marion De Grazia, notebook of musings, 42.

31. Locust, *The Rest of the Story*, 115.

32. Ibid., 120–22.

33. Ibid., 126–27.

34. Locust interview.

35. Ibid.

36. Affidavit of Property Value, parcel no. 304-39-123, Navajo County Recorder's Office, Holbrook, AZ, accessed July 23, 2013, http://www.thecountyrecorder.com/Image.aspx?DK=570671&PN=1.

Chapter 20

1. Personal papers, De Grazia chronology, courtesy of Jennifer Potter.

2. De Grazia, *His Thoughts and His Philosophy*.

3. *Arizona Daily Star*, June 12, 1977.

4. Butler, "Words of the Artist," 46.

5. Davenport oral history, 9.

6. *Tucson Citizen*, September 18, 1981.

7. *Phoenix Gazette*, September 14, 1981.

8. Thorne, "The World of De Grazia," 193.

9. Ibid., 196.

10. Locust oral history, 24.

11. Locust, *The Rest of the Story*, 191.

12. Ibid., 194.

13. Ibid., 198.

14. Locust oral history, 25.

15. Butler, "Words of the Artist," 24.

16. Ron Butler, "De Grazia and the Indians," accessed December 17, 2011, http://blog.absolutearts.com/blogs/archives/00000340.html.

17. Davenport oral history, 14.

18. Ibid., 9.

19. Personal calendars, 1981, DeGrazia Foundation archives, series 1, box 1, folder 5.

20. Locust, *The Rest of the Story*, 200–201.

21. Locust, e-mail message to author, n.d.

22. De Grazia, interview by Rita Davenport, *A Rainbow of Color*, VHS-043, DeGrazia Foundation archives.

23. Locust oral history, 26, 27, 38.

24. Kerson, *Remembrance of Tucson's Past*, 119.

25. Frontain oral history, 6.

26. Wilson, Frontain, and Stacey, "De Grazia: Three Views," 6.

27. Locust, *The Rest of the Story*, 211.

28. Ibid., 213.

29. *Copper Era*, June 27, 1990.

30. Marion De Grazia, notebook of musings, 10.

31. Ibid., 30.

32. Domino, e-mail message to author, n.d.

33. *Tucson Citizen*, September 18, 1982.

34. Domino, e-mail message to author, n.d.

35. Marion De Grazia, notebook of musings, 7.

36. Ibid., 53.

Epilogue

1. *Arizona Daily Star*, September 26, 1982.

2. Ibid.

3. Locust, *The Rest of the Story*, 195.

4. *Arizona Daily Star*, June 7, 2009.

5. Marion De Grazia, notebook of musings, 47.

6. Marion De Grazia to "Dear Papa," May 6, 1983, DeGrazia Foundation archives, series 1, box 2, folder 19.

7. Buck Saunders, inventory of De Grazia artwork, June 9, 1983, DeGrazia Foundation library.

8. Laber interview.

9. Marion De Grazia, notebook of musings, 12.

10. Butler, "De Grazia and the Indians."

11. Marion De Grazia, notebook of musings, 34.

12. Laber, e-mail message to author, n.d.

13. Marion De Grazia, notebook of musings, 15.

14. Butler, "De Grazia and the Indians."

15. *Inside Tucson Business*, April 15, 1996.

16. *Arizona Daily Star*, September 17, 1996.

17. Laber interview.

18. De Grazia Art and Cultural Foundation Inc., National Center for Charitable Statistics, accessed July 18, 2013, http://nccsweb.urban.org/orgs/profile.php/860339837?popup=1.

19. DeGrazia Foundation, Inc., Return of Private Foundation, form 990-PF, 2009, Department of the Treasury, Internal Revenue Service, accessed July 18, 2013, http://irs990.charityblossom.org/990PF/201006/860339837.pdf.

20. DeGrazia Foundation, Inc., Return of Organization Exempt from Income Tax, form 990-PF, June 30, 2012, Department of the Treasury, Internal Revenue Service, courtesy of Lance Laber.

21. *Inside Tucson Business*, April 15, 1996.

22. *Tucson Citizen*, October 7, 1982; Trust of Domingo Star (De Grazia), case no. TE357, filed December 5, 1995, Clerk's Office, Pima County Superior Court, Tucson, AZ.

23. Locust, *The Rest of the Story*, 226.

24. Trust of Domingo Star (De Grazia).

25. Estate of Ettore "Ted" DeGrazia, case no. 9890, filed October 5, 1982, Clerk's Office, Pima County Superior Court, Tucson, AZ.

26. "City Limits: An Artist's Past," *Tucson Weekly*, n.d., 1987–93 scrapbook, DeGrazia Foundation library.

27. *Arizona Daily Star*, October 26, 1986.

28. *Tucson Citizen*, July 27, 1987.

29. *Arizona Republic*, August 9, 1987; *Arizona Daily Star*, August 1, 1987.

30. Marion De Grazia, last will and testament, filed December 19, 2002, Clerk's Office, Pima County Superior Court, Tucson, AZ.

31. "Domingo De Grazia, Spanish Guitar," accessed March 23, 2012, http://www.degraziamusic.com/?page_id=2.

32. De Grazia, narrative, National Register of Historic Places, sect. 8, p. 29.

33. Cohn, telephone interview with author, September 24, 2012.

34. Laber, e-mail message to author, September 20, 2012.

35. *Chicago Tribune*, November 23, 1978.

36. Marion De Grazia, notebook of musings, 27.

Bibliography

Author Interviews

Brown, Fred. October 5, 2010, Bisbee, AZ.

Cohn, Sherrye L. September 24, 2012, telephone.

De Grazia, Domingo. February 8, 2011, Tucson, AZ.

De Grazia, Lucia. Numerous interviews from December 2011 to March 2012, Tucson, AZ.

Diamos, Joana. February 3, 2011, Tucson, AZ.

Domino, Brian. December 28, 2011, Tucson, AZ.

Feldman, Ira. August 4, 2011, Tucson, AZ.

Grieve, Hal. October 28, 2010, Tucson, AZ.

Hirale, Al. October 5, 2010, Bisbee, AZ.

Laber, Lance. Numerous interviews from September 2011 to June 2012, Tucson, AZ.

Locust, Carol. November 3, 2010, Tucson, AZ.

McCarville, Tom. March 28, 2011, Casa Grande, AZ.

Moss, Ginny. November 7, 2010, e-mail.

Potter, Jennifer. January 8, 2011, Tucson, AZ.

Riddle, Jack. October 5, 2010, Bisbee, AZ.

Wingate, Adina. July 27, 2011, telephone.

Oral Histories

All oral histories are from the DeGrazia Foundation archives, Tucson, Arizona.

Alexander, John. Interview by Melissa McCormick, March 6, 1998.

Bell, Marjorie. Interview by Karen Nystedt, October 23, 1996.

Brown, Rick. Interview by Jim Frazer, March 11, 1996.

Butler, Ron. Interview by Karen Nystedt, May 13, 1997.

Chanin, Abraham S. Interview by Jim McNulty, May 6, 1996.

Clark, La Verne Harrell. Interview by Karen Nystedt, March 10, 1997.

Davenport, Rita. Interview by Melissa McCormick, June 22, 1998.

De Grazia, Lucia. Interview by Susan Vance, August 29, 1998.

De Grazia, Marion. Interview by David Hoefferle, August 10, 1996.

De Grazia, Ted. Interview by Paul Sobey, n.d.

DeWald, Louise. Interview by Chuck Debow, June 7, 1996.

Dyck, Paul. Interview by Abe Chanin, October 6, 1996.

Edmonson, Travis. Interview by Chuck Debow, September 24, 1996.

Feeney, Eleanor Rice. Interview by Abe Chanin, May 21, 1997.

Figueroa, Delia. Interview by Karen Nystedt, October 24, 1996.

Fisher, Dave and Norma. Interview by Melissa McCormick, March 6, 1998.

Fisher, Diane. Interview by Susan Vance, January 25, 1999.

France, Richard. Interview by Melissa McCormick, December 12, 1997.

Franco, Thomas. Interview by Abe Chanin, August 1998.

Frontain, Dick. Interview by Susan Vance, August 6, 2006.

Galpin, Phil. Interview by Susan Vance, May 1, 2008.

Grieve, Harold. Interview by Susan Vance, August 10, 1998.

Hammarstrom, Cecilia. Interview by Susan Vance, November 5, 1998.

Horky, Virginia. Interview by Mary Lu Moore, March 19, 1997.

Huff, John. Interview by Susan Vance, August 10, 1998.

Jacobson, Edward "Bud." Interview by James McNulty, April 1, 1998.

Knagge, Beatrice. Interview by Susan Vance, April 30, 1998.

La Fond, Jim. Interview by Jim Frazer, March 21, 1996.

Landeen, Fred. Interview by James McNulty, April 30, 1996.

Laturo, Ben. Interview by Susan Vance, January 17, 2008.

Locust, Carol. Interview by Susan Vance, August 9, 2006.

McBride, Robert. Interview by Melissa McCormick, November 18, 1997.

McKusick, Robert T. Written memoir (in lieu of oral history), March 30, 2009.

Miller, Robert F. Interview by Susan Vance, June 20, 1997.

Peterson, Cele. Interview by James McNulty, June 7, 1996.

————. Interview by Susan Vance, August 10, 2006.

Pichetto, Phyllis. Interview by Karen Nystedt, September 23, 1997.

Pintek, John. Interview by Abe Chanin, June 10, 1997.

Prescott, Cassandra. Interview by Susan Vance, September 24, 1998.

Pritchard, Varda. Interview by Karen Nystedt, November 15, 1996.

Quintanilla, Genevieve. Interview by Melissa McCormick, December 3, 1997.

Renner, Ginger. Interview by Chuck Debow, June 26, 1996.

Saunders, Leobarda "Leo." Interview by Chuck Debow, April 30, 1996.

Shaw, Elizabeth. Interview by Abe Chanin, January 10, 1997.

Sheaffer, Jack. Interview by Abe Chanin, April 3, 1997.

Sonderegger, Leo and Marian. Interview by Melissa McCormick, November 11, 1997.

Thure, Karen. Interview by James McNulty, April 24, 1996.

Toney, Ken. Interview by Jim Frazer, March 12, 1996.

Wilson, Maggie. Interview by Chuck Debow, September 10, 1996.

Books and Magazines

Bret-Harte, John. *Tucson: Portrait of a Desert Pueblo*. Sun Valley, CA: American Historical Press, 2001.

Butler, Ron. "Gene 'Shorty' Thorn: A Childlike Directness." *Southwest Art*, September 1982, 66–67.

———. "The Colors between Earth and Sky." Accessed August 6, 2013. http://www.thefreelibrary.com/The+colors+between+earth+and+sky.-a013905688.

———. "Trekking the Superstitions." *Frontier*, June 1981, 34, 36, 38–39.

———. "With De Grazia among the Seris." *Westways*, October 1978, 38–41.

Cain, Joella. "The Real Ted De Grazia." *Arizona Woman*, January 1979, 9–10.

Carlson, Raymond. "An Artist in Navajoland." *Arizona Highways*, August 1967, 14, 27–29.

———. "De Grazia." *Arizona Highways*, February 1941, 30–33.

———. "De Grazia." *Arizona Highways*, March 1949, 28–35.

Chanin, Abe, with Mildred Chanin. *This Land, These Voices.* Flagstaff, AZ: Northland Press, 1977.

"Christmas on the Desert." *Arizona Days and Ways, Arizona Republic,* December 22, 1963, 10–15.

Cogut, Ted, and Bill Conger. *History of Arizona's Clifton-Morenci Mining District: A Personal Approach.* Thatcher, AZ: Mining History, 1999.

Cohn, Sherrye L. *Why We Look at Art, What Happens When We Do.* Indianapolis: Dog Ear Publishing, 2008.

Colquhoun, James. *The History of the Clifton-Morenci Mining District.* London: John Murray, 1924.

Conrotto, Eugene L. "One Man's Southwest." *Desert Magazine*, December 1960, 22–25.

Coze, Paul. "A Voice in the Southwest." *Arizona Highways*, January 1955, 28–29, 33.

Cutts, Anson B. "De Grazia." *Point West*, August 1960, 18–21.

Davis, Loda Mae. "De Grazia—Arizona's Impetuous Impasto." *The Trumpeteer*, Spring 1952.

De Grazia. Tucson: University of Arizona Museum of Art, 1973.

De Grazia, Marion. *De Grazia: A Biographical Sketch.* Tucson, AZ: Gallery in the Sun Publications, 1966.

———. *De Grazia: A Diamond in the Rough, The Facets Glow.* Tucson, AZ: DeGrazia Foundation, 1992.

———. *M Collection.* Tucson, AZ: Gallery in the Sun Publications, 1971.

———. *Son of Lightning.* Tucson, AZ: DeGrazia Foundation, 1992.

"De Grazia, Painter and Potter." *The Magazine Tucson*, October 1948, 30–31.

De Grazia, Ted. *Ah Ha Toro.* Flagstaff, AZ: Northland Press, 1967.

———. *Arizona South, Book 1: Impressions of Papago and Yaqui Indians.* Tucson, AZ: De Grazia Studios, 1950.

———. *Arizona South, Book 2: The Flute Player.* Tucson, AZ: De Grazia Studios, 1952.

———. *Arizona South, Book 3: Mission in the Santa Catalinas.* Tucson, AZ: De Grazia Studios, 1951.

———. *Arizona South, Book 4: Padre Nuestro.* Tucson, AZ: De Grazia Studios, 1953.

————. *Arizona South, Book 5: The Blue Lady.* Tucson, AZ: De Grazia Studios, 1957.

————. "The Blue Lady." *Desert*, December 1961, 4–5.

————. "Cabeza de Vaca." *Arizona Highways*, August 1973, 35–43.

————. *Christmas Fantasies.* Tucson, AZ: Gallery in the Sun Publications, 1977.

————. *De Grazia and His Mountain, the Superstition.* Tucson, AZ: Gallery in the Sun Publications, 1972.

————. *De Grazia: A Biographical Sketch.* Tucson, AZ: Gallery in the Sun Publications, 1966.

————. *De Grazia Creates Enamels.* Tucson, AZ: Gallery in the Sun Publications, 1975.

————. *De Grazia in Graphics.* Tucson, AZ: Gallery in the Sun Publications, 1980.

————. *De Grazia Moods in Gold, Silver, Precious Gems, and Cookies.* Tucson, AZ: Gallery in the Sun Publications, 1974.

————. *De Grazia Paints Cabeza de Vaca.* Tucson, AZ: Gallery in the Sun Publications, 1973.

————. *De Grazia Paints the Apache Indians and Myths of the Chiricahua Apaches.* Tucson, AZ: Gallery in the Sun Publications, 1976.

————. *De Grazia Paints the Papago Indian Legends.* Tucson, AZ: Gallery in the Sun Publications, 1975.

————. *De Grazia Paints the Signs of the Zodiac.* Tucson, AZ: Gallery in the Sun Publications, 1971.

————. *De Grazia Paints the Yaqui Easter.* Tucson, AZ: University of Arizona Press, 1968.

————. *De Grazia's Borderlands Sketches.* Tucson, AZ: Southwest Center, University of Arizona, 1997.

————. *Father Junipero Serra: Sketches of His Life in California.* Los Angeles: W. Ritchie Press, 1969.

————. *Illustrated Catalog of Reproductions.* Tucson, AZ: De Grazia Studios, 1961–1970.

————. "Operation: Arrowhead." *Arizona Medicine*, September 1973, 632.

————. *Our Lady of Guadalupe.* Tucson, AZ: Arizona South, 1953.

————. *Padre Kino: Memorable Events in the Life and Times of the Immortal Priest-Colonizer of the Southwest, Depicted in Drawings by DeGrazia.* Los Angeles: Southwest Museum, 1962.

————. "Papago Pilgrimage." *Arizona Highways*, October 1959, 10–13.

————. *A Tale of Apache Indians, Mexicans, and Mission in Arizona South.* Tucson, AZ: De Grazia Studios, 1951.

————. "Texture." *Mountain States Architecture*, March 1966, 10–11.

————. *The Rose and the Robe: The Travels of Fray Junipero Serra in California.* Palm Desert, CA: Best-West Publications, 1968.

————. *The Way of the Cross.* Tucson, AZ: De Grazia Associates, 1964.

De Grazia, Ted, and Rita Davenport. *De Grazia and Mexican Cookery.* Flagstaff, AZ: Northland Press, 1981.

De Grazia, Ted, with Nancy Vardaman. "Make Your Own Pottery." *Family Circle*, January 1950, 36–37, 74–75.

De Grazia, Ted, with William Neil Smith. *The Seri Indians: A Primitive People of Tiburon Island in the Gulf of California*. Flagstaff, AZ: Northland Press, 1970.

Dentzel, Carl Schaefer. "De Grazia." *Arizona Host*, 1977, 8–10.

"Desert Church." *This Week Magazine*, December 19, 1953, n.p.

Elliot, Susan K. "Arizona's 'Irreverent Angel' Lives Up to His Reputation." *The Plate Collector*, December 1, 1980, 25, 28–30.

———. "Getting to Know Ted De Grazia." *Collectors Mart*, Spring 1988, 56–60.

Faulk, Odie B. *Arizona: A Short History*. Norman: University of Oklahoma Press, 1970.

Ford, Rebecca. "The Art and Craft of Ted De Grazia." *Craft & Art Market*, July–August 1977, 8, 36, 38, 40, 44–45.

Frontain, Dick. *De Grazia in Fotos*. Tucson, AZ: Los Amigos, 1977.

Gordon, Alvin J. With illustrations by Ted De Grazia. *Brooms of Mexico*. Palm Desert, CA: Best-West Publications, 1965.

———. With illustrations by Ted De Grazia. *Inherit the Earth*. Tucson: University of Arizona Press, 1963.

———. With illustrations by Ted De Grazia. *Journeys with Saint Francis of Assisi*. Palm Desert, CA: Best-West Publications, 1966.

Gust, Dodie. "Seri Indian Land." *Sketch Book*, March 6–26, 1970, 1, 6.

Keatley, Vivien. "Mission in the Sun." *Arizona Highways*, November 1955, 31–37.

Kerson, Alexandra Diamos De Grazia. *Remembrance of Tucson's Past: Century Ago and More, and Less in Tucson, Arizona*. Tucson, AZ: El Siglo Publishers, 1985.

Kluger, James R. *The Clifton-Morenci Strike: Labor Difficulty in Arizona, 1915–1916*. Tucson: University of Arizona Press, 1970.

Lalich, Richard. "Images of De Grazia." *Plate World*, July–August 1985, 26–31.

Lanning, Rick. "De Grazia: Legend of the Southwest." *Argosy*, October 1976, 21–22, 62–63.

———. "Portrait of an Artist." *Desert*, August 1981, 20–23.

Lawrenzi, Geno, Jr., and David G. Molina. "They were my creations" *Identity*, January 1977, 50–52.

Lenon, Robert. *It Seems Like Only Yesterday: Mining and Mapping in Arizona's First Century*. Vol. 2, *Bisbee and Patagonia*. Lincoln, NE: iUniverse, 2005.

Locust, Carol. *De Grazia: The Rest of the Story*. Tucson, AZ: U.S. Press, 2004.

Luchs, Kurt. *Plate World*, November 1987, 72, 74, 76, 77–78.

Luey, Beth, and Noel J. Stowe. *Arizona at 75: The Next 25 Years*. Tucson: University of Arizona Press, 1989.

Manoil, Moyca Christy. "Notes from the Editor." *Arizona Living*, April 1963, 4–5.

Martinelli, Phylis Cancilla. *Undermining Race: Ethnic Identities in Arizona Copper Camps, 1880–1920*. Tucson: University of Arizona Press, 2009.

Maw, Dolly. "Artist-Genius, Hermit-Millionaire." *San Diego Magazine*, December 1968, 90–93.

Mellinger, Philip J. *Race and Labor in Western Copper: The Fight for Equality, 1896–1918*. Tucson: University of Arizona Press, 1995.

Miller, George A. "De Grazia: The Legacy Endures." *Tucson Lifestyle*, October 1989, 66–67.

"Painting Music in Color: Untaught Artist Seeks the Relation between Art and Music." *Monthly Pix*, April 1948, 12–13.

Redl, Harry. *The World of De Grazia: Artist of the American-Southwest*. Phoenix: Chrysalis Publishing, 1981.

Reed, William. *De Grazia: The Irreverent Angel*. San Diego, CA: Frontier Heritage Press, 1971.

Rosenfeld, Dorcas. *De Grazia as I Know Him*. Phoenix: C. O. L. Publishing, 1974.

Sears, Bill. "Mission in the Hills." *Western Ways*, April 1954, 14–17.

Settle, Paula. "Superstition Gallery: A Living De Grazia." *The Magazine Tucson*, December 1974, 13–14.

Shaw, Elizabeth. "Ted De Grazia." *Point West*, June 1964, 36–40.

———. "Painter's Pilgrimage." *New Mexico Magazine*, January 1965, 25–26, 39.

Sonnichsen, C. L. *Tucson: The Life and Times of an American City*. Norman: University of Oklahoma Press, 1982.

Sutherland, Mason. "From Tucson to Tombstone." *National Geographic Magazine*, September 1953, 343–84.

Taylor, Michael Ray. "Wanted: Lost Paintings." *America*, Spring 1989, 17–18.

"Ted De Grazia: The People Painter." *Highroads*, December 1970, 4–5, 8.

Thorne, George. "The World of De Grazia." *San Diego Magazine*, December 1981, 192–96.

van Maanen, James. "De Grazia: A Fresh Look." *Collector Editions*, Spring 1987, 28–30.

West, Pat. "De Grazia Paints the Cocopah Indians." *Western Ways*, Spring 1972, 9–11.

Whitney, Dwight. "I Have a Jaundiced Eye but a Young Mind." *TV Guide*, March 6–12, 1971. Accessed September 4, 2010. www.highwaypatroltv.com/TVGuide1971/.

Wilson, Maggie. "De Grazia: The Man, the Artist, the Spirit." *Elite*, Winter 1982, 7–10, 90–91.

Wilson, Maggie, Dick Frontain, and Joseph Stacey. "De Grazia: Three Views; Artist of the People." *Arizona Highways*, March 1983, 2–15.

The WPA Guide to 1930s Arizona. Tucson: University of Arizona Press, reprinted 1989.

Unpublished Works

Butler, Ron. "Words of the Artist" (book proposal, n.d.). Northern Arizona University, Cline Library.

Dalton, Karen Jeanne. "Kitsch and Southwest Hybridity in the Art of Ted De Grazia." Master's thesis, University of South Florida, 2007.

De Grazia, Marion. Notebook of musings, n.d. DeGrazia Foundation archives, series 2, box 3, folder 7.

De Grazia, Ted. "Art and Its Relation to Music in Music Education." Master's thesis, University of Arizona, 1945.

———. Handwritten autobiography, n.d. DeGrazia Foundation archives, series 2, box 3, folder 12.

Maw, Dolly. Book proposal, October 5, 1968. DeGrazia Foundation archives, series 2, box 3, folder 19.

Olson, Nellie C. "The Unpredictable De Grazia" (unpublished manuscript, n.d.). DeGrazia Foundation archives, series 2, box 3, folder 21.

Papers of Ada Pierce McCormick, 1881–1978. Special Collections, University of Arizona Library.

Pulice, Joe. "My Childhood Days with Ted De Grazia" (unpublished testimonial, n.d.). DeGrazia Foundation archives, series 2, box 3, folder 22.

Rosenfeld, Dorcas. "Ettore De Grazia" (unpublished manuscript, n.d.). DeGrazia Foundation archives, series 2, box 3, folder 24.

Ted De Grazia folder. Arizona Historical Society, Tucson.

Watt, Roberta. "History of Morenci, Arizona." Master's thesis, University of Arizona, 1956.

Audiovisual Materials

De Grazia, Ted. *His Thoughts and Philosophy*. Gallery in the Sun Productions, 1971. Vinyl recording.

———. Interview by Tom Galvin. *The Today Show*, NBC Television, 1967. VHS tape.

The following films are from De Grazia's Gallery in the Sun archives and were transfered to DVDs by Arizona Film and Video Archive, Jerome, Arizona.

The Artist, the Man, the Legend.
Bull Fight in Naco, Mexico.
Cabeza de Vaca.
Chiaroscuro.
Corrida.
De Grazia 1977.
Elisha M. Reavis.
End of the Rainbow.
The Flute Player.
Home Movies Diamos Family.
1939 Beauty Contest.

Index

About the Authors

JAMES W. JOHNSON is a retired journalism professor at the University of Arizona, where he taught for twenty-five years. He is also a veteran newspaperman, having worked at the *Philadelphia Inquirer*, the *Oregonian*, the *Providence Journal*, the *Arizona Republic*, the *Arizona Daily Star*, and the *Oakland Tribune*. He has published six books, including two by the University of Arizona Press: *Mo: The Life and Times of Morris K. Udall* and *Arizona Politicians: The Noble and the Notorious*. He currently is at work on a book, *The Black Bruins*, about four African Americans, including Jackie Robinson, who played football for UCLA in the late 1930s and went on in their later years to national attention. He lives in Tucson, Arizona, with his wife, Marilyn.

MARILYN D. JOHNSON is a former reporter and copyeditor at the *Oregonian*, the *Arizona Republic*, the *Arizona Business Gazette*, and the *Tucson Citizen*. She holds a bachelor's degree in English from San Francisco State University and a master's degree in journalism from the University of Arizona.